Pollen Grains & Honeydew

A guide for identifying the plant sources in honey

by Margaret Anne Adams

With contributions by Christine Coulsting and Alan Riach

ISBN: 978-1-914934-23-0

Published 2021 by: Northern Bee Books, Scout Bottom Farm, Mytholmroyd,
Hebden Bridge HX7 5JS (UK)
www.northernbeebooks.co.uk

Front cover image: Pollen grains in Maggie Tavilla's honey sample; the honey won a
first prize at the Warwickshire Beekeepers Honey Show on 9th of September 2019.

Layout by www.SiPat.co.uk

Pollen Grains & Honeydew
A guide for identifying the plant sources in honey

Margaret Anne Adams

With contributions from
Christine Coulsting & Alan Riach

Acknowledgements

During the Covid lockdown, members of the Scottish Beekeepers' Facebook Group read my posts about the latest flowers to produce pollen in our bees' foraging area, and they asked me to produce a book. Gradually members of the Group and members of the British and Irish Beekeepers' Facebook Group started sending me samples of their honey, and the digital photos from my pollen slides helped me to identify most of the pollens in their honey. Some of these honeys feature in this book.

I got to work on the book, knowing now that there was a need for a simple approach to help beekeepers to identify the sources of their honey, for themselves, at home. I was determined to help beekeepers to overcome the obstacles described in an article in Bee Culture called "Searching for Pollen in Honey". The author Vaughn Bryant said, in March 1917:

"To analyse honey samples using the pollen contents requires a "long learning curve!" This is not to say that it is impossible for a beekeeper to learn how to do this, but most of those who want to do it do not have the needed botanical background, the equipment to do the extraction process, or the pollen reference collections needed to help them identify the potential thousands of pollen types they could find in their samples".

My husband John always encourages my efforts, and he gave me the equipment to get started with honey identification. I was already able to use a microscope, thanks to Mrs D V Sansome BSc Hons, who taught Biology at Taunton Technical College in the 1960s. She was the best of teachers and allowed me to spend as much time as I liked in the laboratory, using the microscopes and the egg incubator to watch the development of the chick. She opened our eyes to all the primitive plants around us and their intricate life cycles that were visible under a microscope.

In April 2017 Alan Riach and his wife Cynthia ran an inspiring Microscopy Course for Beekeepers, at St Andrew's University. Over a long weekend, the twenty-four participants were taught how to dissect bees, how to extract pollen from honey and how to make pollen slides from flowers and the pollens spun out of 10 gram samples of honey. Ann Chilcott, Bron Wright, Tony Harris, Fiona Highet, Marie Carnegie, and David Wright were there to help us with these tasks. Alan has kindly contributed an article on Pollen Coefficients to this book.

Despite these experiences, there was plenty to learn about identifying the flowers that bloom in our bees' foraging area and about taking photos of the pollen

grains on my microscope slides; the photos had to be good enough to be used to recognise the pollens in our honey. Helen Murray, Technical Support & Sales Director at Brunel Microscopes was helpful and happy to answer all my questions.

My Cyberspace friend and companion, in this steep learning curve, was Christine Coulsting. At times we felt like sleuths, and we got great joy when we identified a rare plant or unusual pollen grain in honey. Christine lives in a rural area, in the South of England, that also has well stocked, private gardens. John and I live in the Rhins of Galloway where herds of cattle are bred for beef and milk; there are many wild flowers and trees around the pastures and in our acre. By selective weeding of aggressive plants the diversity of wild flowers has increased over the years. However, when people sent me honey samples from far off places I needed to search beyond my own pollen slide collection in the unwieldy, international, online Pollen data bases. Similarly, Christine could not constantly visit neighbours' gardens, asking for cultivars and exotic flowers from which to collect pollen, for her slide collection, to identify some of the unusual pollens in her own honey. In this book, Christine has written about the painstaking methods she has developed to narrow down the overwhelming number of possibilities, when using the online, international pollen banks and other resources.

The next stage was to describe the equipment and methods that beekeepers need, to find out what sort of honey they have extracted. I was delighted that Karuna Shivani Rocco Rinck agreed to come to our cottage, try out the methods as described, and ask questions if something needed clarifying.

Finally, there are a lot more solids in honey than pollen grains, and I am grateful to every person who sent me honey samples. The samples came from apiaries between Inverness and Pont-de-Vaux in south east France. Some honey samples smelt delicious and even exotic. Some honey smelt unappetizing and contained unexpected objects. Every honey was different and taught me something new and fascinating. Most honey is extracted in the summer and contains honeydew but counting honeydew elements is not yet a well-developed science. My findings on honeydew are in Section 4, "Understanding the honey solids seen under a microscope"

Throughout, my son Christopher and his wife Jackie have been enthusiastic and supportive. I am also grateful to Jeremy Burbidge, Jonathan Burbidge, Ann Chilcott,

Acknowledgements

Jackie Elliot, Gino A Jabbar, Fiona Keith, Caroline Mackenzie, Younus Nur, Danny Ralph, Dani Akrigg, and Stephen Riley, for encouraging me to finish this project, as I could have gone on making improvements ad infinitum. Bryan Mason, Karuna Shivani Rocco Rinck, Fritti Moore and Nick Adams have kindly allowed me to use one of their photos. Maggie Tavilla was the first person to send me a sample from an English honey that had won a first prize; a glimpse through the microscope, of a few grains of that honey feature on the cover of this book. Sarah Price was very appreciative from my very first post on Facebook. Helen Nelson made useful suggestions and shared my posts, while Ruary Rudd kept me on my toes, with his criticisms. My daughter Louise Hardwick has patiently read through the text with me and discussed the grammar and spelling in detail.

Dr Musa Ali, Consultant Respiratory Physician, has been responsible for my care since May, when I was diagnosed with malignant mesothelioma. His wisdom and kindness have enabled me to stay as well as possible and see this through. My children and their families have all worked hard to help me and John during this time.

I hope the beekeepers who read this book will manage to acquire the equipment, collect pollens, and examine their honey, as it is an amazingly enjoyable experience. Maybe you will find you have a special honey from time to time and be able to label the jars with a specific label.

A trolley with drawers is useful as a mini, mobile laboratory. The equipment can then be wheeled safely into the kitchen. Boxes can be bought to store microscope slides. The photos of the pollen grains can be stored in a file on a computer, each grain labelled by family, species, and its common name.

Have fun!

Margaret Anne Adams

Auchnotteroch, Scotland.

3rd November 2021

Personal names index

Personal names index

Surname	Forename	Page
Keith	Lawrence	144
Keogh Jones	Donovan	213, 221
Mackenzie	Caroline	Acknowledgements, 242
Mason	Bryan	Acknowledgements, 276, 277
Moore	Fritti	Acknowledgements, 218,219
Murray	Helen	Acknowledgements
Nelson	Helen	Acknowledgements
Noblet	Paul	58, 60, 61
Nur	Younus	Acknowledgements
Power & Syred	Science Library	52
Price	Sarah	Acknowledgements
Ralph	Danny	256, 267
Riach	Alan	Acknowledgements, 342 - 349
Riach	Cynthia	Acknowledgements
Riley	Stephen	Acknowledgements
Rudd	Ruary	Acknowledgements

Contents

Contents

Contents

Contents

Contents

Section 7: Determining the composition of honey by measuring the proportions of the different pollens that it contains; by Alan Riach343

Why is it essential to make a collection of pollen slides before attempting to determine the plant sources used by our bees to produce honey?

There are about 350,000 species of flowering plant, each with its own, unique pollen. These plants are grouped into over 400 families. For example, Rosaceae, the rose family, consists of nearly 5000 species, including early summer sources of nectar for bees, such as hawthorn, plum, apple, pear, and cherry blossoms.

The pollens from the members of a family only differ in subtle ways. However, if we make a collection of digital photos, of the pollen from flowers in the foraging area of our bees, the task becomes manageable. To identify the plant sources of our honey, we just have to match the pollen grains we find in a sample of the honey, with the pollens we have gathered from flowers, during the year.

This book guides you through the processes step by step.

A GLIMPSE OF A FEW OF THE THOUSANDS OF POLLEN GRAINS AND HONEYDEW ELEMENTS, IN A 10 GRAM SAMPLE OF HONEY

Montbretia 49 μm

Bluebell 55 μm

HONEYDEW ELEMENTS

Sycamore 36 μm

Cow parsley 25 μm by 15 μm

Creeping thistle 41 μm

Meadowsweet 18 μm

Hawthorn 38 μm

Lime 33 μm

White clover 23 μm

Rosebay willowherb 77 μm

Himalayan balsam 28 μm

Wild garlic 28 μm

Knapweed 31 μm

Ling heather 31 μm

Blackberry 36 μm

Wisteria 30 μm

Prickly sow-thistle 33 μm

Meadowsweet 18 μm

Yeast

Margaret Anne Adams 17/05/2021

Section 1

Equipment and methods for making pollen slides from flowers, pollen loads and honey

Shopping list for the equipment needed when making pollen slides

Essential equipment	Uses of the equipment
Secateurs	For collecting flowers
Paper or plastic bags	For separating specimens collected
Vases	For keeping specimens till the stamens dehisce
Tweezers and fine scissors	To remove anthers from flowers
3 watch glasses	To collect and wash pollen
A pack of 5 ml Pasteur plastic pipettes	To transfer liquids and pollen in solution
Isopropanol	To wash pollen
Filter paper such as coffee filter bags	To soak up liquids
Microscope slides and cover slips	To preserve and view pollen
Clear and fuchsine glycerine jelly	To mount and stain pollen
Flat ended tweezers	To lower cover slips
Microscope slide hotplate (not a spirit lamp as inflammable liquids cause a fire).	To warm slides
Cocktail sticks	To spread pollen neatly on a glass slide
Scalpel	To remove overflow jelly
Nail varnish	To seal the edges of the cover slips
Digital microscope	To examine pollen then take and file photos

Shopping list for the extra equipment needed when making pollen slides from honey

Essential equipment	Uses of the equipment
All the equipment for making a pollen slide listed on the previous page, plus:	
Professional mini digital scale	For weighing 10 grams of honey and 20 grams of water
3 small pots	To weigh and dissolve honey in water
3 small glass rods or three small teaspoons	For stirring honey till it is completely dissolved in the water
800-1 centrifuge machine	For spinning the solids out of the honey solution
A pack of 15ml plastic tubes with screw caps	For containing honey solution in the centrifuge
Test tube stand	To keep the test tubes upright and for draining them after washing out and rinsing
6 plastic beakers	For keeping pipettes apart when dealing with 2 or 3 specimens of honey. And for holding clean water.

Calibrating the eyepiece graticule to measure pollen grains and honeydew elements in microns (µm)

Equipment

1. A compound microscope

2. A screwdriver to free the eyepiece lock screw

3. A10x measuring eyepiece for your microscope with the eyepiece graticule already in place

4. A stage micrometer, which is a microscope slide engraved with an accurate scale

SI unit of length for pollen grains

Pollen grain dimensions are measured in micrometres/microns for which the symbol is µm. One micron is one millionth of a metre.

EQUIPMENT FOR CALIBRATING THE EYEPIECE GRATICULE OF A COMPOUND MICROSCOPE

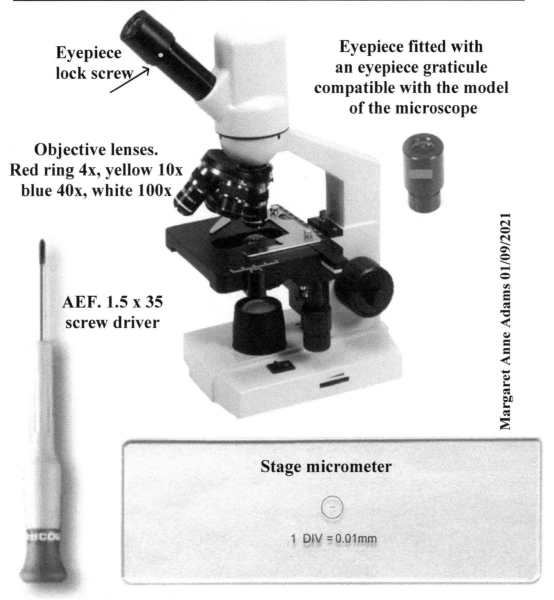

Eyepiece lock screw

Eyepiece fitted with an eyepiece graticule compatible with the model of the microscope

Objective lenses. Red ring 4x, yellow 10x blue 40x, white 100x

AEF. 1.5 x 35 screw driver

Margaret Anne Adams 01/09/2021

Stage micrometer

1 DIV = 0.01mm

Calibrating the eyepiece graticule of a compound microscope to measure pollen grains and honeydew elements in microns (μm)

Method

1. Loosen the eyepiece lock screw.

2. Remove the 10x eyepiece from the microscope and replace it with the lens fitted with an eyepiece graticule. Do not tighten the screw completely–leave enough slack so that you can rotate the eyepiece to orientate the scale onto a pollen grain's diameters, whatever its orientation

3. Find the stage micrometer and focus on the engraved scale, looking in turn through the 4x objective lens, then through the 10x and finally the 40x.

4. With the 40x objective lens in place, line up the engraved scale on the stage. micrometer with the scale on the eyepiece graticule and then take a reading from the two scales. Reading from the two scales count the number of divisions on the stage graticule that correspond to 100 divisions on the eyepiece graticule. 100 divisions represent 1 mm, so each division is 10 micrometres (microns) or 10 μm.

5. For my microscope 100 divisions on the eyepiece graticule match 26 divisions on the stage micrometer. This means that one eyepiece graticule division measures 2.6 μm of pollen grain.

6. Now replace the stage micrometer with a pollen slide and measure a pollen grain. If the grain measures 11 divisions on the eyepiece graticule the pollen grain measures 11 x 2.6 = 28.6 μm or 29 μm to the nearest whole number

7. To avoid having to do a calculation every time make, print, and laminate a spread sheet with the pollen sizes corresponding to 1 to 100 divisions on the eyepiece graticule.

8. The same procedure can be carried out for each objective lens.

CALIBRATING THE EYEPIECE GRATICULE OF A COMPOUND MICROSCOPE

MEASURING THE LENGTH OF A HIMALAYA BALSAM POLLEN GRAIN

SCALES OF THE EYEPIECE GRATICULE AND THE STAGE MICROMETER LINED UP

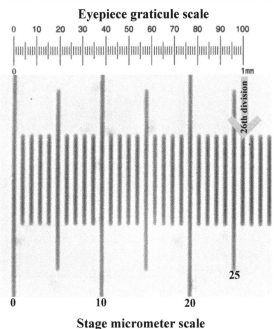

Eyepiece graticule scale

0 10 20 30 40 50 60 70 80 90 100

1mm

26th division

25

0 10 20

Stage micrometer scale

VIEW OF THE POLLEN GRAIN THROUGH THE MICROSCOPE

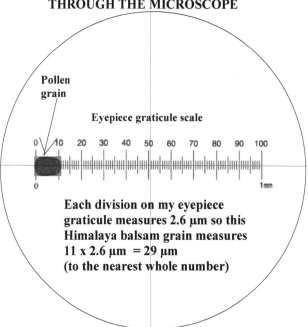

Pollen grain

Eyepiece graticule scale

0 10 20 30 40 50 60 70 80 90 100

0 1mm

Each division on my eyepiece graticule measures 2.6 μm so this Himalaya balsam grain measures
11 x 2.6 μm = 29 μm
(to the nearest whole number)

Making a pollen slide from flowers in a well-ventilated kitchen

Equipment

1. Flowers and a vase of water.

2. Fine scissors to remove anthers from the flowers.

3. Good ventilation using the kitchen extractor and an open window, so you don't breathe in evaporated isopropanol.

4. Isopropanol to wash the pollen and soak any pollenkitt from the pollen grains.

5. A jar of white glycerine jelly, a jar of fuchsine glycerine jelly and jars to mix the white and fuchsine jellies in to make different strengths of stain.

6. An electric hotplate, as using spirit lamps while working with isopropanol is hazardous.

7. 2 Pasteur pipettes

8. A container of hot tap water (at about 50°C to immerse a jar of jelly, to melt the jelly, but not leave it hotter than 40°C in its liquid state)

9. A watch glass, a flat microscope slide and a coverslip; all must be washed with washing up liquid, rinsed and dried. Drain or dry with a cloth that leaves no fibres on the glass. As Jcloths are made of wood pulp they do leave fibres which spoil the pollen slide. Finally polish with lens tissues.

10. 2 pairs of tweezers, one pair pointed and the other blunt ended.

11. Strips of filter paper

12. For more than one species of flower, the sets of equipment must be kept separate and labelled.

EQUIPMENT FOR MAKING A POLLEN SLIDE FROM FLOWERS

1) Flowers

4)

Isopropanol

Highly Flammable. Irritating to eyes. Vapours may cause drowsiness and dizziness. Keep container tightly closed. Keep away from sources of ignition. No smoking. Avoid contact with skin & eyes. In case of contact with eyes, rinse immediately with plenty of water and seek medical advice.

5)

6) Hotplate

9) Lens cleaning tissues

Microscope slide

Watch glass

Cover slip

7) Pasteur pipettes

Scissors 2)

Pointed tweezers 10)

Blunt tweezers

11) Filter paper

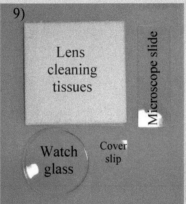
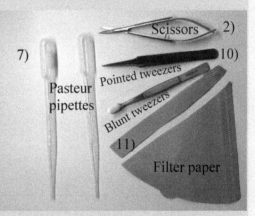

12) For more than one species of flower all equipment must be labelled. Tweezers and scissors must be washed and dried after each species.

Blueberry Red currant Black currant
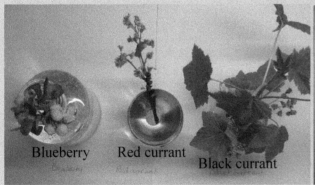
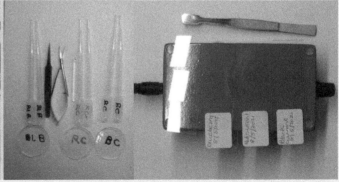

Making a pollen slide from flowers in a well-ventilated kitchen

Method

Set up the equipment as described on the previous page.

1. Pick flowers in bud so the anthers aren't contaminated by pollens from other species, and put them in a vase of water, on a window sill, away from any flowers of another species.

2. When the flowers have opened, examine the anthers with a magnifier, to see if they have dehisced and if pollen is available.

3. Plug the hotplate into an electric socket and set the temperature to 40°C.

4. Immerse the jar of prepared jelly in the hot water.

5. Turn on the extractor and open the window.

6. Snip some ripe anthers onto a watch glass.

7. Using a pipette, pour some isopropanol on the anthers, to wash the pollen off. The pollen sinks to the bottom of the watch glass.

8. Remove the empty anthers with tweezers.

9. Soak up most of the surplus isopropanol and plant debris with strips of filter paper. If with some pollens there is a lot of yellow pollenkitt dissolved in the isopropanol, wash the pollen a second time

10. Using a pipette put a small amount of pollen on the warm microscope slide on the hotplate, and spread it to cover an area just smaller than the cover slip

11. When the isopropanol has evaporated, place a drop of melted, pink glycerine jelly onto the pollen with the second pipette. If there is an air bubble on the top of the drop of jelly, gently suck up the bubble with the pipette. Do not squeeze surplus jelly back into the jelly jar in case some pollen has been picked up.

12. Holding one edge of the coverslip with flat ended tweezers, place the opposite edge on the edge of the pollen then gently lower the coverslip onto the jelly.

13. Leave the slide on the hotplate for 10 minutes for the pollen grains to hydrate and absorb the fuchsine stain. When cool seal the edge of the cover slip with nail varnish, having cut away any overflow of jelly.

MAKING A POLLEN SLIDE FROM FLOWERS

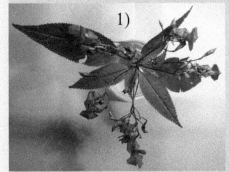

1)

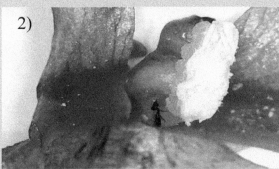

2)

4)

6)

7)

8)

9)

10) and 11)

12) and 13)

Examining the pollen grains on a slide

Your aim is to obtain good photographs that record a pollen grain's features, so that you can recognise it when you are looking at the pollen grains in your own honey.

In this book, there are photos of the pollen grains from the flowers gathered in our bees' foraging area, in 2020.

1. Switch on the microscope.

2. Using the stage clip, fix the slide on the stage platform. Move the stage till the pollen is over the beam of light.

3. With your x10 calibrated eyepiece graticule and the x4 objective in place, move the condenser iris control lever to the right to reduce the light; find the pollen grains using the coarse focus control then use the fine focus to get a clear picture of pollen in the field of view

4. Now fine focus again with the x10 objective in place and try to locate an area with pristine pollen grains

5. Next chose then focus on grains chosen for the features described below, using the x40 objective

and the condenser iris control lever to the left, to increase the light under the stage.

6. The useful features of the pollen grain, that you may be able to record, at this x10 Xx40 = x400 magnification are:

 * the shape of the grain in polar view,
 * the shape of the grain in equatorial view,
 * the number and type of germination apertures,
 * features visible on the top surface,
 * the intine and the layers making up the exine, seen by focusing down, to get a cross-sectional view of the pollen grain
 * and the size of the grain.

Examples of a many features can be seen in the pictures of the pollens recorded in this book.

For beekeepers in areas with lots of private gardens, Christine Coulsting has written a section for this book where she describes her approach for trying to identify pollens in her honey, that are not in her slide collection. It is a daunting task and very time consuming to identify a pollen we haven't seen before.

Examining the pollen grains on a slide

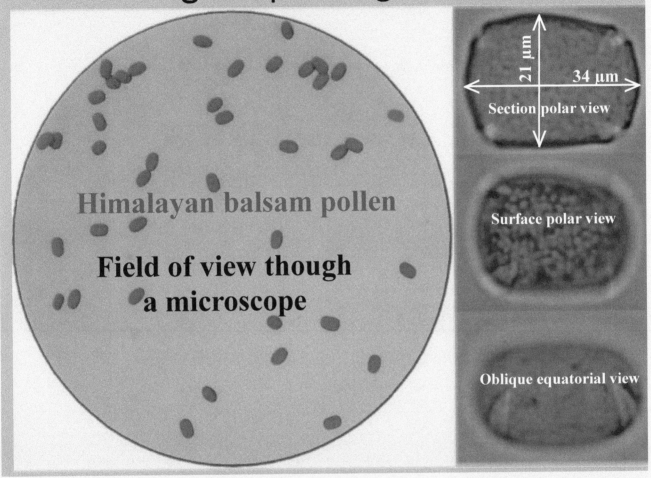

Himalayan balsam pollen

Field of view though a microscope

21 μm

34 μm

Section polar view

Surface polar view

Oblique equatorial view

Measuring pollen grains of different shapes

Measure the pollen grains, after focusing down to get a sectional view of a grain, in polar and equatorial view.

Omit protuberances from the germination apertures as they can vary in a grain according to hydration.

Measure prominent ornaments, such as spines separately and count the number of spines between apertures.

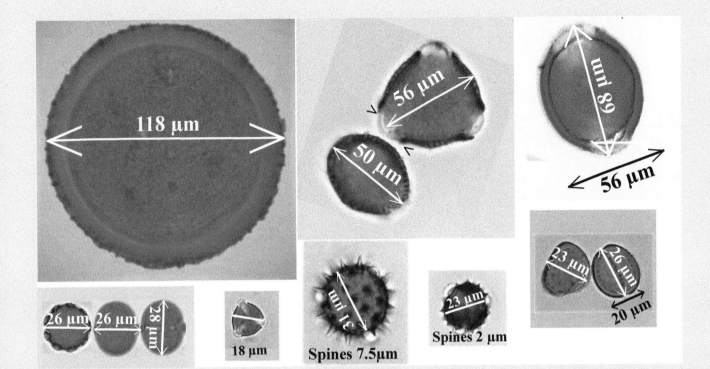

118 µm

56 µm

50 µm

68 µm

56 µm

26 µm 26 µm 28 µm

18 µm

31 µm
Spines 7.5µm

23 µm
Spines 2 µm

23 µm 26 µm

20 µm

Making a pollen slide from a bee's pollen loads

Equipment

1. A glass honey jar and a square of cardboard 15 cm by 15 cm.

2. A bee with pollen loads.

3. A drop of "Insect killing fluid" to anaesthetize the bee.

4. A watch glass.

5. A pair of pointed tweezers or a pin to remove the pollen loads.

6. Warm water to wash the pollen loads.

7. Strips of filter paper.

8. A jar of fuchsine glycerine jelly as prepared for flower pollen.

9. An electric hotplate, as using spirit lamps while working with insect killing fluid is hazardous.

10. 2 Pasteur pipettes.

11. A container of hot tap water (at about 50 °C to immerse a jar of jelly, to melt the jelly, but not leave it hotter than 40 °C in its liquid state).

12. A flat microscope slide and a coverslip; all must be washed with washing up liquid, rinsed and dried. Drain or dry with a cloth that leaves no fibres on the glass. As J cloths are made of wood pulp they do leave fibres which spoil the pollen slide. Finally polish with lens tissues.

13. A pair of blunt ended tweezers.

EQUIPMENT FOR MAKING A POLLEN SLIDE FROM POLLEN LOADS

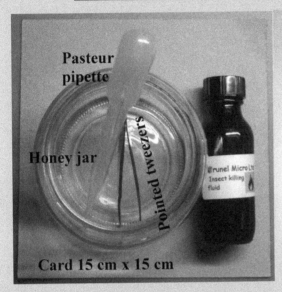

Pasteur pipette

Honey jar

Pointed tweezers

Card 15 cm x 15 cm

Brunel Micro Ltd
Insect killing fluid

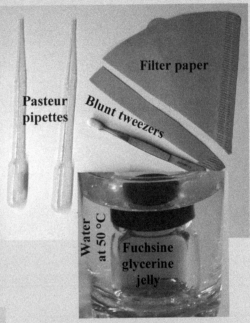

Pasteur pipettes

Blunt tweezers

Filter paper

Water at 50 °C

Fuchsine glycerine jelly

Margaret Anne Adams 22/09/2021

Lens cleaning tissues

Microscope slide

Watch glass

Cover slip

Making a pollen slide from a bee's pollen loads

Method Set up the equipment as described on the previous page

1. <u>On a flower</u>, hold the jar above the bee and when she flies up into it, slip the card underneath to prevent her escaping. Or <u>at the hive entrance</u>, hold the jar over a bee on the face of the hive and slide the card between the hive and the jar to prevent her escaping.

2. Place the card and the jar on a flat surface with the cardboard underneath and put a drop of insect killing fluid on the cardboard, close to the jar. Slide the jar over the fluid so that the bee breathes in the 'anaesthetic'. Indoors the window should be open and an extractor switched on. Outdoors, work upwind.

3. Put the bee on a watch glass and remove the pollen loads with tweezers, or push them off with a pin.

4. Lift the bee off the watch glass and put her in a warm place to recover.

5. Plug the hotplate into an electric socket and set the temperature to 40°C

6. Label a slide and put it, and a cover slip, on the hotplate.

7. Immerse the jar of prepared fuchsine jelly into hot water at about 50°C, to melt the jelly and leave at less than 40°C.

8. Put some warm water on the watch glass onto the pollen loads and stir to dissolve and wash away the saliva and nectar that hold the pollen grains together like an adhesive. The pollen grains will sink to the bottom of the watch glass, and some of the surplus water can be soaked up with a strip of filter paper. The grains will have to be washed twice to get rid of the 'adhesive'.

9. Using a pipette put a drop of the wet pollen on the warm microscope slide, on the hotplate, and spread it to cover an area just smaller than the cover slip.

10. When the water has evaporated, place a drop of melted, pink glycerine jelly onto the pollen with the second pipette. If there is an air bubble on the top of the drop of jelly, gently suck up the bubble with the pipette. Do not squeeze surplus jelly back into the jelly jar in case some pollen has been picked up.

11. Holding one edge of the coverslip with flat ended tweezers, place the opposite edge on the edge of the pollen then gently lower the coverslip onto the jelly.

12. Leave the slide on the hotplate for 10 minutes for the pollen grains to hydrate and absorb the fuchsine stain. When cool seal the edge of the cover slip with nail varnish, having cut away any overflow of jelly.

METHOD FOR MAKING A POLLEN SLIDE FROM POLLEN LOADS

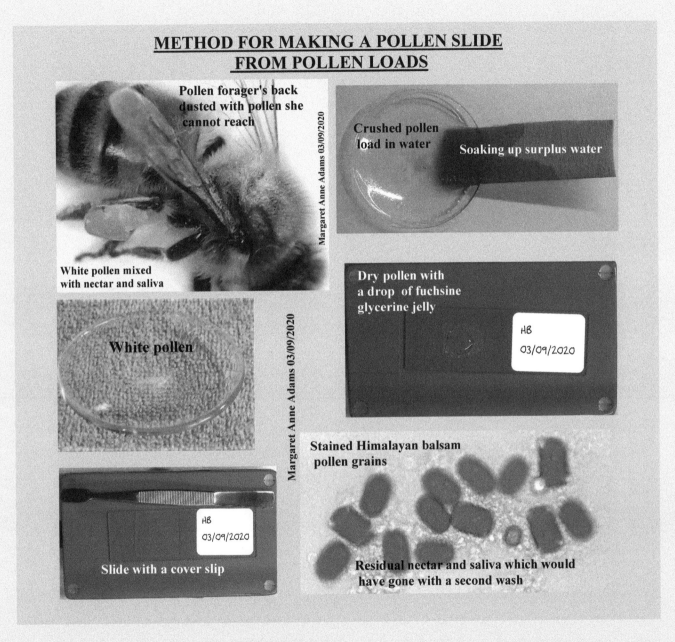

Pollen forager's back dusted with pollen she cannot reach

Margaret Anne Adams 03/09/2020

White pollen mixed with nectar and saliva

Crushed pollen load in water

Soaking up surplus water

White pollen

Margaret Anne Adams 03/09/2020

Dry pollen with a drop of fuchsine glycerine jelly

HB
03/09/2020

Slide with a cover slip

HB
03/09/2020

Stained Himalayan balsam pollen grains

Residual nectar and saliva which would have gone with a second wash

13. Examine the pollen under the microscope and measure the grains. If the pollen loads were collected at the hive entrance the grains can be identified by comparing them with photos of pollens in your slide collection.

Making a slide from the solids spun off a 10 gram sample of honey

Equipment

1. All the equipment listed for making a pollen slide from a foragers pollen loads, apart from the watch glass.

2. As this is a time-consuming procedure it is worth analysing three honey samples at the same time, but keep the A, B and C equipment separate to avoid pollens from one sample getting into the other samples.

3. Three teaspoons.

4. Warm water.

5. Three pots for mixing the honey samples with water.

6. Six Pasteur pipettes – 2 per sample.

7. 3 beakers to separate the 3 pairs of pipettes and spoons.

8. 3 beakers of water.

9. A professional mini digital weighing scale.

10. Six 15 ml plastic test tubes.

11. A test tube stand.

12. An electric centrifuge with the capacity to hold six test tubes to contain the six 15ml plastic test tubes with screw caps.

EQUIPMENT FOR MAKING A POLLEN SLIDE FROM THE SOLIDS SPUN OFF A 10 GRAM SAMPLE OF HONEY

FOR SEVERAL SAMPLES, LABEL ALL THE EQUIPMENT

HONEY SAMPLE

DIGITAL MICROSCOPE

PLASTIC TEST TUBES WITH SCREW TOPS

PASTEUR PIPETTES

HOTPLATE, SLIDES COVER SLIPS

GLYCERINE JELLY STAIN

TEST TUBE STAND

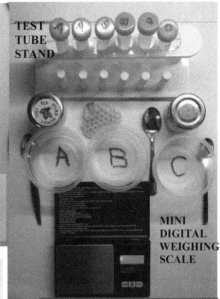

MINI DIGITAL WEIGHING SCALE

Margaret Anne Adams 25/09/2021

CENTRIFUGE top view

CENTRIFUGE side view

800-1 Centrifugal Machine

MADE IN CHINA

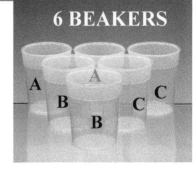

6 BEAKERS

Making a slide from the solids spun off a 10 gram sample of honey

Method Set up the equipment as described on the previous page

1. Pour some warm water into a beaker A. Place pot A on the weighing scale and zero the scale. Using teaspoon A, weigh out 10 grams of honey A and add 20 grams of the warm water. Stir the honey and water till the honey has dissolved. Discard teaspoon A.

2. Using a Pasteur pipette A, transfer 15 ml of the dissolved honey into each of the two A screw top, plastic test tubes and close firmly. Put the pipette A in the second beaker A. Place the two A test tubes in the centrifuge, opposite each other.

3. Repeat for B / C then place the lid on the centrifuge.

4. Set the centrifuge timer to 10 minutes, and gradually work up, a click at a time, to a speed of 2500 rpm.

5. Place the 6 test tubes into the rack. With pipette A from the A beaker, remove the liquid from both A test tubes then transfer the sediment from one so that all the sediment is in the other A test tube. Add water from beaker A to both A test tubes, to the 15 ml mark, and return pipette A to beaker A. Put Screw the caps back on and place them opposite each other in the centrifuge.

6. Repeat for B and C.

7. Set the centrifuge for another 10 minutes at 2500 rpm.

8. Plug in the hotplate and set the temperature to just under 40°C. Place 3 clean, labelled slides and 3 clean cover slips on the hotplate. Immerse the jar of glycerine jelly in in a pot of hot (50°C) water to melt the jelly.

9. When the centrifuge has spun for 10 minutes and stopped, place the three test tubes with sediment in the rack and dispose of the other three.

10. With the same pipette A, remove all but a drop of the water from test tube A, stir the sediment into the drop of water, and put the sediment onto Slide A on the hot plate. Spread the sediment into a square that will fit under the cover slip. Leave till the water has evaporated. Using the second, clean pipette A, add a drop of jelly to the nowdry sediment. Lower a cover slip onto the jelly with the help of blunt ended tweezers. Leave the slide to warm for 10 minutes.

11. Examine the pollens on the slide at x400.

12. Repeat for B and C.

MAKING A SLIDE FROM THE SOLIDS SPUN OFF A 10 GRAM SAMPLE OF HONEY

ZERO THE SCALE

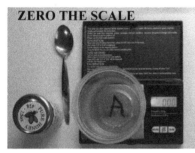

Margaret Anne Adams 26/09/2021

WEIGH 10 g OF HONEY

ADD 20 g OF WARM WATER & STIR TO DISSOLVE THE HONEY

6 BEAKERS

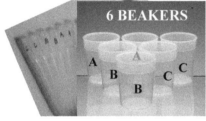

PUT 15 ml IN EACH A TEST TUBE

Examine the slide for pollen at x 400

Stain the dry sediment

Cover slips

Microscope slides

Bottom of test tube

Sediment

Section 2
Examining the pollen slides under the microscope and understanding what we see

Understanding the honey solids seen under the microscope

Nearly all the pollen grains in sample 'A' could be identified from the photos from my 2020 pollen microscope slides.

This multifloral honey also contains honeydew. Most of the honeys I have examined contain honeydew. Some of these honeys feature in this book.

Honeydew fungal elements have to be counted in the same way as pollen grains when doing a complete analysis of honey. When examining honey to find the predominant nectar sources, the presence of substantial amounts of honeydew should be mentioned along with the main and secondary sources of the honey.

SOME OF THE THOUSANDS OF POLLEN GRAINS AND HONEYDEW ELEMENTS, THAT I FOUND IN THE 10 GRAM SAMPLE OF HONEY A FROM THE BEES AT ANNAN ACADEMY BEE CLUB APIARY

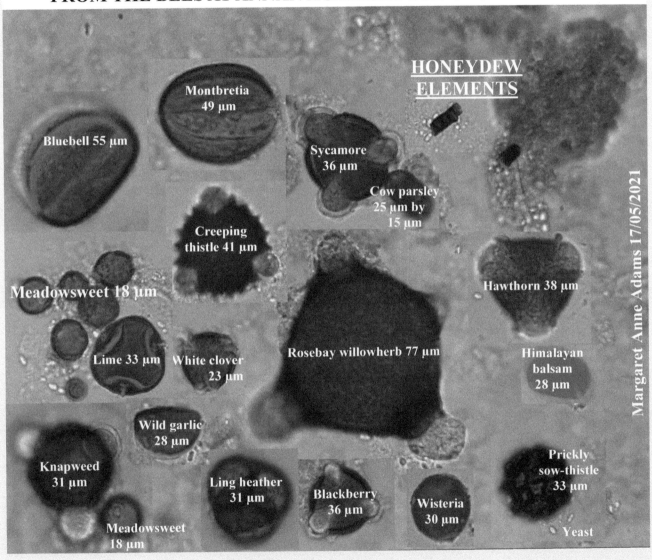

HONEYDEW ELEMENTS

Montbretia 49 µm

Bluebell 55 µm

Sycamore 36 µm

Cow parsley 25 µm by 15 µm

Creeping thistle 41 µm

Hawthorn 38 µm

Meadowsweet 18 µm

Lime 33 µm

White clover 23 µm

Rosebay willowherb 77 µm

Himalayan balsam 28 µm

Wild garlic 28 µm

Knapweed 31 µm

Ling heather 31 µm

Blackberry 36 µm

Wisteria 30 µm

Prickly sow-thistle 33 µm

Meadowsweet 18 µm

Yeast

Margaret Anne Adams 17/05/2021

Understanding the honey solids seen under the microscope

Pollen coefficients – forget-me-not

To find out if a honey is mainly from one source a minimum of 300 pollen grains must be identified in some randomly chosen areas of the honey pollen slide, and a tally done of the different plants they come from. After that the pollens from plants without nectar should be removed from the count, and the tally of each remaining pollen has to be adjusted according to its pollen coefficient.

Pollen coefficients reduce the apparent amount of honey in the sample from plants whose pollen is always over represented. Pollen coefficients also increase the apparent amount of honey from plants whose pollen is always under represented.

The structure of a flower and the size of a pollen grain both influence the amount of pollen that ends up in honey.

When a Honey bee forages for nectar in a forget-me-not corolla tube, her mouthparts rub on the anthers causing clumps of pollen to fall down the flower tube into the nectar, and she sucks up the tiny, 7 μm pollen grains with the nectar. The forget-me-not pollen coefficient is 5000. This means there are 5000 thousands of grains in 10 grams of pure forget-me-not honey – in other words 5 million pollen grains per 10 grams of the honey.

Boraginaceae Myosotis Forget-me-not flower structure

Honey bee sucking nectar

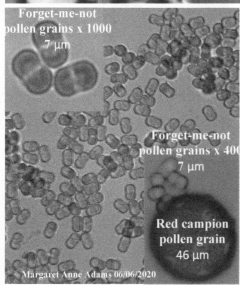

Forget-me-not pollen grains x 1000
7 μm

Forget-me-not pollen grains x 400
7 μm

Red campion pollen grain
46 μm

Margaret Anne Adams 06/06/2020

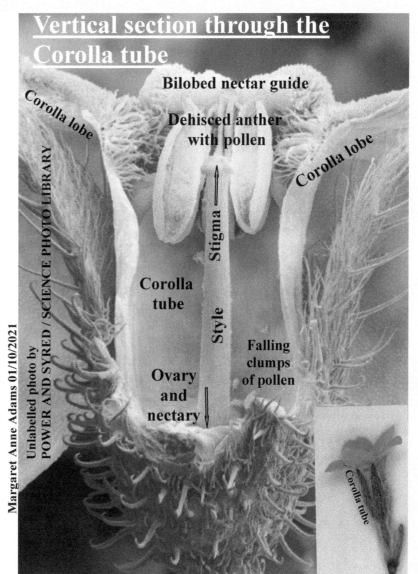

Vertical section through the Corolla tube

Bilobed nectar guide

Corolla lobe

Dehisced anther with pollen

Corolla lobe

Stigma

Corolla tube

Style

Falling clumps of pollen

Ovary and nectary

Corolla tube

Margaret Anne Adams 01/10/2021

Unlabelled photo by POWER AND SYRED / SCIENCE PHOTO LIBRARY

Understanding the honey solids seen under the microscope

Pollen coefficients – Rosebay willowherb

When a Honey bee forages on Rosebay willowherb nectar, some pollen gets into her honey crop too, but the anthers are far outside too far from nectar tube to mix with the nectar. Also the pollen grains are so large (about 100 μm) that most of those that enter the bee's honey crop, end up in her gut; this is because the proventriculus valve is able to remove them from her crop, while she is returning to the hive. The pollen coefficient for this flower is 0.3 which means there are 300 grains of pollen in 10 grams of pure Rosebay willowherb honey.

While foragers return to the hive, the longer the journey, the greater the number of pollen grains and other solids removed from the crop.

The coefficients for most other pollens fall in between these two extremes, Forget-me-not '5000' and Rosebay willowherb '0.3'.

A list of pollen coefficients is free to view on line, on page 18 of Vaughn M. Bryant JR's 's paper 'The R-values of honey: Pollen coefficients".

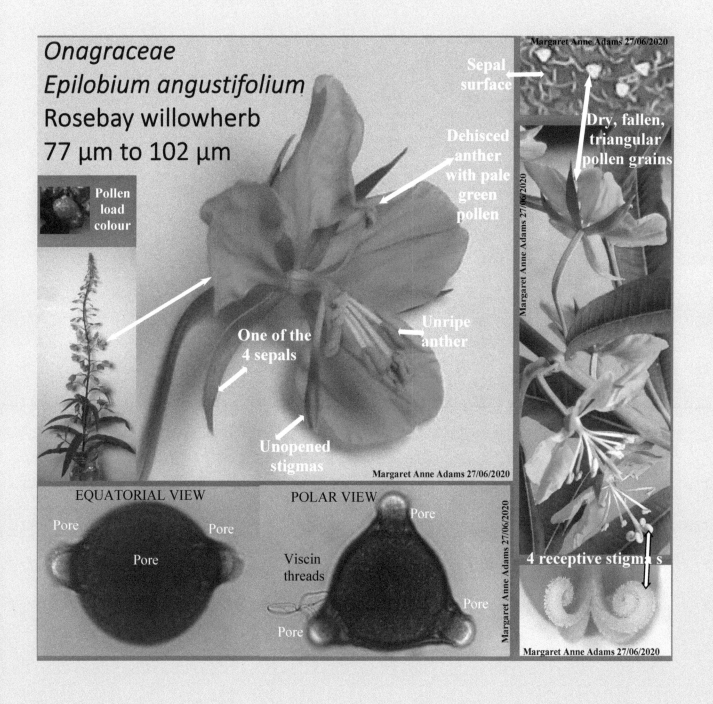

Onagraceae
Epilobium angustifolium
Rosebay willowherb
77 µm to 102 µm

Pollen load colour

Dehisced anther with pale green pollen

Sepal surface

Dry, fallen, triangular pollen grains

One of the 4 sepals

Unripe anther

Unopened stigmas

Margaret Anne Adams 27/06/2020

EQUATORIAL VIEW

Pore

Pore

Pore

POLAR VIEW

Pore

Viscin threads

Pore

Pore

Margaret Anne Adams 27/06/2020

4 receptive stigmas

Margaret Anne Adams 27/06/2020

Section 3

Calculating the main nectar sources of honey from the pollens found in a 10 gram sample

What are the problems that face us, when we attempt to determine the plant sources, used by our bees to produce honey?

Beekeepers want to find out the floral sources of their honey and to know if their honey can be labelled, as coming from a valued monofloral source. Beekeepers that take their bees to a specific crop know what honey they have. Experienced beekeepers can taste and smell their honey and recognize which plants have produced the nectar for their honey.

However, the regulations on honey labelling require a more rigorous investigation. Spinning pollen out of a 10-gram sample of honey and examining the grains under a microscope does reveal quite a lot about the composition of honey. This it is not an exact science as it stands, even when the Pollen coefficients are used to adjust the pollen counts. Many pollen coefficients have not been determined and we are asked to use 50 and assume that there are 50,000 grains per 10 grams of honey in all these cases. Himalayan balsam honey has not got an official pollen coefficient yet, so 50 is used.

Wind borne pollens like pine, and pollens from flowers such as Meadowsweet (*Filipendula*), that provide no nectar reward to honeybees, must be omitted from the count and calculations.

Recently beekeepers have been sending samples of their honey away, for plant identification using DNA barcoding of pollens in honey samples, but these beekeepers are told that it is not always possible for this to differentiate accurately, species within a family like *Brassicaceae*.

There is a problem with this form of DNA analysis; I have examined honey sent to me by beekeepers living between the North of Scotland and Central France, and most of them contain honeydew elements and not just Pollen. However, Paul Noblet's 2019 honey sample came from a costal area with marshes; only 13 different pollens were found, and none were from trees that provide bees with large quantities of honeydew; So, I was confident to calculate the composition of his honey sample, from the bar chart he received from the Honey Monitoring scheme.

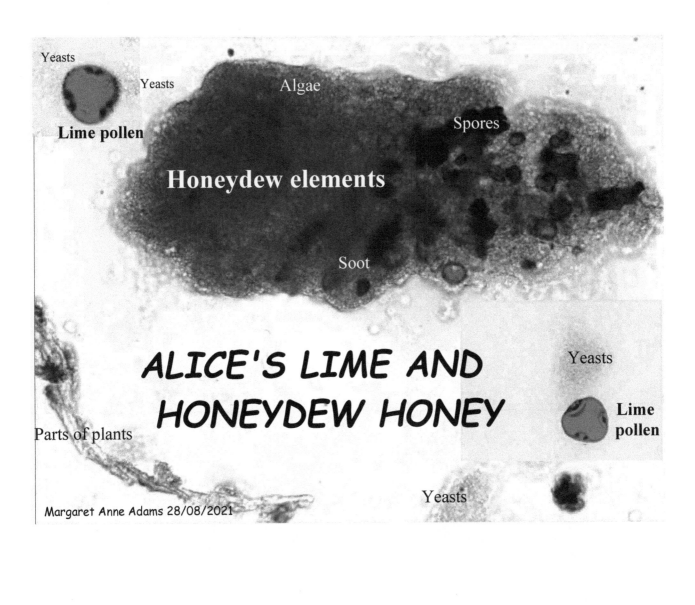

Using a bar chart of all the taxa of pollen in a sample, to calculate the composition of a honey with no honeydew elements

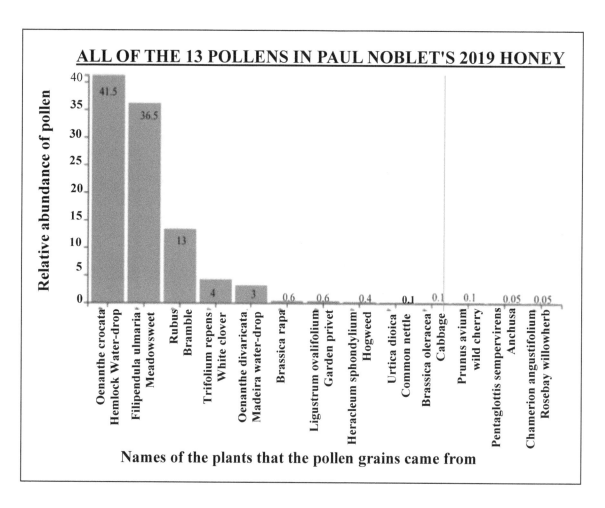

THE PERCENTAGE COMPOSITION OF PAUL NOBLET'S HONEY SAMPLE, CALCULATED FROM NECTAR PRODUCING PLANTS, IN THE CHART SHOWING THE 13 POLLENS FOUND.

NECTAR PRODUCING FLOWERS	PROPORTION OF POLLEN	POLLEN %	POLLEN COEFFICIENT PC	POLLEN%/PC	% COMPOSITION OF HONEY	
BRAMBLE	13	68.78	50	1.3576	57.712	58%
WHITE CLOVER	4	21.16	50	0.4232	17.990	18%
TURNIP	0.6	3.17	150	0.02116	00.900	1%
PRIVET	0.6	3.17	25	0.12696	05.397	5%
CABBAGE	0.1	0.53	150	0.03533	01.502	2%
WILD CHERRY	0.1	0.53	25	0.02120	00.901	1%
ANCHUSA	0.05	0.11	250	0.00044	00.019	0%
ROSEBAY WILLOWHERB	0.05	0.11	0.3	0.36667	15.587	16%
TOTALS	18.9	100.56		2.35256	100.008	

RESULT

- The predominant honey is Rubus, Blackberry.
- Trifolium repens, White clover and Chamerion Angustifolium are secondary pollens.
- Ligustrum ovalifolium, Privet is an important minor pollen.

Method of extracting honey before assessing its nectar source

For honey to be assessed in the way we have described, the combs in the super frames should be examined to make sure that none of the cells contain stored pollen or beebread.

Next the honey must be extracted from the combs after uncapping, by draining or spinning the frames.

The calculations cannot be applied to honey extracted by pressing the combs, as extra pollen may be included in that too.

Pollen spun from pressed honey (x100)

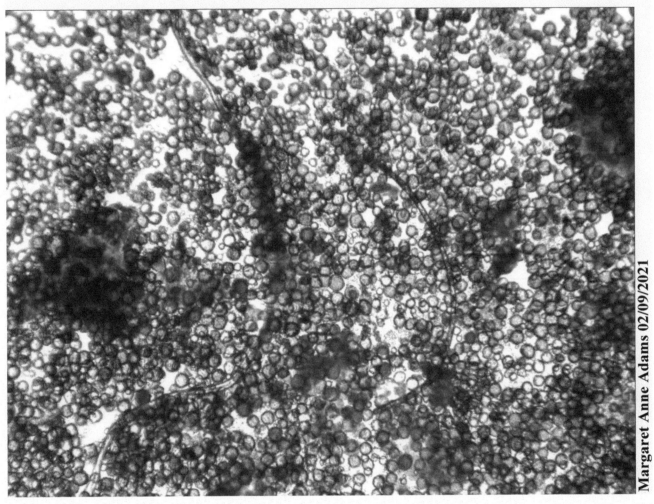

Margaret Anne Adams 02/09/2021

Section 4
Understanding the honey solids seen under a microscope

Unusual finds

A few honeys that beekeepers sent to me to examine, contained unappetizing solids, such as insect parts, nematodes, hairs and threads from cleaning cloths. Wiping the insides of washed, honey extracting equipment with a Jcloth, rather than leaving it to drain, can result in blue wood pulp fibres appearing in the next batch of honey.

Nematodes can be picked up by Honey bees as they forage on Honeydew, that has fallen onto the soil, under a tree.

Beekeepers who use miticides, to minimise varroa mite infestations in their colonies, will not find acarine mites in or on their bees.

Threads and hairs

Margaret Anne Adams 26/11/2019

Insect parts

Margaret Anne Adams 15/11/2019

Female Acarapis woodi

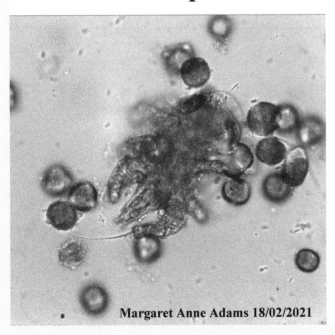

Margaret Anne Adams 18/02/2021

A nematode

Margaret Anne Adams 16/11/2019

Honeydew

Phloem Sap takes nutrients, such as sugars and amino acids, to every part of a plant. Xylem sap takes minerals and extra water to the parts above ground. Aphids suck in either according to their needs.

Honeydew is modified plant sap excreted by aphids. It is interesting to watch and record aphids feeding on flowers, under a microscope. The aphid sucks plant sap and when her abdomen is almost at bursting point, she squirts honeydew from her anus.

The fresh honeydew on the knapweed flower is clear and not yet contaminated.

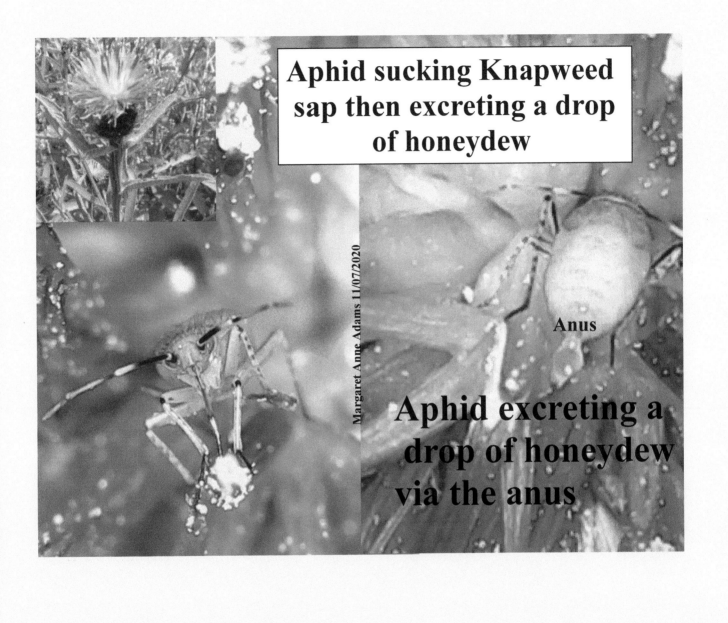

Aphid sucking Knapweed sap then excreting a drop of honeydew

Margaret Anne Adams 11/07/2020

Anus

Aphid excreting a drop of honeydew via the anus

Honeydew elements

The honeydew in UK honey mostly comes from trees such as Lime, sycamore and oak. Female Aphids are active, giving birth to new female aphids and feeding on the underside of leaves. The honeydew they excrete, drips down onto the tops of the leaves beneath, the bark and the soil under the tree. Soon this sugary medium becomes nourishment for other insects, for yeasts and spore producing algae, sooty moulds and fungi.

Meanwhile airborne particles such as pine pollen and soot adhere to the sticky honeydew. Humus gets incorporated into honeydew on the ground. Aphids die on the underside of the leaves and their body parts also drop down, when younger aphids disturb the corpses.

The photos are of leaves from one of our sycamores, in September 2021. When the leaves fall to the woodland floor they will rot, and in the spring the spores of the Sycamore tar spot fungus will be dispersed in the air and adhere to the new leaves, to begin the life cycle again. In cities where leaves are swept up this renewal cannot happen so easily.

In the autumn winged male aphids and winged female aphids develop and mate. The female lays eggs, on the bark. These eggs contain antifreeze, so they will overwinter, surviving very low temperatures. Every surviving, undamaged egg will produce only female aphids in the spring when the new leaves appear. The young female aphids move onto the fresh leaves to suck sap and give birth to live young female aphids.

Aphid activity on the underside of sycamore leaves

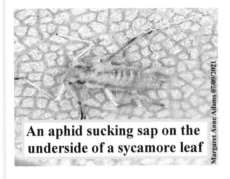

An aphid sucking sap on the underside of a sycamore leaf

An aphid disturbing the remains of a dead aphid

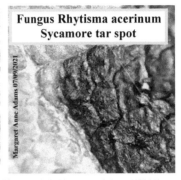

Fungus Rhytisma acerinum Sycamore tar spot

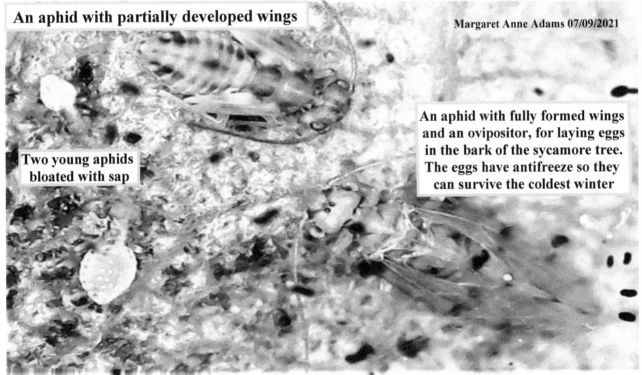

An aphid with partially developed wings

Margaret Anne Adams 07/09/2021

Two young aphids bloated with sap

An aphid with fully formed wings and an ovipositor, for laying eggs in the bark of the sycamore tree. The eggs have antifreeze so they can survive the coldest winter

Honeydew sugars

In the summer, first thing in the morning, dew keeps honeydew moist and bees collect it; if the sun comes out, the warmth dries up the honeydew, and when bees return for more, and if the tree is in flower, they collect the nectar instead. Lime tree flowers are sheltered from the rain by the leaves, so inevitably some pollen from those flowers drops onto the leaves below and ends up in honeydew too; those few pollen grains can help us to identify the source of honeydew in our honey.

Aphids transform some of the plant sap's monosaccharides fructose and glucose and the disaccharide sucrose into the trisaccharides raffinose and melezitose. The large melezitose crystals can be seen in honey solids, under the microscope. These crystals are indigestible to honey bees, and it accumulates in their gut; it is therefore unwise to leave honeydew honey for colonies to feed on in the winter, when bad weather prevents cleansing flights.

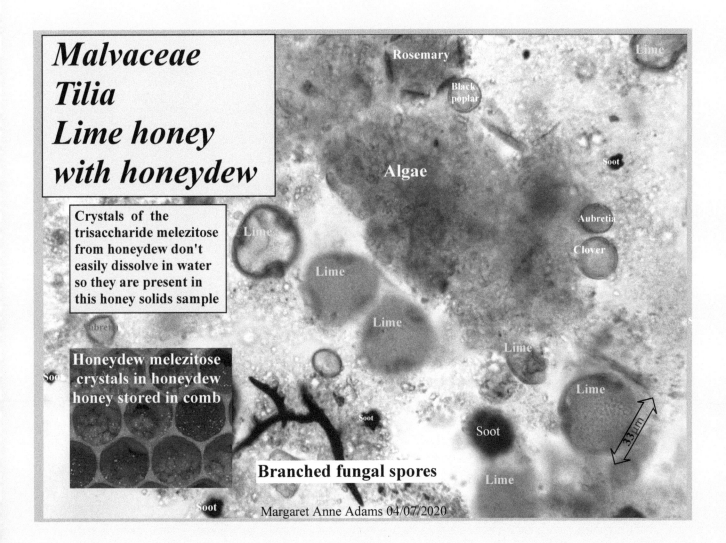

Malvaceae
Tilia
Lime honey
with honeydew

Crystals of the trisaccharide melezitose from honeydew don't easily dissolve in water so they are present in this honey solids sample

Honeydew melezitose crystals in honeydew honey stored in comb

Rosemary

Black poplar

Algae

Soot

Aubretia

Lime

Clover

Lime

Lime

Lime

Lime

Lime

Lime

Soot

Soot

Soot

Soot

Branched fungal spores

33μm

Margaret Anne Adams 04/07/2020

Soot from human activity

Lime honey from city trees contains honeydew with particles of soot from various sources.

Honeydew elements don't look appetizing but they rarely spoil the honey, even if, for example, there is a huge fire, and black smoke is blown all over Sycamore and Lime trees, whose leaves are wet with honeydew. If bees collect this sooty honeydew, their honey will be very dark, but it still tastes quite pleasant.

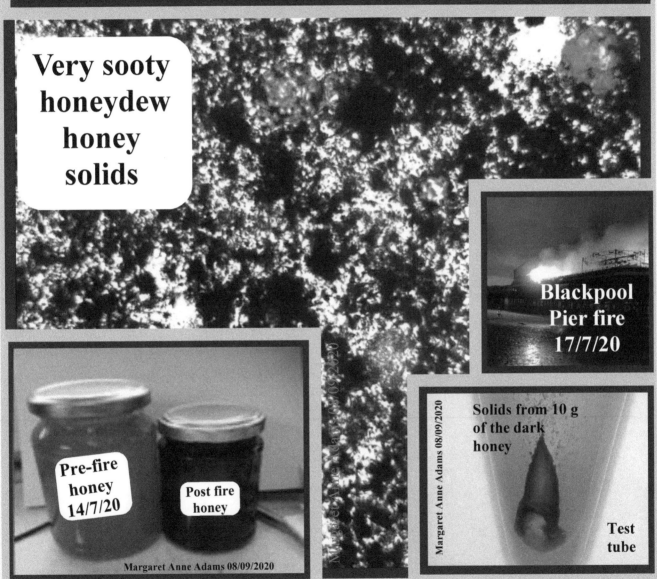

Mica Goldstone's dark, post Blackpool Pier fire honey

Very sooty honeydew honey solids

Blackpool Pier fire 17/7/20

Pre-fire honey 14/7/20

Post fire honey

Margaret Anne Adams 08/09/2020

Solids from 10 g of the dark honey

Margaret Anne Adams 08/09/2020

Test tube

Section 5

The pollens of flowers that bloomed in our bees' foraging area, in south west Scotland, pollen loads and honey examined in 2020 and 2021

Amaryllidaceae, Galanthus nivalis, Wild snowdrop 28 μm

Every year, the wild snowdrop is one of the first examples of the perfect relationship between flowers that have evolved naturally with bees. The nectar reward and the pollen are easily to collect from the simple, open flower.

On the other hand, cultivars such as *Galanthus nivalis* 'Flore Peno' have been bred by humans, but the flowers are complicated and offer little reward to foraging bees.

Snowdrops flower in the woodland before the trees have leaves. Honey bees forage where the open single flowers are bathed in sunshine.

The pollen grains are smooth, oval and boatshaped. The single germination aperture is a long furrow or 'sulcus'.

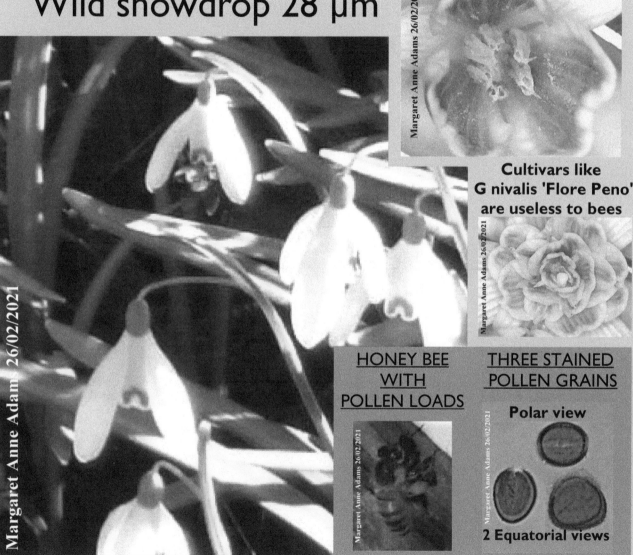

Amaryllidaceae
Galanthas nivalis
Wild snowdrop 28 µm

Centre of the Wild snowdrop with pollen and nectar easily accessed by honey bees

Margaret Anne Adams 26/02/2021

Cultivars like G nivalis 'Flore Peno' are useless to bees

Margaret Anne Adams 26/02/2021

Margaret Anne Adams 26/02/2021

HONEY BEE WITH POLLEN LOADS

THREE STAINED POLLEN GRAINS

Polar view

Margaret Anne Adams 26/02/2021

Margaret Anne Adams 26/02/2021

2 Equatorial views

Ulmaceae,
Ulmus glabra,
Scotch elm or Wych elm. 31 μm

The Wych elm is one of the first trees to produce pollen each year, so the weather is rarely warm enough in Scotland for the bees to benefit from it.

However, when the sun shines on swathes of wild snowdrops in the wood Wych elm pollen may blow onto open snowdrops flowers. For this reason, if you want a pure pollen sample, it is wise to pick flowers in bud and take them into the house to open and wait for the for the anthers to dehisce.

The Wych elm is a British native elm species. In Scotland there are so many of these trees that is also called Scotch elm. Loch Lomond is called Lac Leaman in Gaelic, which means 'Lake of the Elms'.

The elm is wind pollinated so the tree produces huge quantities of pollen which form little clouds, if you tap the flowers, after the anthers have dehisced.

Most of the medium sized pollen grains have 4 or 5 small pores.

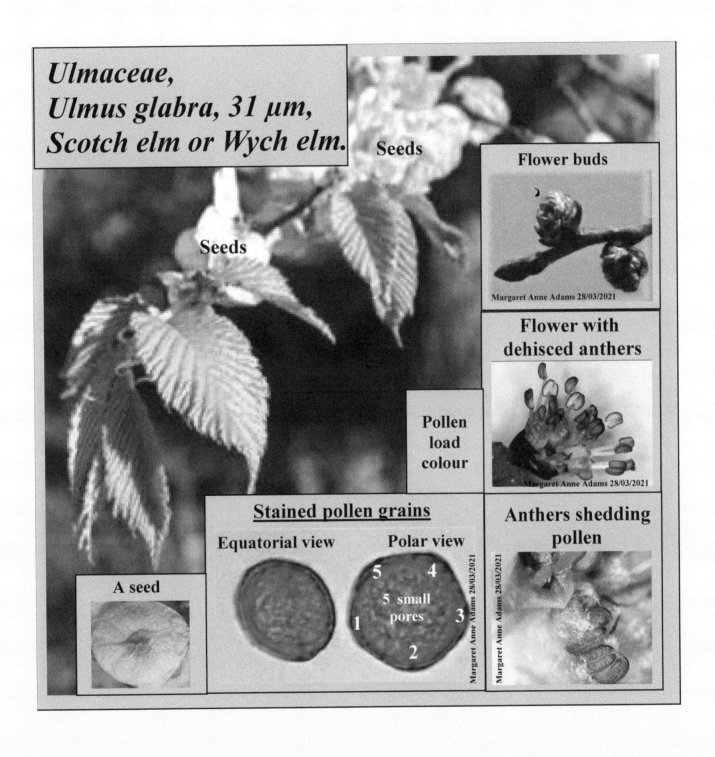

Ulmaceae,
Ulmus glabra, 31 µm,
Scotch elm or Wych elm.

Seeds

Seeds

Flower buds

Margaret Anne Adams 28/03/2021

Flower with dehisced anthers

Margaret Anne Adams 28/03/2021

Pollen load colour

Stained pollen grains

Equatorial view

Polar view

5 4

5 small pores

1 3

2

Margaret Anne Adams 28/03/2021

A seed

Anthers shedding pollen

Margaret Anne Adams 28/03/2021

Corylaceae,
Corylus,
Hazel

If a microscope lacks a calibrated eyepiece graticule, Hazel pollen grains are a handy 'yard stick' to estimate the size of other pollen grains. By rounding the size of the Hazel pollen grain to 25 μm, a crocus pollen grain that is about 4 x the size of a Hazel pollen grain, would be roughly 100 μm. Hazel pollen can be collected in the spring, stained and preserved in diluted alcohol for use throughout the rest of the year as a reference for size. The size of a pollen grain is essential for identifying it from those of similar appearance.

Corylaceae, Corylus avellana, Hazel. 25 μm

Stained pollen grains

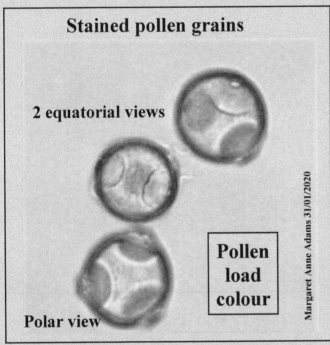

2 equatorial views

Polar view

Pollen load colour

Margaret Anne Adams 31/01/2020

June

Margaret Anne Adams 07/2014

A catkin has over 100 male flowers

Margaret Anne Adams 28/01/2020

January to April

Margaret Anne Adams 31/07/2005

July nuts

One of the flowers with dehisced anthers and pollen

Margaret Anne Adams 21/04/2021

January to April

Betulacaea,
Alnus,
Alder

Alder pollen is one of earliest to appear each year the UK. It is dispersed by air currents but on warm days bees will collect it.

- The signals for the queen to up her rate of laying in the spring is the lengthening of the hours of daylight and the availability of fresh pollen.
- Once pollen is collected regularly by foragers the house bees will chuck out the beebread that was stored in the autumn, to make room for fresh pollen.
- Old pellets can be mistaken for chalk brood, but when pressed between the fingers they crumble into layers and powder.

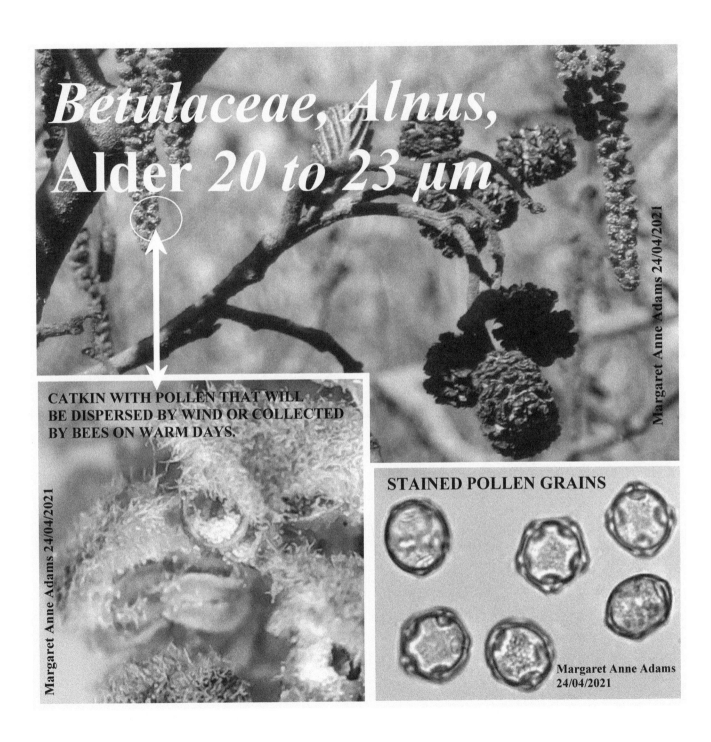

Betulaceae, Alnus, Alder 20 to 23 μm

CATKIN WITH POLLEN THAT WILL
BE DISPERSED BY WIND OR COLLECTED
BY BEES ON WARM DAYS.

STAINED POLLEN GRAINS

Margaret Anne Adams 24/04/2021

Margaret Anne Adams 24/04/2021

Margaret Anne Adams
24/04/2021

Brassicaceae, Erysium, Wallflower

Wallflower Scarlet Bedder is flowering in a sheltered spot. Like Oilseed Rape, it is a member of the cabbage family. The two small, round pollen grains, lying side by side, are useful for seeing a few pollen features.

The left hand one is seen in polar view and the right hand one is an oblique equatorial view. The photo shows that there are three apertures in the shape of furrows and the surface of the grains is pitted.

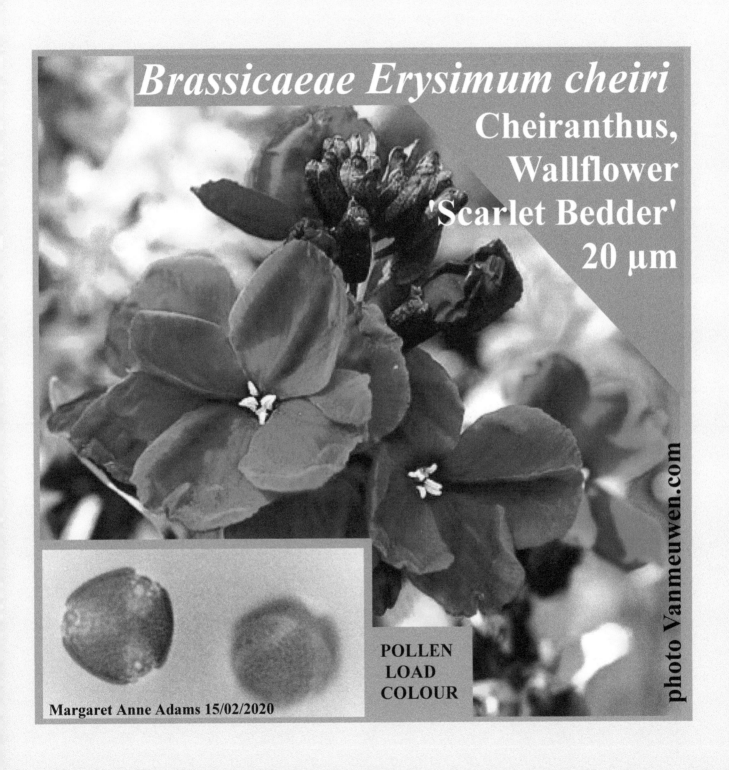

Brassicaeae Erysimum cheiri

**Cheiranthus,
Wallflower
'Scarlet Bedder'
20 μm**

POLLEN
LOAD
COLOUR

Margaret Anne Adams 15/02/2020

photo Vanmeuwen.com

Papilionaceae,
Ulex 31 μm,
Gorse, Whin or Furze

Despite gorse being in flower, all winter, here in Southwest Scotland, there has been no pollen in the flowers until today, 17th February 2020.

In Scotland, Whin pollen is a valuable source of protein for bees; the crude protein is well above the 20% minimum level required. Wherever honeybees have access to quantities of this pollen, their colonies should expand, and the resultant bees should be long lived.

Pollen loads gathered by Honey bees in the morning are brown and those gathered in the afternoon are yellow due to the saliva and crop contents used to stick the pollen grains together in the corbiculae.

The views in the second photo show that the grains are shaped like thick, triangular cushions. The germination apertures are furrows with pores that are barely visible.

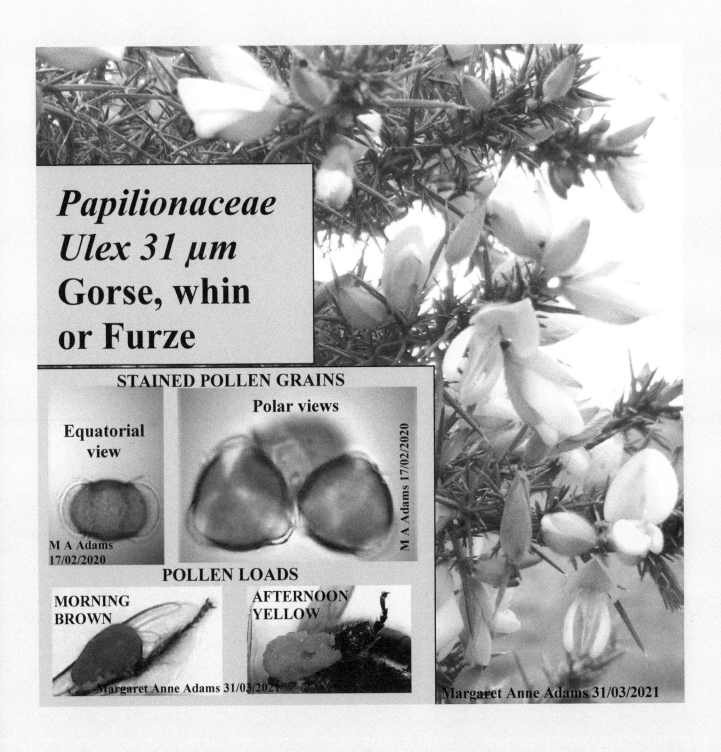

Papilionaceae
Ulex 31 μm
Gorse, whin
or Furze

STAINED POLLEN GRAINS

Polar views

Equatorial
view

M A Adams 17/02/2020

M A Adams
17/02/2020

POLLEN LOADS

MORNING
BROWN

AFTERNOON
YELLOW

Margaret Anne Adams 31/03/2021

Margaret Anne Adams 31/03/2021

Montiaceae,
Claytonia sibirica,
Pink Purslane

Pink purslane is a tiny, wild, woodland flower peculiar to Scotland. The leaves can be added to salad. The plant can also reproduce vegetatively, and in Ayrshire this has produced the white variety called the Stewarton flower.

The medium-sized pollen grains have micro spines and three sunken apertures with ornamented edges

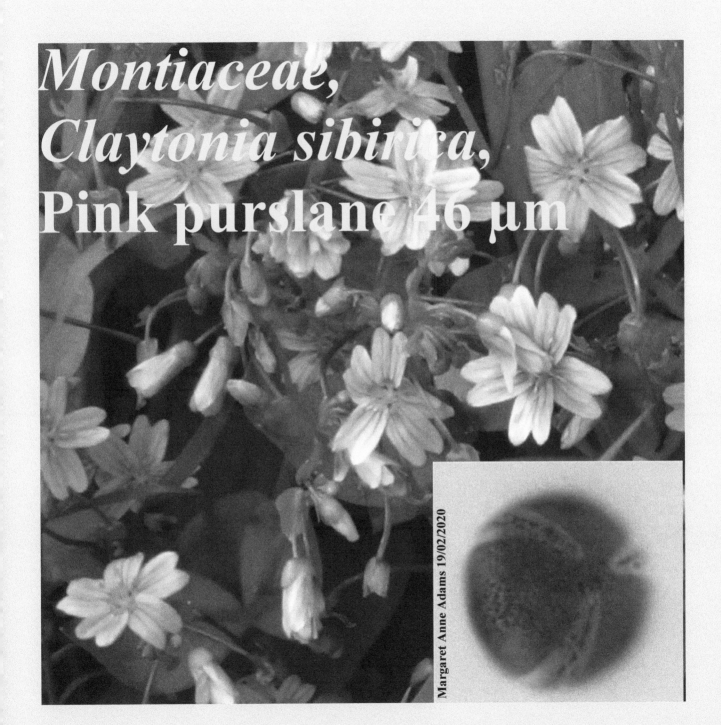

Montiaceae,
Claytonia sibirica,
Pink purslane 46 μm

Margaret Anne Adams 19/02/2020

Salicaceae,
Salix verminalis,
Osier or Basket Willow 20 μm

Salix verminalis, the Osier or Basket Willow is a native species and there are male and female trees. If willow is propagated from sticks from male trees, the resulting trees will be male and therefore pollen producers.

There are 400 species of willow with a potential of 600 to 700 kilos of pollen per acre. Bees usually ignore the hybrids.

The small, spheroidal pollen grains have three sunken, ornamented furrows with pores, and the surface is netted.

Salicaceae
Salix verminalis
Osier or Basket willow 20 μm

A group of stained pollen grains

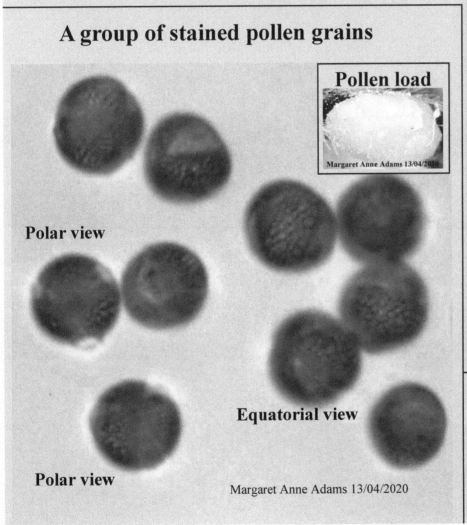

Polar view

Polar view

Equatorial view

Margaret Anne Adams 13/04/2020

Pollen load

Margaret Anne Adams 13/04/2020

Margaret Anne Adams 13/04/2020

Dehisced anthers with pollen

Margaret Anne Adams 13/04/2020

Catkin

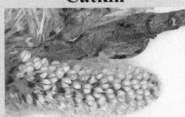

Margaret Anne Adams 13/04/2020

Boraginaceae,
Symphytum grandiflorum,
Creeping comfrey 28 by 36 μm

Creeping Comfrey, *Symphytum grandiflorum* is an excellent all year-round ground cover for orchards and woods. The plants flower early in the spring. On warmer days, Carder bees can be seen biting a hole at the base of the flower; this enables both them and Honey bees to forage for nectar, despite their short tongues and the length of the narrow flowers.

The shape of the pollen grains is prolate; the equatorial view is oval it has a 36 μm pole to pole diameter, with a bulge round the equator; the polar view is circular with a 28 μm diameter. The surface is covered with minute globules. There are more than 6 short furrows with pores around the equator, which can be seen in the first two pollen photos.

Boraginaceae, Symphytum grandiflorum, Creeping comfrey, 28 by 36 µm

August foliage

February flowers

Margaret Anne Adams 24/02/2020

STAINED POLLEN GRAINS

Oblique equatorial view

Equatorial view

Polar view

Margaret Anne Adams 24/02/2020

Margaret Anne Adams 26/082021

Iridaceae,
Crocus sativus,
Purple Crocus 92 to 118 μm

This pollen is from a purple crocus, which was growing, among some self-seeded vetch and foxgloves. If the flower is picked in the bud, it is less likely to contain other pollens that can blow in from other plants. The photos of the large, spherical pollen grains highlight the netted surface and conical spines. The pollen grain has an indefinite number of apertures. These grains occur in a range of sizes

Insect pollinated flowers usually have sticky pollen, with a rough surface, which makes the pollen grains stick to the plumose hairs all over the bee's body. If this yellow, sticky, fatty pollenkitt isn't removed from the pollen grains, they will not absorb stain, hence the three brown pollen grains in the picture. If grains are not properly stained it is harder to focus on details under the microscope. The pollenkitt should be thoroughly washed off with isopropanol, on a watch glass before transferring the pollen to a glass slide. A second wash may be needed.

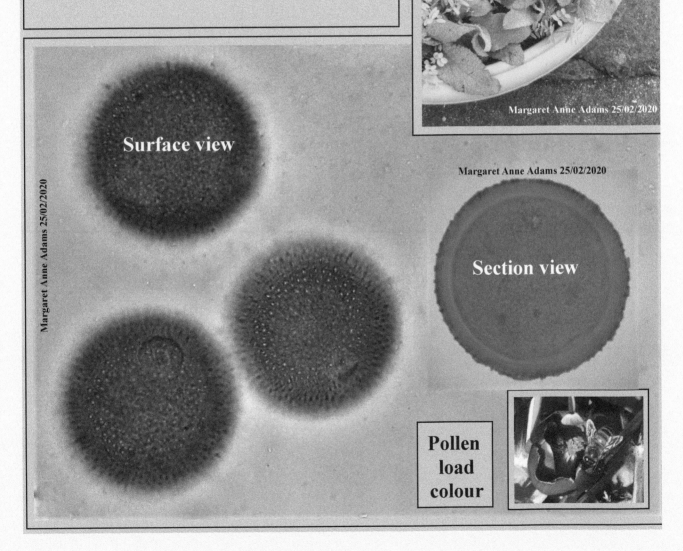

Iridaceae,
Crocus sativus,
Purple crocus. 92 to 118 µm

Margaret Anne Adams 25/02/2020

Surface view

Margaret Anne Adams 25/02/2020

Margaret Anne Adams 25/02/2020

Section view

Pollen
load
colour

Amaryllidaceae,
Narcissus pseudonarcissus,
Wild Daffodil 38 μm

The Wild Daffodil is the UK's only native *Narcissus*, and it takes at least five years for the seeds to become a flowering plant. The plants and flowers are smaller and paler yellow than the common daffodil.

As the pollen grains are egg shaped, we see a huge number of shapes under the microscope. This is because the grains can lie in various positions and as we focus we see various outline views (imagine all the possible ways of slicing a hard boiled egg!). The transparency of pollen grains can be seen in the photo.

The grain has one long, large aperture as seen on the grains in the middle of the right hand side of the photo. The surface is a fine net. There is lots of pollenkitt to rinse off the pollen when preparing it for a microscope slide.

Amaryllidaceae
Narcissus pseudonarcissus
Wild Daffodil 38 µm

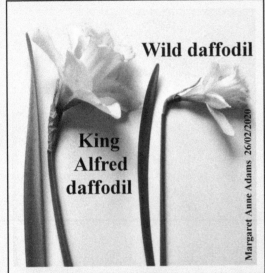

Wild daffodil

King
Alfred
daffodil

Margaret Anne Adams 26/02/2020

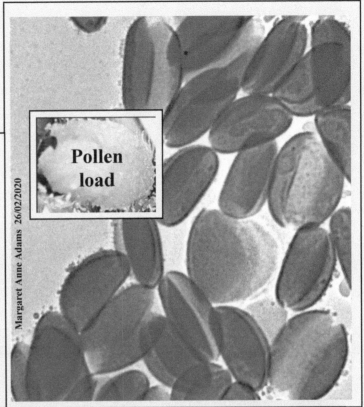

Pollen
load

Margaret Anne Adams 26/02/2020

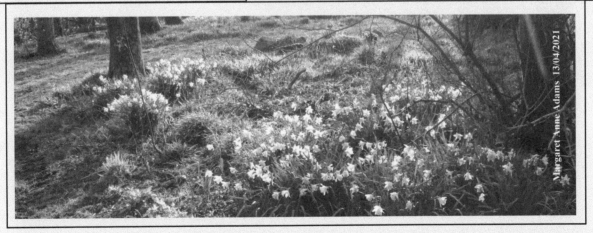

Margaret Anne Adams 13/04/2021

Primulaceae,
Primula vulgaris,
Common Primrose thrum 31 μm

There are two primrose pollens, which always grow on separate plants ; these plants are the thrum, and the pin morphs of the Common Primrose. Pin and thrum flowers pollinate each other but cannot self pollinate.

In the thrum morph, the style only grows halfway up the flower tube, so the stigma is halfway up, inside the tube. The filaments reach the top of the flower tube, so the anthers with the yellow pollen, are outside the flower tube, as seen in the inset photo, middle left.

The spheroidal grains can lie in many different positions. The thrum pollen grain can have seven to twelve sunken, germination furrows; the grain in polar view, top right, has eight. The surface is netted and coated with sticky, yellow pollenkitt, which was washed off with isopropanol, on a watch glass, before the pollen was put on a slide and stained.

Primulaceae
Primula vulgaris
Common Primrose
thrum 31 μm

Anthers with pollen

Thrum or short-styled morph

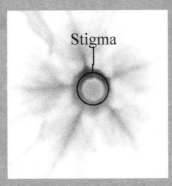

Stigma

Pin or long-styled morph

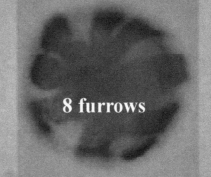

8 furrows

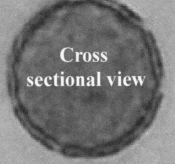

Oblique Polar view

Cross sectional view

Margaret Anne Adams 02/03/2020

Pollen load at the hive entrance – 26/02/2021

After removing the orange pollen loads from a returning forager, a slide was made to find out if she had been working on crocuses or snowdrops.

Comparing the grains for size and shape, with the pollens on slides made previously from the two flowers, showed that bee had been foraging on snowdrops.

POLLEN LOAD AT THE HIVE ENTRANCE 26/02/2021

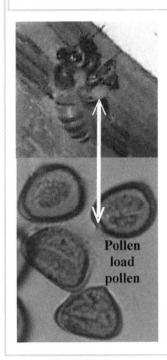

Pollen load pollen

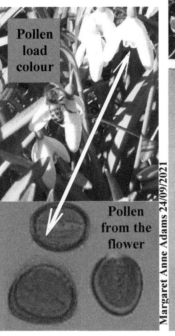

Pollen load colour

Pollen from the flower

Margaret Anne Adams 24/09/2021

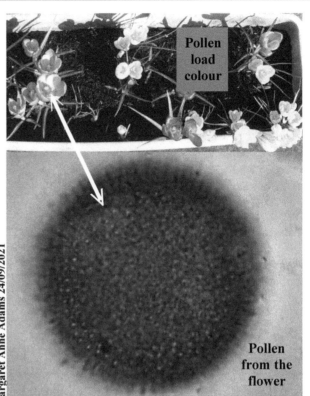

Pollen load colour

Pollen from the flower

Pollen loads taken from a honey bee – 11/03/2020

Today the bees were flying in the warm sun and bringing in plenty of pollen; a bee was chosen with light orange pollen and a microscope slide was prepared, to find out what the bee was foraging on.

On colour alone it would be either snowdrop, crocus or gorse pollen loads.

The grains measured 31μm, and when their shape and size is compared with the photos posted of the other three pollens, it is easy to see that the bee had been foraging on gorse, this afternoon.

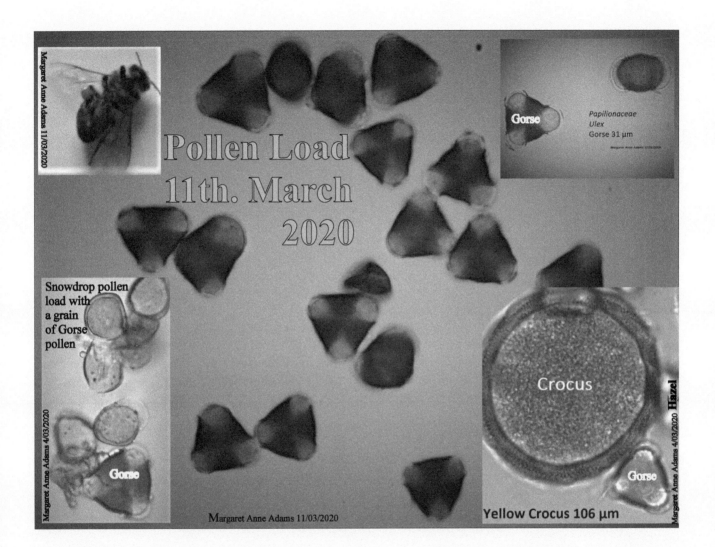

Pollen Load
11th. March
2020

Gorse

Papilionaceae
Ulex
Gorse 31 µm

Margaret Anne Adams 12/03/2020

Margaret Anne Adams 11/03/2020

Snowdrop pollen
load with
a grain
of Gorse
pollen

Gorse

Margaret Anne Adams 4/03/2020

Crocus

Yellow Crocus 106 µm

Gorse

Margaret Anne Adams 4/03/2020 Hazel

Margaret Anne Adams 11/03/2020

Asteraceae,
Taraxacum officinale,
Dandelion 28 to 38 μm

The name dandelion comes from the French 'dent de lion' meaning 'lion's tooth' which describes the leaves.

Dandelion nectar is rich in sugars so honey bees prefer it; fruit farmers mow them down, before the fruit trees blossom. This drastic measure keeps the bees concentrated on pollinating fruit blossom, to ensure the quality and quantity of the fruit. Each apple flower that is fully pollinated, produces a larger, and more perfectly shaped apple as long as the pollen is from a compatible tree and fertilization takes place.

Dandelion honey has an unpleasant taste but luckily the bees consume it all, long before beekeepers remove any honey. Where the bees are storing dandelion nectar, the comb becomes orangy yellow and is particularly bright on freshly built brace comb.

It was surprising to find that the pollen grains varied in size and most of them had 4 or 5 germination apertures not 3.

Despite washing the sample twice in isopropanol, some of the grains hung on to their pollenkitt. Even nectar foragers return to the hive smothered in the sticky, yellow dandelion pollen grains.

Asteraceae Taraxacum officinale Dandelion 28 to 38 μm

Brace comb used to process Dandelion nectar

Margaret Anne Adams March 2014

Margaret Anne Adams 09/04/2021

5 Germination pores

Pollenkitt

4 Germination pores

Germination pore

Pollen load colour

Photo to check the presence of pollen

Margaret Anne Adams 09/04/2021

Margaret Anne Adams 09/04/2021

Rosaceae,
Prunus spinosa,
Blackthorn 36 μm

This flower was out six days ago but, despite making four slides, I could only find pollen grains with three germinating apertures - none with four, which do exist; it was like looking for a four leafed clover in a field of clover. The three apertures are long furrows with pores. The brown, medium sized grains are shaped like thick, triangular cushions. The five grains in the photo area all lying in different positions so it might be hard to identify them in honey if the long furrows were not clearly in view.

Following the 'Inclosure Acts' as 'Enclosure Acts' were originally called, blackthorn hedges were planted and sloe gin was made from the berries. Today, many British people still steep sloes in sugar and gin / vodka / brandy or another spirit that comes to hand to make a traditional Christmas liqueur.

Rosaceae
Prunus spinosa
Blackthorn 36 µm

Pollen
Load
Colour

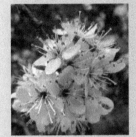

March Flowers

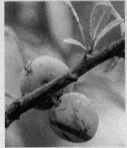

**Autumn sloes
Best after first frosts
or time in the freezer.**

Margaret Anne Adams 17/03/2020

Brassicaceae, Aubrieta 26 μm

Aubrieta grows in profusion and provides early pollen and nectar for Honey bees. The flower is named after Claude Aubriet, an 18th century French Botanical Artist at the Jardin du Roi, now known as the 'Jardin des plantes' in Paris.

Aubrieta flowers have small, spheroidal pollen grains with three ornamented germination apertures, consisting of furrows with pores. The surface is reticulate.

Brassicaceae
Aubrieta
26 μm

Polar view

Equatorial
view

Equatorial
view

Pollen load
colour

Margaret Anne Adams 24/03 2020

Amaryllidaceae,
Allium ursinum,
Wild or bear garlic 31 μm

Wild garlic flowers are visited by Honey bees, and even though the nectar and pollen smells and tastes of garlic, by the time the nectar has been ripened into honey, the garlic taste and smell have disappeared, leaving the pollen grains as a clue to the nectar source. However, colonies usually use up early honey stores long before we take any.

The yellow, medium sized, prolate pollen grains are lightly sculptured and have only one germination aperture, called a 'sulcus' as it is an 'elongated aperture situated distally'. The sulcus can be seen in the top right grain in the photo.

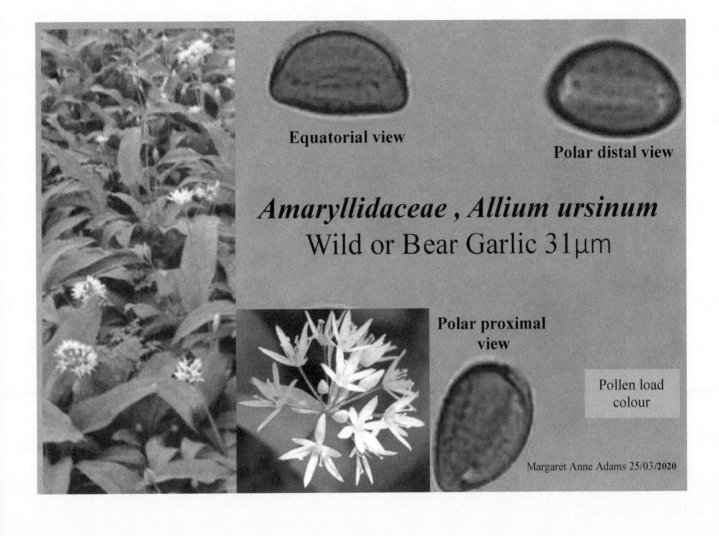

Equatorial view

Polar distal view

Amaryllidaceae , Allium ursinum
Wild or Bear Garlic 31μm

Polar proximal
view

Pollen load
colour

Margaret Anne Adams 25/03/2020

Rosaceae,
Prunus,
Patio plum 31 μm

A patio plum tree in a big tub is useful for beekeeping in a small garden, a rooftop or urban setting as, not only does it provide the bees with pollen and nectar but, in the summer when the foliage is dense and it reaches 5 feet, it can be moved to shade hives from the sun. However, late in the season, the tree or the plums must be removed away from colonies of bees, before the wasps start to look for sweet nourishment when their queen stops laying.

This is the first year this patio plum tree has flowered so it will be interesting to see what sort of fruit it produces.

These medium sized yellow pollen grains, like others of the prunus genus, are triangular in polar view and oblate in equatorial view. They too have three generative apertures in the form of furrows with pores.

Margaret Anne Adams 27/03/2020

Margaret Anne Adams
27/03/2020

Pollen load colour

Rosaceae
Prunus
"Patio plum tree"
31 μm

Margaret Anne Adams 27/03/2020

Polar
View

Equatorial
view

Rosaceae,
Prunus domestica,
Victoria plum 38 μm

Sharp's Emperor plum was renamed Denyer's Victoria to celebrate the Coronation of Queen Victoria in 1837.

These Victoria plum pollen grains are the largest prunus pollen grains produced here, so far this year. Size is sometimes the only way to identify pollen grains in the same species.

The four pollen grains in the photo are positioned in the haphazard way they land in a microscope slide. They are medium sized, oblate, triangular in polar view and have three germination apertures in the form of furrows with pores.

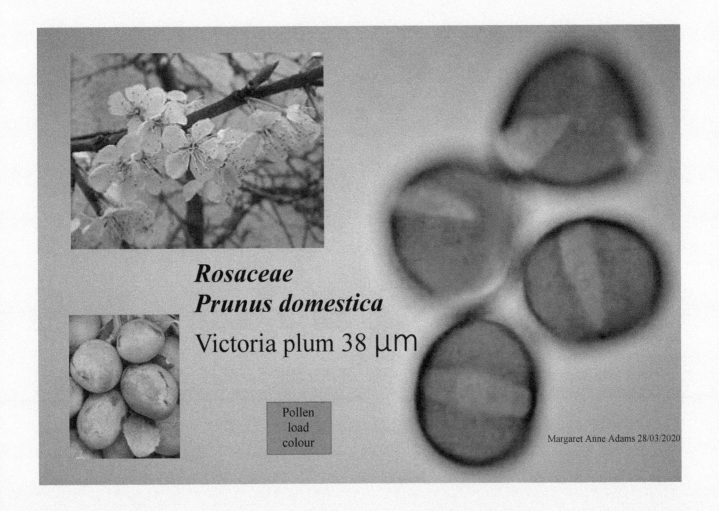

Rosaceae
Prunus domestica

Victoria plum 38 μm

Pollen
load
colour

Margaret Anne Adams 28/03/2020

Ranunculaceae,
Ficaria verna,
Lesser celandine 31 μm

Today is the first days of spring, and by coincidence the first lesser celandine, called the 'harbinger of spring', appeared in our copse this morning.

The flower in the photo is special for another reason too; it has rotational symmetry of order 3, having three radially symmetrical, sepaloid tepals (ST) alternating with three pairs of petaloid tepals (PT). You will find the number of petaloid tepals can vary between 7 and 12 in others.

The medium-sized, yellow pollen grains are spheroidal, and the ornamented germination apertures are furrows with pores. The whole surface is covered with minute sculptured elements just visible with a light microscope.

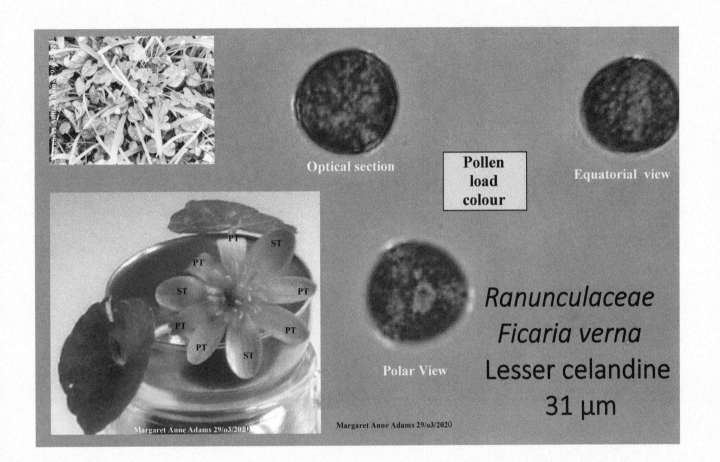

Optical section

Pollen load colour

Equatorial view

Polar View

Ranunculaceae
Ficaria verna
Lesser celandine
31 μm

Margaret Anne Adams 29/o3/2020

Margaret Anne Adams 29/o3/2020

Rosaceae,
Prunus domestica,
Greengage 41 µm

In 1724, Sir Thomas Gage imported some Reine Claude plum trees from France but the labels were lost in transit so he named them Greengages.

The flowers are not self fertile, but cross pollination with pollen from the Victoria plum tree which flowers at the same time and is compatible, can lead to fertilization and fruit.

The yellow pollen grains are even larger than those of the Victoria plum but the pollen loads are the same colour. Again the three ornamented germination apertures are furrows with pores and the surface is striated and perforated.

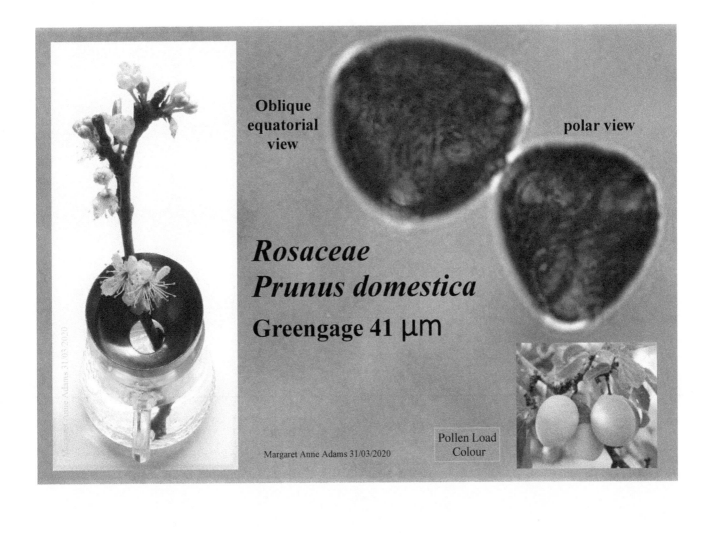

Oblique equatorial view

polar view

Rosaceae
Prunus domestica

Greengage 41 μm

Pollen Load
Colour

Margaret Anne Adams 31/03/2020

Salicaceae,
Salix caprea,
Goat Willow 18 μm

In 1724, Sir Thomas Gage imported some Reine Claude plum trees from France but the labels were lost in transit so he named them Greengages.

The flowers are not self fertile, but cross pollination with pollen from the Victoria plum tree which flowers at the same time and is compatible, can lead to fertilization and fruit.

The yellow pollen grains are even larger than those of the Victoria plum but the pollen loads are the same colour. Again the three ornamented germination apertures are furrows with pores and the surface is striated and perforated.

Salicaceae
Salix caprea
Goat willow
stained pollen
grains 18 µm

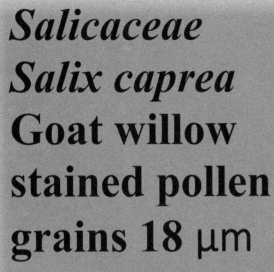

**Pollen
load
colour**

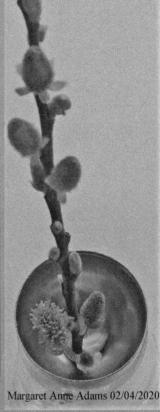

Margaret Anne Adams 03/04/2021

Margaret Anne Adams 02/04/2020

Margaret Anne Adams 02/04/2020

Willow whistle

Liliaceae,
Tulipa sp.,
Tulip 97 μm

Tulips flower early in the season and the brightly coloured flowers attract foraging bees. The bees go from tulip to tulip carrying different tulip pollens; this causes cross-pollination and self-pollination. When fertilisation occurs new varieties can result.

This tulip has very large, black pollen grains. The grains have one sunken germination aperture and a surface covered with a compact worm-like sculpturing. The pollen wall close to the germination aperture has a bi-layered intine.

124

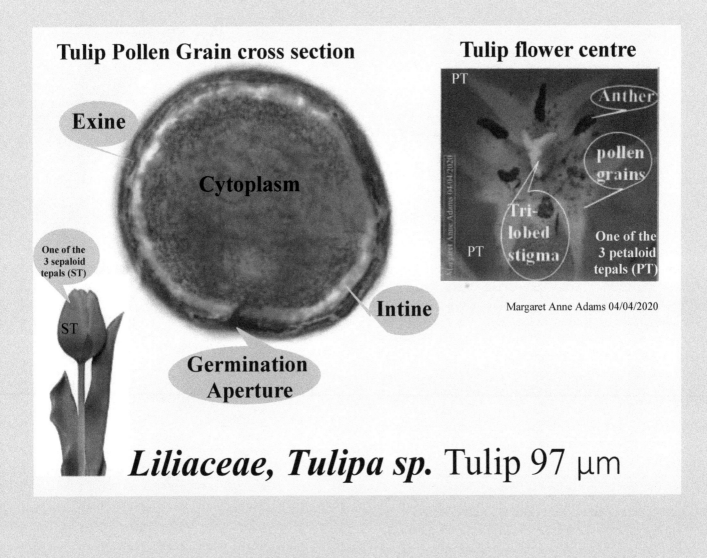

Tulip Pollen Grain cross section

Exine

Cytoplasm

One of the 3 sepaloid tepals (ST)

ST

Intine

Germination Aperture

Tulip flower centre

PT

Anther

pollen grains

Tri-lobed stigma

PT

One of the 3 petaloid tepals (PT)

Margaret Anne Adams 04/04/2020

Liliaceae, Tulipa sp. Tulip 97 μm

Liliaceae,
Fritillaria Meleagris,
Snake's Head Fritillary 64 μm

These wild flowers grow, from dormant bulbs, in their thousands, in ancient meadows, along with cowslips and dandelions. The flower bud looks like a snake's head in the long grass, but when the flower opens the bell hangs down to protect the stamens, the pistil and the nectaries. As the bells sway in the breeze the chequered flowers reflect near infra red and UV light, and bees can see which flowers need pollinating. The seeds germinate in the silt left after floods have drained away and form bulbs which flower after 5 to 8 years. The bulbs thrive in soil that is not too fertile and where there are no grazing animals. They benefit from the field being mown once the flowers have set seed.

The large, yellow pollen grains are oblate with one germinating pore at the far end of a sunken furrow. The surface of the grain is ornamented with an irregular net.

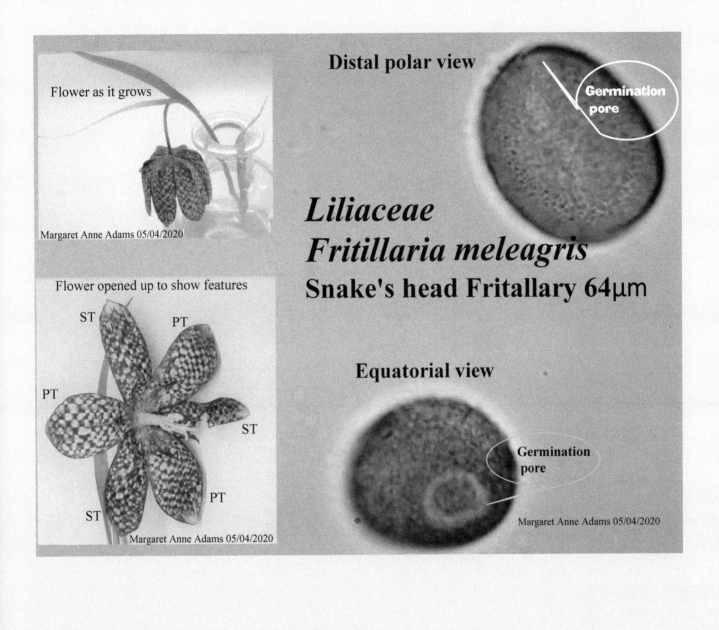

Distal polar view

Germination pore

Flower as it grows

Margaret Anne Adams 05/04/2020

Liliaceae
Fritillaria meleagris
Snake's head Fritallary 64μm

Flower opened up to show features

ST
PT
PT
ST
ST
PT
ST

Margaret Anne Adams 05/04/2020

Equatorial view

Germination pore

Margaret Anne Adams 05/04/2020

Asparagaceae,
Scilla siberica,
Wood squill or Siberian Squill 49 μm

This tiny wild flower gets its name, not from its geographical origin, but from its ability to function in very cold weather, even the stamens will dehisce at 4.7°C. but the bees are clustered at those temperatures.

Although it is supposed to be rare in SW Scotland, it grows wild near Portpatrick, in the grass, on the cliffs around Killantringan Lighthouse. It can be grown from seeds or bulbs to form a blue carpet of flowers.

The medium sized, oblate pollen grains have one germination aperture in the form of a furrow. The nectar, saliva and honey mixed with the 'grey' pollen gives the pollen load a greenish blue tinge.

Asparagaceae,
Scilla siberica
Siberian squill
or Wood squill. 49 µm

Bee culture 14/02/2017

Margaret Anne Adams 08/04/2020

Flowers on grass

Margaret Anne Adams 08/04/2020

Flower with blue anthers

Margaret Anne Adams 08/04/2020

Close up of dehisced anther and 'grey' pollen

Margaret Anne Adams 08/04/2020

POLLEN LOAD COLOUR

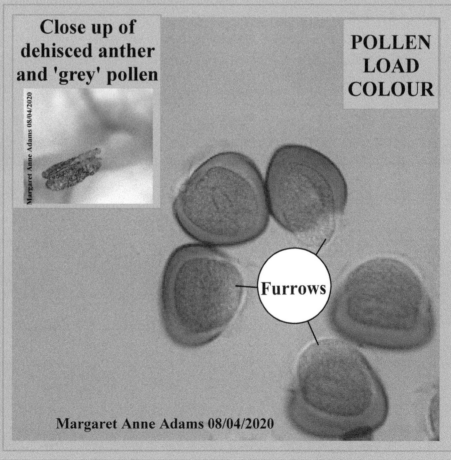

Furrows

Margaret Anne Adams 08/04/2020

Salicaceae,
Salix alba,
White willow 18 μm

The white willow has silvery white leaves, and in the breeze, the undersides of the leaves show, making the foliage look even paler.

The variety 'caerulea' is grown to make cricket bats.

The pollen grains are the same size as those of *Salix Caprea*. If you have both trees in the vicinity it would be difficult to differentiate the pollen loads taken at the hive entrance, without, marking the bees on the trees with different colours or a DNA test.

The very small, yellow pollen grains have three germination apertures in the form of furrows. The surface is covered with an irregular net.

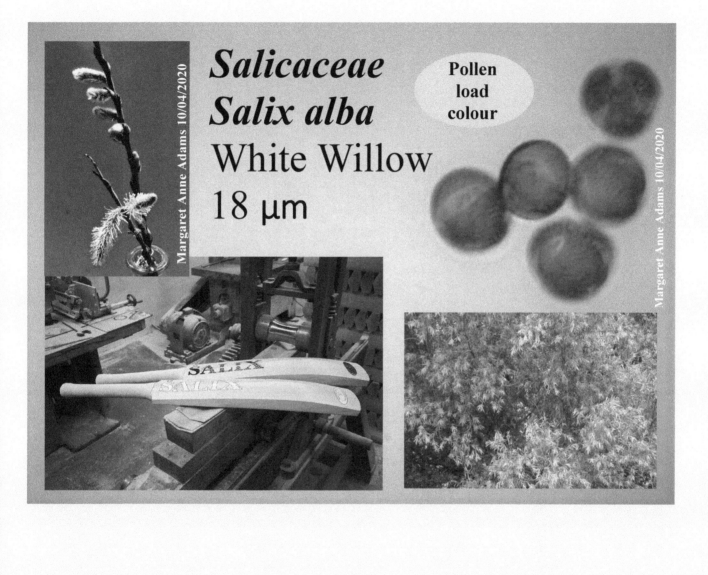

Salicaceae
Salix alba
White Willow
18 μm

Pollen
load
colour

Margaret Anne Adams 10/04/2020

Margaret Anne Adams 10/04/2020

Brassicaceae, Lunaria annua, Honesty 26 μm

Lunaria means 'moonlike' to describe the seed pods. The seeds are dispersed by strong winds that send parts of the brittle dried plant tumbling around, scattering pods and seeds on it's way. When the flowers come into bloom in April, remains of last years seed pods are still hanging onto dried stalks, among the new plants.

Honey bees take pollen and nectar from honesty, but they are likely to chose more nourishing pollens and more easily accessible nectar, than honesty provides in the deep flower tube.

The small, yellow, oblate pollen grains have three furrows and a regular netted surface.

Brassicaceae
Lunaria annua
Honesty 26 μm

Equatorial view

Pollen load colour

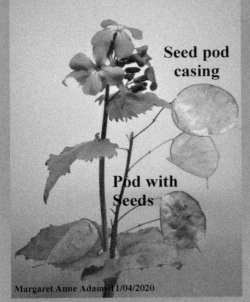

Seed pod casing

Pod with Seeds

Margaret Anne Adams 11/04/2020

Margaret Anne Adams 11/04/2020

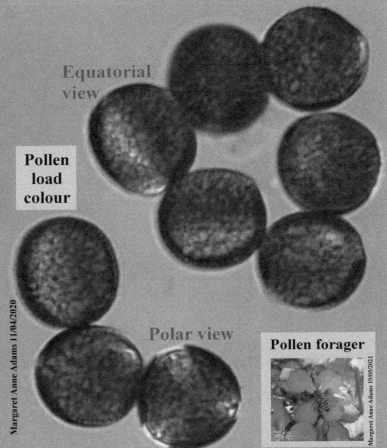

Polar view

Pollen forager

Margaret Anne Adams 19/05/2021

Rosaceae,
Prunus avium,
Wild Cherry or Gean 38 μm

The name 'avium' means 'wilderness', hence wild cherry. This is not the same as the Bird Cherry which is Prunus padus. The wood is strong and used for making cask hoops and decorative veneers.

The cherries are eaten by birdsand mammals, who digest the flesh of the fruit and disperse the stones in their droppings.This way new Wild Cherry trees pop up in unexpected places, like the ones in the picture. These trees can be raised by potting up the cherry stones and replanting the trees in suitable places, when they are about a metre high. They grow to a height of several meters and the trunk is relatively straight.

The medium sized, brown pollen grains are like stout triangular cushions. The three germination apertures are furrows with pores. The surface ornamentation is striate.

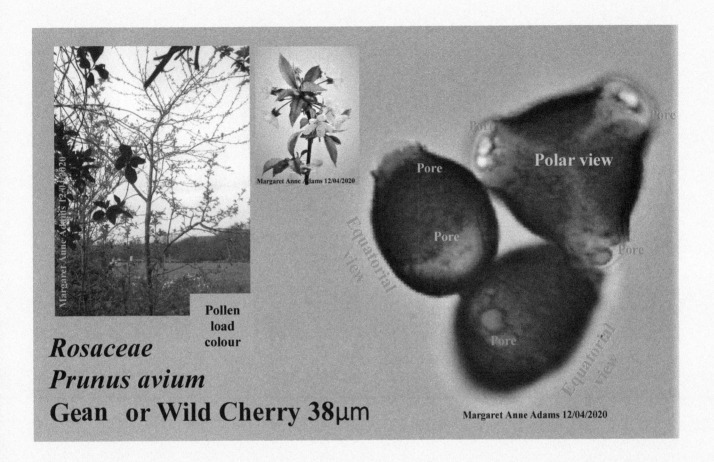

Rosaceae
Prunus avium
Gean or Wild Cherry 38μm

Pollen
load
colour

Margaret Anne Adams 12/04/2020

Margaret Anne Adams 12/04/2020

Polar view

Pore

Pore

Pore

Pore

Pore

Pore

Equatorial view

Equatorial view

Margaret Anne Adams 12/04/2020

Grossulariaceae,
Ribes uva-crispa,
Gooseberry 'careless' 28 μm

'Gooseberry bush' was a 19th century euphemism for 'short and curlies' so when children asked questions, they were told truthfully, that babies were born under a gooseberry bush.

Honey bees are attracted to the easily accessible nectar and collect pollen incidentally. Gooseberry honey, is medium coloured and flavoursome and can be extracted when the bees are near fruit farms growing gooseberry bushes commercially.

The greyish white, spheroidal pollen grains are smooth with seven or more germination pores distributed, more or less regularly, over the whole surface, in elongated furrow like areas.

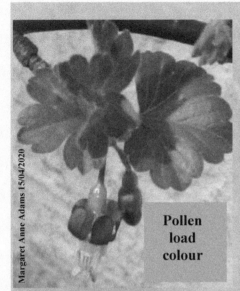

**Pollen
load
colour**

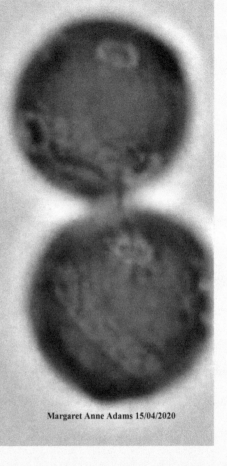

Grossulariaceae
Ribes uva-crispa
Gooseberry 'careless' 28 μm

Asparagaceae,
Hyacinthoides non-scripta,
Common bluebell 56 μm

The pollen was taken from the first flower to open in the bluebell wood this year. The background picture was taken in May 2019.

If a short-tongued bumblebee has bitten a hole at the back of the long flower tube, to get at the nectar, Honey bees also have access to the nectar.

The pollen is similar to that of the Siberian squill except that the grains are white, not blue, and although they vary in size, they are larger. When mixed with nectar by the forager the pollen load takes on a dull yellow tinge. The single germination aperture is a furrow as labelled in the bottom grain; the surface is netted.

Asparagaceae
Hyacinthoides non-scripta
Common bluebell 51 µm

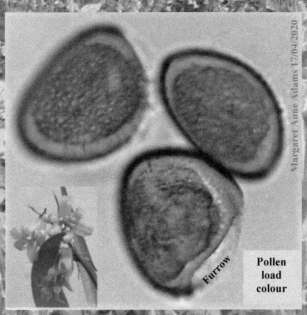

Margaret Anne Adams 17/04/2020

Furrow

Pollen load colour

Margaret Anne Adams 17/04/2020

Caryophyllaceae,
Stellaria holostea,
Greater stitchwort 31 µm

This plant is native to the British isles. 'Stellaria' means star-like. The flowers grow in long grass for support; 'holostea' denotes the brittleness of the thin bone like stems. The suffix 'wort' signifies that the flower can be used to heal or cure the organ or problem in the first part of the common name. Drinking a brew from the plant, it is supposed cure runners stitch.

The dry, yellow pollen grains are dodecahedra. At the centre of each of the twelve pentagonal faces is an ornamented germination pore. The thirty edges of the dodecahedron are decorated with small spines. When these medium sized grains are hydrated, most of the grains become spheroidal and look circular under the microscope and the few that remain dry look polygonal.

140

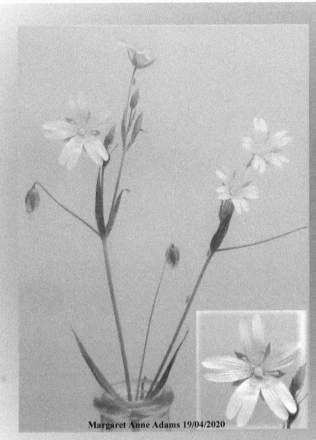

Margaret Anne Adams 19/04/2020

Caryophyllaceae
Stellaria Holostea
Greater stitchwort
31μm

Polar view

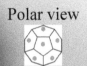

Equatorial view

Margaret Anne Adams 19/04/2020

Violaceae,
Viola riviniana,
Common dog violet 44 μm

The distinguishing features of the Common Dog Violet are its lack of scent, the notched spur behind the flower which is lighter than the petals, and the hairless heart shaped leaves.

This flower is found all over Scotland in the spring. The one in the photo was growing in grass on a steep, steep south facing bank, at the edge of the C13 road which leads down to the East side of Loch Ryan and looks over to the Ferry Terminals.

This is the first pollen so far with four germination pores. The medium sized, yellow grains are shaped like fat circular cushions (oblate). Each pore is in a shallow, sunken furrow. The surface of the grains is perforated and covered with tiny spines.

The spur
is lighter
than the
petals

Margaret Anne Adams 21/04/2020

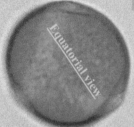
Equatorial view

Oblique polar view

Pore Pore

Pore

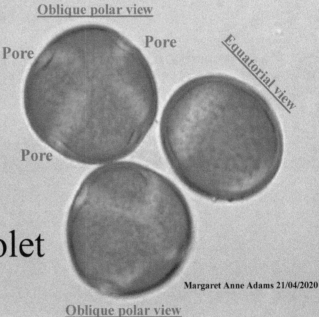
Equatorial view

Margaret Anne Adams 21/04/2020

Oblique polar view

Violaceae
Viola riviniana
Common dog violet
44μm

Papaveraceae,
Mecanopsis cambrica aurantiaca,
Orange Welsh Poppy 29 μm

Bees scramble three or four at a time in the flowers, collecting poppy pollen, and by 10 am on fine days, all the pollen will have been taken to their brood nests. The seeds are tiny and when ever the soil is disturbed , new poppy plants spring up.

In our garden there are four sorts of poppy, that come from seeds given by friends and family. These orange Welsh Poppies always bring happy memories; they come from seeds given to us by Lawrence and Fiona Keith, who did so much towards the resurrection of the Western Galloway Beekeepers Association over a decade ago. On day of Lawrence's cremation in Ayr, we were invited to Jackie Elliot's home where we met for the first time, and she gave us tea and the most delicious gingerbread I have ever tasted.

The yellow, spheroidal pollen grains have three germination pores in feint furrows.

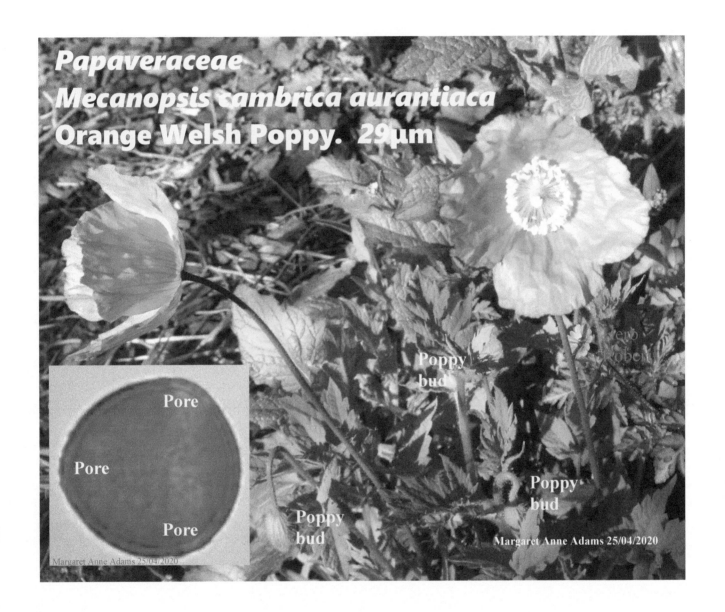

Papaveraceae
Mecanopsis cambrica aurantiaca
Orange Welsh Poppy. 29µm

Pore

Pore

Pore

Poppy bud

Poppy bud

Poppy bud

Rosaceae,
Prunus Regina,
Eating cherry regina 38 μm

Regina is a delicious eating cherry. As cherry trees are not self-fertile they need at least two or three compatible pollinators that must be flowering at same time to be sure of a crop of cherries. In the Scottish climate, it is wise to plant a group of six or more different compatible cherry trees such as Summer Sun, Penny, Lapins, Regina, Sunburst and Morello, all on a dwarfing root stock.

Honey bees collect the pollen and nectar from the flowers and there are also extrafloral nectaries on the leaf petiole. Only one or two fine days are needed for pollination to take place, though frost can damage blossom and the forming fruit.

The pale brown, medium-size, oblate pollen grains have three germination pores in furrows. The surface is striate and perforated.

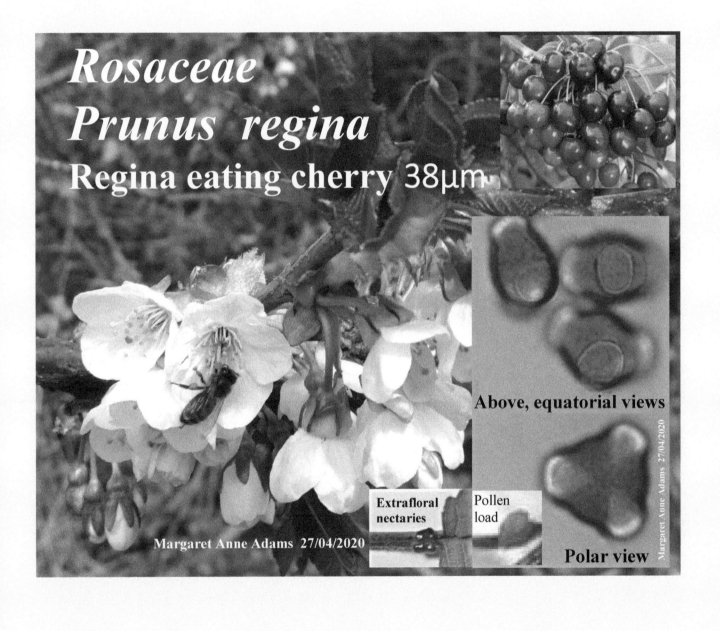

Rosaceae
Prunus regina
Regina eating cherry 38μm

Above, equatorial views

Extrafloral nectaries

Pollen load

Polar view

Margaret Anne Adams 27/04/2020

Margaret Anne Adams 27/04/2020

Rosaceae,
Malus domestica,
Grenadier Apple 36 μm

The Grenadier apple tree can produce big, cooking apples that bake to bursting in just over 30 minutes. It copes with wet weather and the flowers aren't damaged by frost. It is an ideal cooking apple tree for a Scottish garden.

The Grenadierapple tree is inflowering group 3. It is partially self-fertile, but the crop is improved by cross pollination with other nearby, compatible varieties that flower at the same time, such as Charles Ross, Red Devil and crab apple Every apple has five carpels; if fertilization has been complete, each carpel will contain two seeds, totaling 10 seeds per apple, and the apples will be large and perfectly shaped. This can only happen if bees such as Honey bees, solitary bees, bumblebees and hoverflies are plentiful and pollinate the flowers.

Finally, to be sure of perfect fruit with a diameter of 8 cm, cooking apples should be thinned, after the June drop, to one per cluster and be at least 15 cm apart. This will also ensure annual, rather than alternate year fruiting, as the trees can also produce fruit spurs for the following year, when overloaded with small misshapen apples.

The medium-size, yellow, oblate pollen grains have three germination pores in furrows and the surface of the grains is striate and perforated

148

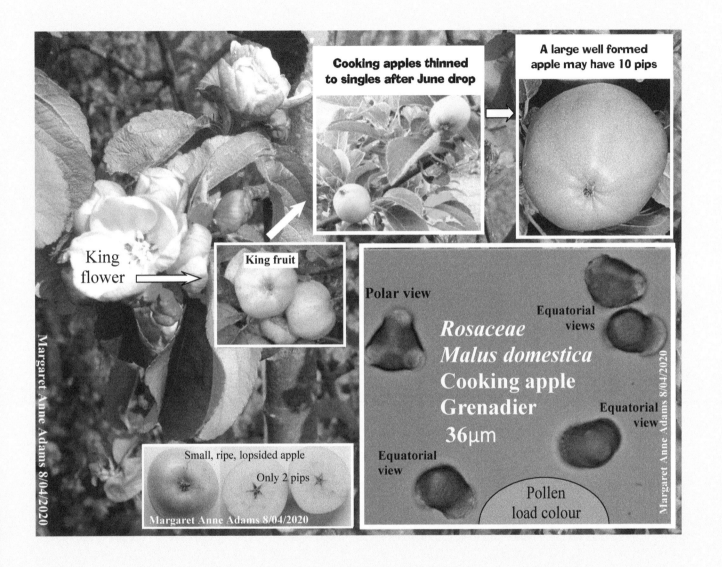

King flower

Cooking apples thinned to singles after June drop

A large well formed apple may have 10 pips

King fruit

Small, ripe, lopsided apple

Only 2 pips

Margaret Anne Adams 8/04/2020

Polar view

Equatorial views

Rosaceae
Malus domestica
Cooking apple
Grenadier
36μm

Equatorial view

Equatorial view

Pollen load colour

Margaret Anne Adams 8/04/2020

Margaret Anne Adams 8/04/2020

Rosaceae,
Pyrus communis 'Beurré'
Pear 'Beuré Hardy' 31 μm

Pear 'Beurré Hardy' is in flowering group 4 and, as it is not self fertile, it needs a pollinating partner of a different variety, that flowers at the same time.

It is difficult to hydrate, stain and make a good slide of this delicate pollen, because the intine bursts easily and the cytoplasm pours out of the grain. However, the delicate nature of the intine facilitates the action of digestive enzymes and helps bees to get nourishment from the pollen in their gut. Pollen grains undergo osmotic shock when passing from the proventriculus to the ventriculus of adult bees; and the action of moisture on the pollen grains in bee bread eaten by larvae in their later stages also causes the cytoplasm to protrude.

The medium-size, white pollen grains are spheroidal and have three furrows with germination pores. The surface of the grains is striate and perforated.

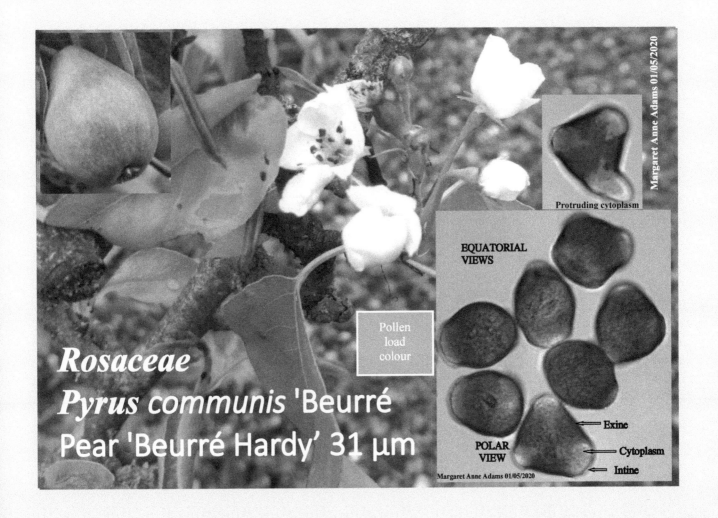

Rosaceae
Pyrus communis 'Beurré
Pear 'Beurré Hardy' 31 µm

Pollen load colour

Protruding cytoplasm

EQUATORIAL VIEWS

POLAR VIEW

Exine

Cytoplasm

Intine

Margaret Anne Adams 01/05/2020

Margaret Anne Adams 01/05/2020

Pollen load collected from the hive entrance – 02/05/2020

We can determine the source of the Pollen load on the bees hind legs by making a slide to comparing the pollen grains in the bee's pollen load with pollens of similar colour, collected from plants still in flower. The candidates are the bluebell, gooseberry, flowering currant and apple Of the four, the one that has pollen grains of the same shape and size as those in the pollen load is apple. There are many varieties of apple in flower at the moment and their pollens are identical in appearance – only DNA could tell them apart.

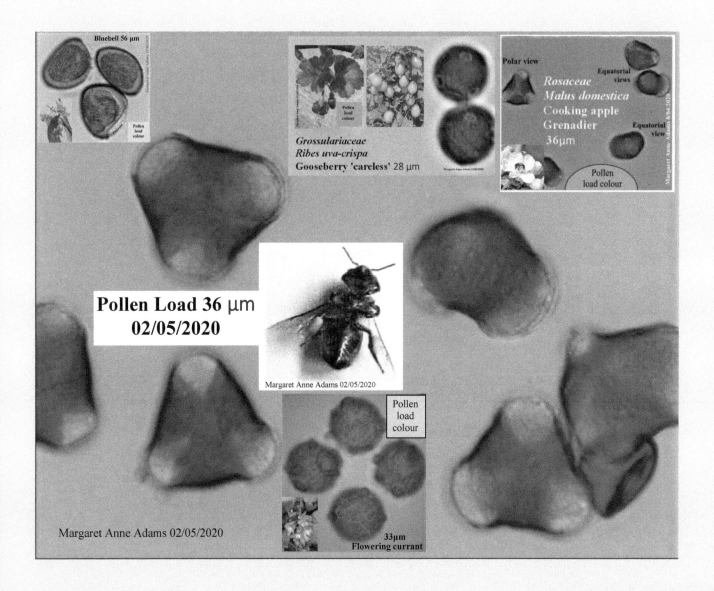

Bluebell 56 μm

Grossulariaceae
Ribes uva-crispa
Gooseberry 'careless' 28 μm

Pollen
load
colour

Rosaceae
Malus domestica
Cooking apple
Grenadier
36μm

Polar view

Equatorial
views

Equatorial
view

Pollen
load colour

Pollen Load 36 μm
02/05/2020

Margaret Anne Adams 02/05/2020

Pollen
load
colour

33μm
Flowering currant

Margaret Anne Adams 02/05/2020

Pollen load collected from the hive entrance – 03/05/2020

Three of the pollens examined so far have the same load colour and shape as the pollen load of the Honey bee forager in the photo: Gorse, Wild Cherry (Gean) and the Eating cherry.

The pollen load, the Wild cherry (Gean) and the Eating Cherry pollen grains all measure 38 μm but Gorse grains only measure 31 μm, so Gorse can be eliminated, although many of the foragers are still working it.

The Eating Cherry trees are still in full bloom, but the Wild Cherry has no flowers left today. So, by process of elimination, we can say that the honey bee in the photo, had been foraging on Eating Cherry flowers.

Pollen load 03/05/2020
Grains 38 μm

Margaret Anne Adams 03/05/2020

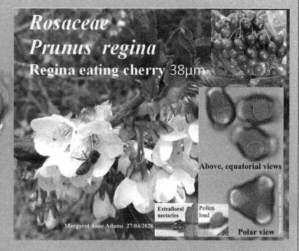

Rosaceae
Prunus regina
Regina eating cherry 38μm

Margaret Anne Adams 27/04/2020

Above, equatorial views

Extrafloral nectaries

Pollen load

Polar view

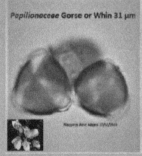

Papilionaceae Gorse or Whin 31 μm

Margaret Anne Adams 17/02/2020

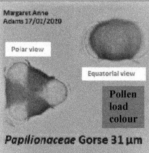

Polar view

Equatorial view

Pollen load colour

Papilionaceae Gorse 31 μm

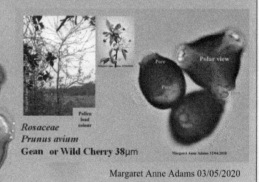

Rosaceae
Prunus avium
Gean or Wild Cherry 38μm

Pollen load colour

Pore

Polar view

Pore

Margaret Anne Adams 03/05/2020

Brassicaceae,
Brassica napus,
Oilseed rape 26 μm

The pollen of Oilseed rape (OSR) is reputed to make honeybees more defensive than usual. Canola is essentially self-pollinating but yields of seeds are improved by the foraging activity of Honey bees.

The quantities of pollen that bees collect from Canola are quite substantial and the essential amino acids (apart from isoleucine) and the crude protein levels in most samples are adequate to meet a bee's nutritional needs. The higher fat levels appear to enhance the attractiveness of the pollen to foragers.

The OSR grown for products destined for animal consumption is low in erucic acid and is called 'Canada oil low acid' abbreviated to 'Canola'.

The medium-size, yellow pollen grains are oblate, circular in polar view and oval in equatorial view. The germination apertures are three sunken furrows. The surface is netted.

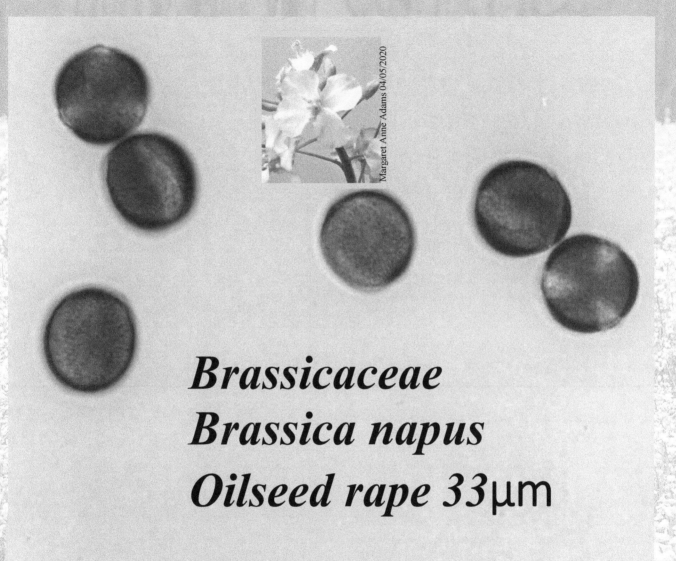

Brassicaceae
Brassica napus
Oilseed rape 33μm

Onagraceae,
Fuchsia Magellanica,
Wild fuchsia 64 μm

Although this Fuchsia originated in South America it has become naturalized and thrives in Scotland. You only have to shove a handful of cuttings into the ground, and you will have soon flowering tree buzzing with bees, from May till October

Short tongued bumblebees make a hole to access the nectar at the top of the long flower tube, and Honey bees take advantage of the hole as they too have short tongues

The viscin threads fasten the large white pollen grains like ropes, and the grains become entangled with other grains, with the bees' plumose hairs and scopae. Thus, the pollen grains adhere only by friction, although nectar added by honey-bees. sometimes reinforces the pollen attachment. The pollen loads appear less compact than usual. Viscin threads are products of evolutionary specialization in the *Onagraceae, Ericaceae* and *Caesalpiniaceae*. Perhaps long ago the threads, like some other unusual features in exine structure, arose as a chance mutation. This structural change of the exine was a valuable adaptation for insect pollination.

158

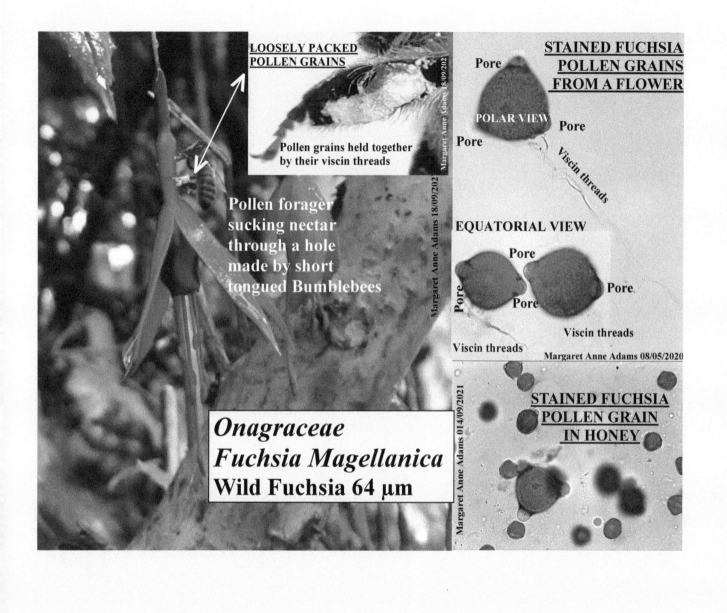

LOOSELY PACKED
POLLEN GRAINS

Pollen grains held together
by their viscin threads

Margaret Anne Adams 18/09/202

Pollen forager
sucking nectar
through a hole
made by short
tongued Bumblebees

Margaret Anne Adams 18/09/202

STAINED FUCHSIA
POLLEN GRAINS
FROM A FLOWER

Pore

POLAR VIEW

Pore

Pore

Viscin threads

EQUATORIAL VIEW

Pore

Pore

Pore

Pore

Viscin threads

Viscin threads

Margaret Anne Adams 08/05/2020

Onagraceae
Fuchsia Magellanica
Wild Fuchsia 64 µm

Margaret Anne Adams 014/09/2021

STAINED FUCHSIA
POLLEN GRAIN
IN HONEY

Plantaginaceae,
Plantago lanceolate,
Ribwort Plantain 31 µm

Bees are attracted to Ribwort Plantain when the flower heads, on their long slender stalks, sway in the breeze.

The medium size, yellow, spheroidal pollen grains have more than 7 germination pores, spaced regularly over the surface of the grain. Surrounding each pore is an annulus. The annuli are ring-like thickenings of the exine. In addition the pores have an operculum; the opercula are structures capping the pore, formed from the intine and exine.

160

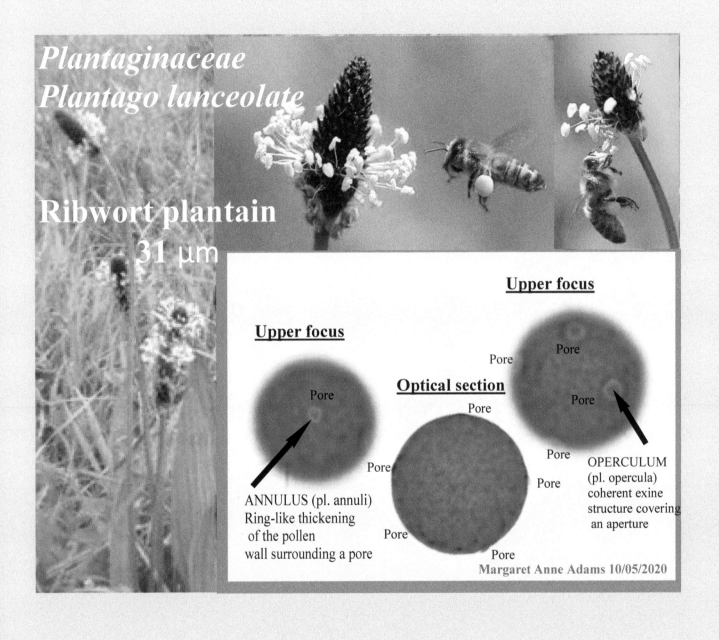

Plantaginaceae
Plantago lanceolate

Ribwort plantain
31 μm

Upper focus

Upper focus

Pore

Optical section

Pore

Pore

Pore

Pore

Pore

Pore

Pore

Pore

Pore

ANNULUS (pl. annuli)
Ring-like thickening
of the pollen
wall surrounding a pore

OPERCULUM
(pl. opercula)
coherent exine
structure covering
an aperture

Margaret Anne Adams 10/05/2020

Rosaceae,
Sorbus aucuparia,
Rowan or Mountain Ash 28 μm

The word Rowan refers to the red fruits *Sorbus* means 'service tree'. Aucuparia refers to the fruits serving as a lure for catching birds. The fruits are a miniature apple so the are called 'pomes' not berries.

They can be used to make a jelly that goes well with lamb or mutton.

Birds and mammals enjoy the pomes, which are full of nutritive ingredients, and as birds cannot digest the seeds, the seeds are distributed in their droppings and grow into new trees.

The small, pale green pollen grains are typical of the Rosaceae family. They are spheroidal with three germination apertures, in the form of furrows, each with a pore. The surface is striate and perforated.

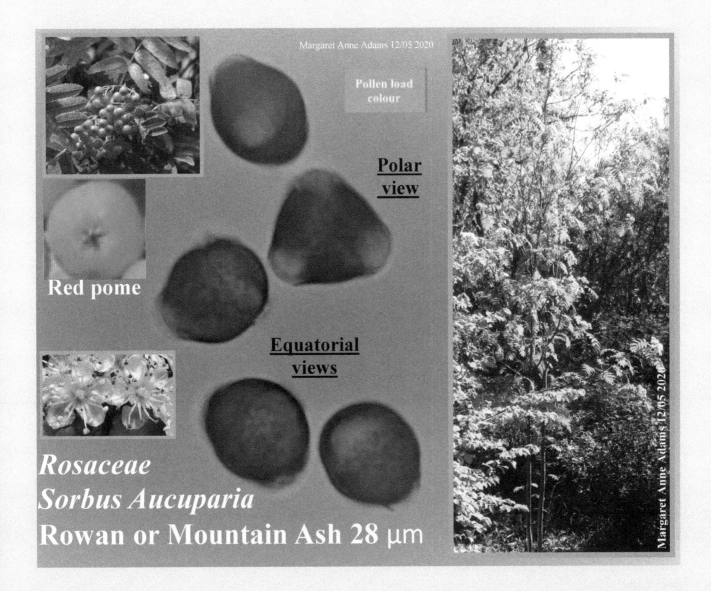

Margaret Anne Adams 12/05 2020

Pollen load colour

Polar view

Red pome

Equatorial views

Rosaceae
Sorbus Aucuparia
Rowan or Mountain Ash 28 µm

Margaret Anne Adams 12/05 2020

Fabaceae,
Cytisus scoparius,
Broom 33 μm

The sight of a forager returning to the hive from Broom is astonishing. As she goes into the broom flower, she triggers a shower of pollen as the stamens flip and make the anthers rub more pollen over the top of her thorax and abdomen. Before returning to the hive she hovers, packing the pollen on her plumose hairs into her pollen baskets; but she cannot reach the top of her thorax and abdomen. Back in the hive she will deposit her pollen loads in cells, round the brood, then house bees will groom from her, the pollen she cannot reach. We know this because foragers do not leave the hive, for their next trip, coated in pollen.

The orange pollen becomes clay coloured, when the forager adds saliva and nectar to stick the pollen grains together, to make sure the pollen loads get back to the hive intact.

The yellow, medium sized spheroidal pollen grains have three ornamented, germination furrows each with a pore. The surface is covered with a fine net and is perforated.

Fabaceae
Cytisus scoparius
Scotch broom 33 μm

Bee foraging in broom flower

stamens spring back and the pollen on the stamens rubs on the foragers back

Anther

Filament

Forager returning from broom

Left leg pollen load

The nectar and saliva on the pollen load being dissolved in a drop of water

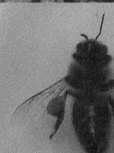

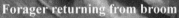

Broom pollen grains 33 μm

Yellow pollen in the watch glass after the pollenkitt has been washed off with isopropanol, before being stained on the glass microscope slide

Margaret Anne Adams 15/05/2020

Sapindaceae,
Aesculus hippocastanum,
Horse chestnut (white) 23 µm

Each spike of flowers only produces five or less conkers because most of the flowers are male. Conkers form on the female and the hermaphrodite flowers at the end of the spike.

Once a bee has pollinated a flower and fertilization has been successful, the stamens curl upwards, and the yellow nectar guides turn apricot then red. Bees see red as black, so they no longer waste time on that flower, which is beneficial to the tree as well.

The stamens of a fresh flower hang down. When a bee enters the flower to collect nectar, pollen falls or brushes onto the bee, any forager that returns the hive with pollen on her wings or back will be groomed by house bees as she deposits her brick red pollen loads in a cell near the brood.

The small, red, spheroidal pollen grains have three furrows each with a pore. The furrow membranes are ornamented with spines and the pores with even bigger spines which look like little crowns as the photos show.

166

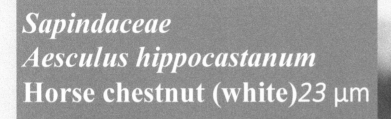

Sapindaceae
Aesculus hippocastanum
Horse chestnut (white) *23* μm

Bee attracted to
flower with yellow
nectar guides

Bees see red as black
and are not attracted
to red nectar guides

Brick red
pollen load

Polar view

Ornamented
furrow
membrane

3 furrows with
ornamented pores

Furrow with
ornamented
pore

As the flower has
been fertilized,
the nectar guides
turn from yellow
to apricot to red

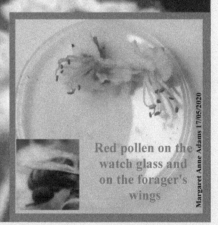

Red pollen on the
watch glass and
on the forager's
wings

Margaret Anne Adams 17/05/2020

Margaret Anne Adams 17/05/2020

Rosaceae,
Crataegus monogyna,
Common hawthorn 46 μm

A variety of insects forage on hawthorn blossoms. However only about twice in a decade does it produce enough nectar for honey bees to make surplus honey. In Scotland, the farmers often leave hawthorns in the hedgerows, to grow into trees and at blossom time they look like royal brides.

The wood gives off a lot of heat when burning and makes good charcoal. As the thorns are sharp it deters animals. 'Hawthorn' means 'hedge of thorns'. Being a very hard wood, it is useful for tool handles. 'Crataegus' means 'strong and sharp'.

As the buds open, the anthers are pink, but by the following day they are brown as the pink 'covers' fall away and decay. The yellow pollen takes on a pale green tinge, when mixed with nectar and saliva on the pollen baskets.

All the flowers are hermaphrodite and the single, central sigma gets covered in pollen as insects delve for nectar. After fertilisation, red pomes are produced which feed birds and animals during the winter. The pome has one seed (monogyna) which is discarded in the droppings and new saplings grow in the spring.

The pale yellow, hydrated, medium size, pollen grains look like plump triangular cushions under the microscope. There are three germination furrows, each with a pore. The surface is striate with perforations.

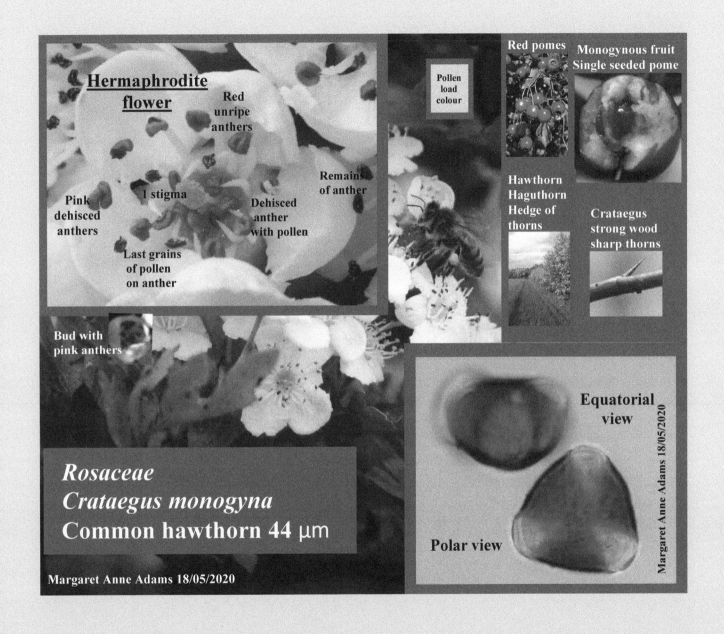

Hermaphrodite flower

Red unripe anthers

Pink dehisced anthers

1 stigma

Remains of anther

Dehisced anther with pollen

Last grains of pollen on anther

Pollen load colour

Red pomes

Monogynous fruit Single seeded pome

Hawthorn Haguthorn Hedge of thorns

Crataegus strong wood sharp thorns

Bud with pink anthers

Rosaceae
Crataegus monogyna
Common hawthorn 44 μm

Equatorial view

Polar view

Margaret Anne Adams 18/05/2020

Margaret Anne Adams 18/05/2020

Sapindaceae,
Acer pseudoplatanus,
Sycamore Scotch maple 36 μm

Sycamores can become huge. The Newbattle Abbey Sycamore was planted in 1550; it grew to a height of 26 metres and the trunk had a diameter of over 1.5 metres when the tree was blown down in a gale four years ago this month. Sycamores produce abundant nectar and pollen and they also have extra floral nectaries, so early in the morning, before the sun dries it up, bees can collect honeydew then concentrate on the flower nectar later on. Two large trees can produce as much nectar and pollen as an acre of clover. As the flowers hang down and are protected by the leaves, rain does not dilute the nectar and bees continue to forage, unlike hawthorn flowers which are open upwards.

The medium size, yellow, spheroidal pollen grains have three smooth germination furrows and the surface is striate and perforated.

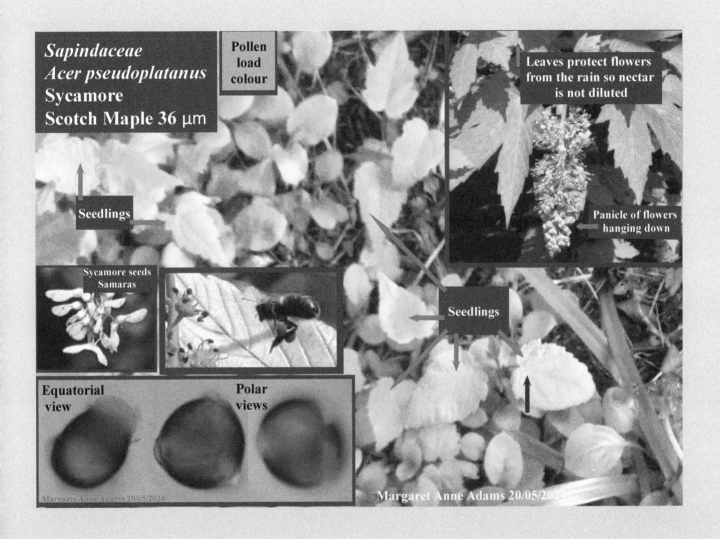

Sapindaceae
Acer pseudoplatanus
Sycamore
Scotch Maple 36 µm

Pollen load colour

Seedlings

Sycamore seeds Samaras

Leaves protect flowers from the rain so nectar is not diluted

Panicle of flowers hanging down

Seedlings

Equatorial view

Polar views

Margaret Anne Adams 20/05/2020

Margaret Anne Adams 20/05/2020

Oleaceae, Jasminum, Jasmine 56 μm

The smell of fresh Jasmine flowers is strongest in the evening, because as the temperature drops so the flowers open and stay open. The flowers are hermaphrodite, but the stamens and pistils develop at different times in the same flower, so they rely on bees and butterflies for cross pollination.

Jasmonates are plant hormones that control many chemical processes in all plants. They are so named because this oxylipin was first isolated from Jasmine oil.

Like many pollens of tiny flowers already mentioned, Jasmine pollen grains are large and showy. The grains are bright yellow and covered with a coarse net There are three smooth germination furrows.

Oleaceae
Jasminum
Jasmine 56 μm

Polar views

Equatorial views

Optical section

Upper focus

Upper focus

Optical section

Optical section

Upper focus

Margaret Anne Adams 23/05/2020

Jasmine photo Christopher Adams 08/05/2020

Rosaceae,
Cotoneaster horizontalis,
Cotoneaster 41 μm

Cotoneaster is a larder and shelter for many creatures all year round. In May, before the bees are flying a red squirrel and a rabbit climbed on it and munched the flowers. On fine days the bush hums with many insects and honey bees throng there all their working hours, foraging for pollen, nectar and dewdrops. Successful fertilisation of the flowers produces masses of berries for mammals and birds to feast on throughout the winter.

The spheroidal, medium sized, greeny-yellow pollen grains have with three germination furrows.

Rosaceae
Cotoneaster horizontalis
Cotoneaster 41 µm

Bee with pollen loads

Margaret Anne Adams 25/05/2020

In the morning before 8 o'clock a rabbit and a red squirrel munch the flowers

Margaret Anne Adams 25/05/2020

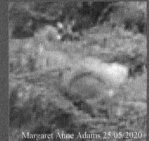

Margaret Anne Adams 25/05/2020

Cotoneaster horizontalis pollen grains

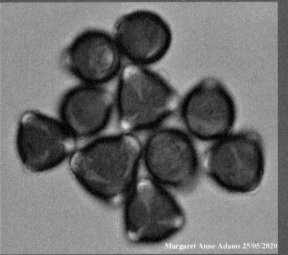

Margaret Anne Adams 25/05/2020

Later in the morning, bees forage for pollen and nectar

Margaret Anne Adams 25/05/2020

Pollen load colour

Margaret Anne Adams 25/05/2020

Rosaceae,
Rubus adaeus,
Raspberry 26 μm

Raspberry pollen grains are small, so the proventriculus does not filter them out of the honey crop of the forager. The nectar deposited in the combs contains between 48,000 and 96,000 pollen grains/10 grams and these grains act as an initiator of very small crystals. The honey sets and becomes whitish, soft and creamy. Raspberry nectar has a high fructose/glucose ratio, so granulation is not triggered by a preponderance of glucose in this case.

Pollination in the open by Honey bees, mason bees or bumblebees is equally successful. Under glass or in polythene tunnels, Honey bees become disorientated due to the glass and plastic film absorbing polarized UV wavelengths. Honey bees use polarized UV light for navigation. Bumble bees (Bombusspp.) and mason bees (Osmiaspp.) are the most useful, manageable alternative to Honey bees.

A raspberry consists of up to 100 druplets/drupelets, each one is a tiny pome.

Like all members of the Rosaceae family, the pollen grains are spheroid with three germinating furrows.

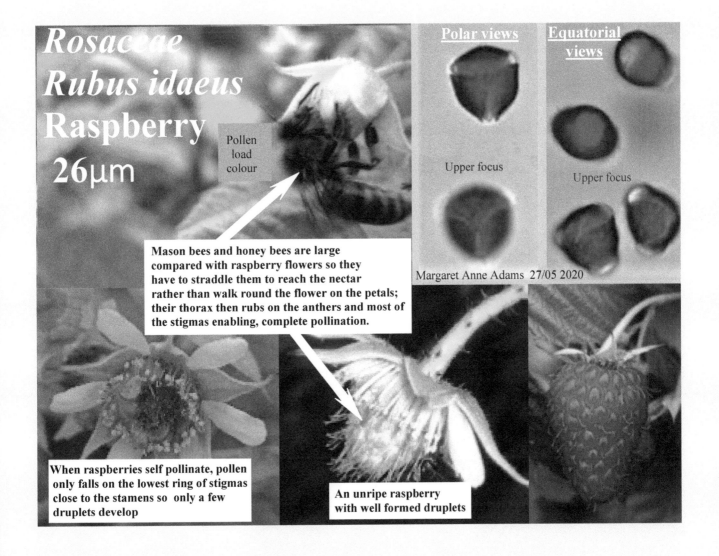

Rosaceae
Rubus idaeus
Raspberry
26μm

Pollen
load
colour

Polar views

Equatorial views

Upper focus

Upper focus

Mason bees and honey bees are large
compared with raspberry flowers so they
have to straddle them to reach the nectar
rather than walk round the flower on the petals;
their thorax then rubs on the anthers and most of
the stigmas enabling, complete pollination.

Margaret Anne Adams 27/05 2020

When raspberries self pollinate, pollen
only falls on the lowest ring of stigmas
close to the stamens so only a few
druplets develop

An unripe raspberry
with well formed druplets

Ericaceae,
Rhododendron ponticum,
Common rhododendron 59 μm

Pollen grains are produced within the anther of the flower. Pollen mother cells divide meiotically to form four conjoined pollen grains called a tetrad. All pollen grains are in the tetrad stage during development. Usually the grains forming the tetrad, separate at maturity into 4 single pollen grains called monads.

This does not happen with rhododendron anthers; they shed their pollen in permanent tetrads. There are 6 possible spacial arrangements of 4 pollen grains. Rhododendron pollen grains are arranged in a tetrahedral tetrad. However on my slide there were also two decussate tetrads, where the grains were paired and the two pairs were at right angle to each other. One of them is at the bottom of the photo.

The toxicity of rhododendron pollen was discussed in the British Medical Journal (ref BMJ1999;319:1419) as follows:

"Rhododendron honey is said to be toxic only if very recentlyproduced by the bees, so commercially produced honey is unlikely toproduce any effects. In addition, honey produced in the spring during the rhododendron flowering season is mostly consumed by the bees and is rarely harvested."

"A Scottish case has been reported where a man licked rhododendronnectar from his hands and rapidly experienced paraesthesiae, loss ofcoordination and an inability to stand, symptoms which resolved completely a few hours later"

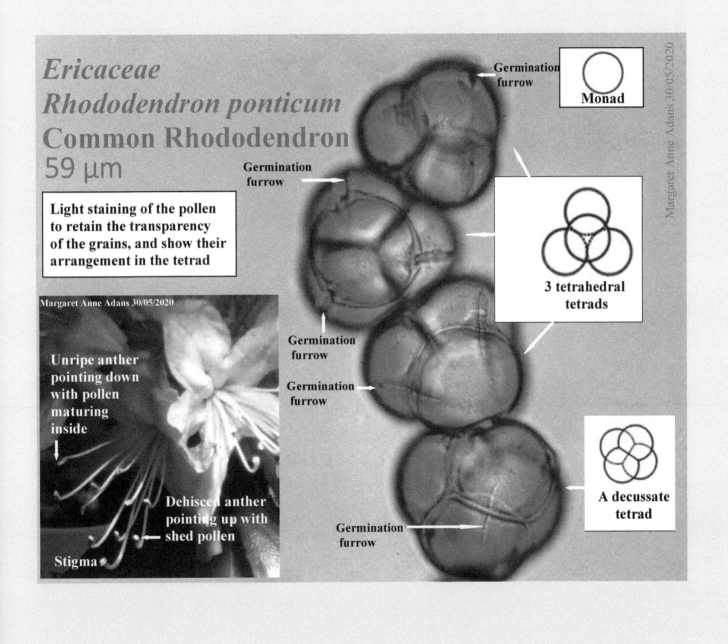

Ericaceae
Rhododendron ponticum
Common Rhododendron
59 μm

Light staining of the pollen to retain the transparency of the grains, and show their arrangement in the tetrad

Germination furrow

Germination furrow

Germination furrow

Germination furrow

Germination furrow

Monad

3 tetrahedral tetrads

A decussate tetrad

Margaret Anne Adans 30/05/2020

Unripe anther pointing down with pollen maturing inside

Dehisced anther pointing up with shed pollen

Stigma

Margaret Anne Adans 30/05/2020

Fabaceae,
Trifolium repens,
White clover 23 μm

The individual flowers on a white clover inflorescence are like those of other plants in the Fabaceae family such as broom and beans

When Honey bees work a fresh white clover inflorescence, they first work the outermost ring of flowers that have nectar and dehisced anthers. In response the flowers that have been pollinated and successfully fertilized droop and fade. The bees then start working on the next, and now outside ring. This continues until all the flowers on the inflorescence have gone brown. This behaviour and response benefits both the plant and the foragers as they save time as they are drawn to the upright freshly open flowers.

Clover honey is pale and sets rapidly with a fine crystal.

The small, brown, spheroidal pollen grains have three germination furrows with pores.

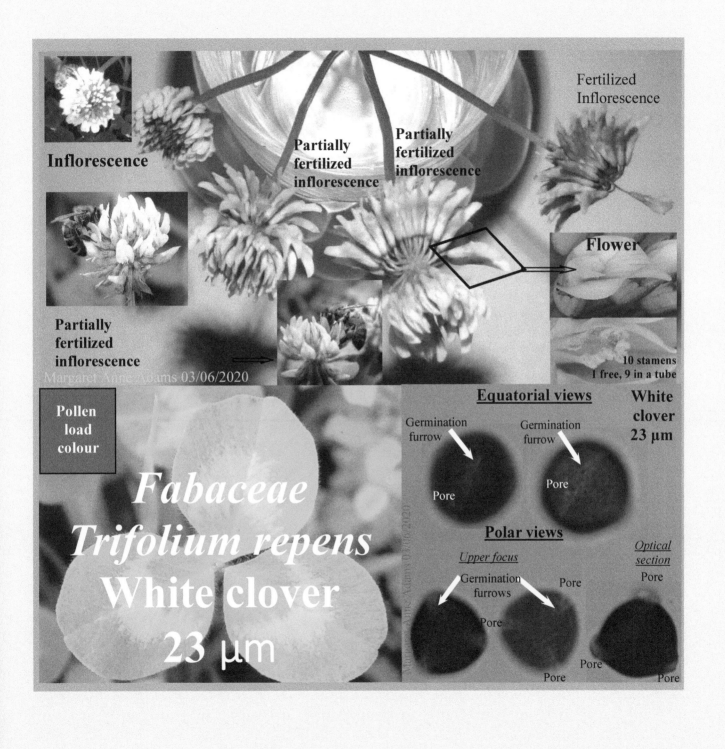

Inflorescence

Partially fertilized inflorescence

Partially fertilized inflorescence

Fertilized Inflorescence

Partially fertilized inflorescence

Margaret Anne Adams 03/06/2020

Flower

10 stamens
1 free, 9 in a tube

Pollen load colour

Fabaceae Trifolium repens White clover 23 μm

Equatorial views

Germination furrow

Germination furrow

Pore

Pore

White clover 23 μm

Polar views

Upper focus

Germination furrows

Pore

Pore

Optical section
Pore

Pore

Pore

Pore

Boraginaceae,
Myosotis,
Forget-me-not 7 μm

When the honeybee forager inserts her proboscis into the corolla tube, it is a tight squeeze as the photo shows. In doing so she disturbs the stamens and dislodges masses of the tiny pollen grains, which get mixed in with the nectar. On her return to the hive, these pollen grains remain in the nectar in her crop as they are too small to be filtered out by the proventriculus.

If forget-me-not pollen is found in a sample of honey, the number of grains will over-represent the amount of forget-me-not honey in the sample. The pollen of every flower type has a 'pollen coefficient' which is used to adjust for over and under representation in the calculation of the proportion of honey from each source.

The forget-me-not pollen in the slide had a few grains of other nearby wildflowers. In the picture there is a red campion grain highlighting that forget-me-not pollen grains are the smallest of all known grains. The smooth, yellow, dumbbell-shaped grains have between 4 and 12 furrows with pores.

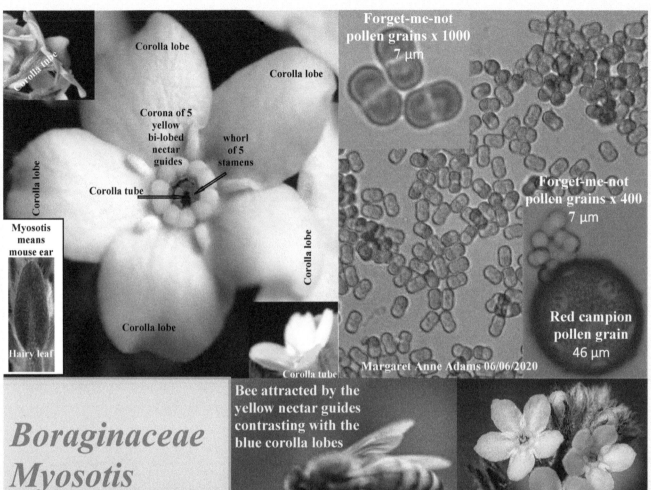

Corolla lobe

Corolla lobe

Corolla tube

Corona of 5 yellow bi-lobed nectar guides

whorl of 5 stamens

Corolla tube

Corolla lobe

Corolla lobe

Corolla lobe

Myosotis means mouse ear

Hairy leaf

Corolla lobe

Corolla tube

Forget-me-not pollen grains x 1000
7 μm

Forget-me-not pollen grains x 400
7 μm

Red campion pollen grain
46 μm

Margaret Anne Adams 06/06/2020

Boraginaceae Myosotis Forget-me-not 7 μm

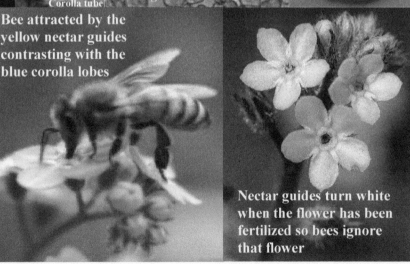

Bee attracted by the yellow nectar guides contrasting with the blue corolla lobes

Nectar guides turn white when the flower has been fertilized so bees ignore that flower

Rosaceae,
Rubus fruticosus,
Bramble 28 μm

Brambles are an important pollen and nectar source for bees as it flowers from June till September. Bramble honey is golden, relatively thick, yet transparent, with a delicate flavour. It is high in fructose so it is slow to granulate but when it does the crystals are coarse. If some bramble nectar is collected with ling heather nectar, the bramble crystals in the heather honey are star shaped.

Brambles can take over land very fast as the canes grow about 8 feet in the spring, the tips then root down and more canes spring up and leapfrog across the land and plants. Yet if controlled, brambles are a valuable windbreak, refuge for wildlife, a strong barricade, a source of fruit and as a bonus, the bark of the canes can be used to weave baskets and bind skeps.

The small, grey, spheroidal pollen grains have three sunken furrows, each with a pore. The surface is smooth.

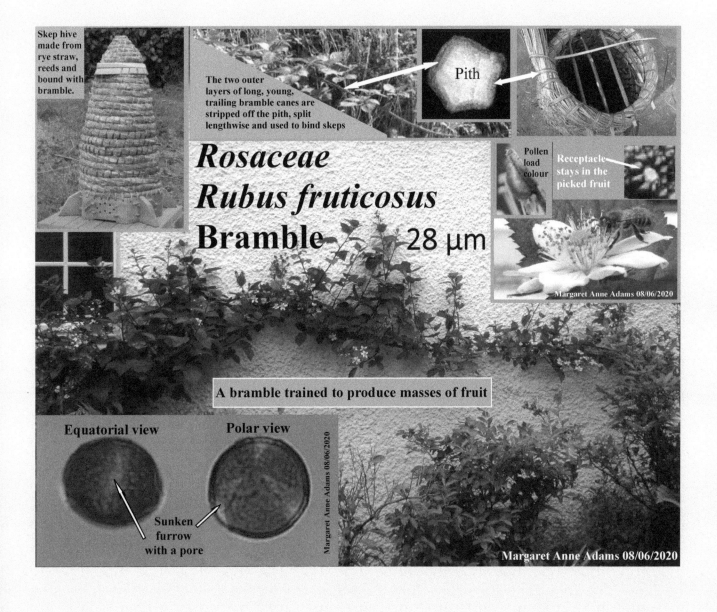

Skep hive made from rye straw, reeds and bound with bramble.

The two outer layers of long, young, trailing bramble canes are stripped off the pith, split lengthwise and used to bind skeps

Pith

Rosaceae
Rubus fruticosus
Bramble 28 μm

Pollen load colour

Receptacle stays in the picked fruit

Margaret Anne Adams 08/06/2020

A bramble trained to produce masses of fruit

Equatorial view

Polar view

Margaret Anne Adams 08/06/2020

Sunken furrow with a pore

Margaret Anne Adams 08/06/2020

Rosaceae,
Rosa canina,
Dog rose 31 µm

Dog rose plants can grow up to 5m by scrambling up tall trees and along hedges. They grip, as they climb, using their prickles, which are shaped like the canine teeth of dogs. In June and July the plant produces lots of simple flowers abounding with pollen which are ideal for bees. In the autumn they are covered with rosehips, providing food for birds and mammals.

During the WW2 children were given rosehip syrup as rosehips are rich in vitamin C. Unfortunately the authorities did not realise that by boiling the hips to make the syrup, the vitamin C was destroyed. I was lucky for a while, as the village School teacher at Balloch, near Culloden Moor, knew that turnips also contained vitamin C and other healthy ingredients, so she gave us a cube of raw turnip everyday at Interval/break time.

The medium size, yellow, spheroidal pollen grains have three furrows with pores.

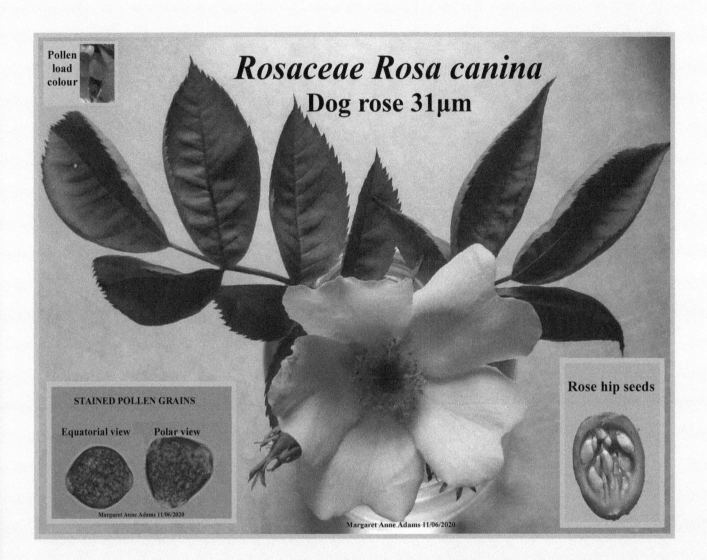

Pollen load colour

Rosaceae Rosa canina
Dog rose 31μm

STAINED POLLEN GRAINS

Equatorial view Polar view

Margaret Anne Adams 11/06/2020

Rose hip seeds

Margaret Anne Adams 11/06/2020

Polemoniaceae, Polemonium caeruleum, Jacob's ladder 44 µm

Jacob's ladder plants are shunned by rabbits, which can be useful in a country garden, but for Honey bees the flowers are a good source of pollen and nectar, so there may be some beautiful pollen grains in the next lot of honey.

The pinnate leaves are ladder-like giving *Polemonium caeruleum* its common name. In a dream, Jacob saw a ladder leading up to heaven, with angels climbing up and down it. (He was using a stone for a pillow at the time.)

The orange, medium sized pollen grains are spherical. They have at least six regularly arranged pores. The surface is striato-reticulate and microechinate.

Polemoniaceae
Polemonium caeruleum
Jacobs ladder 44 µm

Polar view

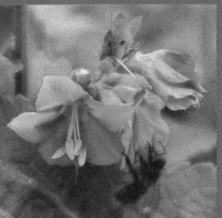

Karuna Shivani Rocco Rinck 28/6/2021

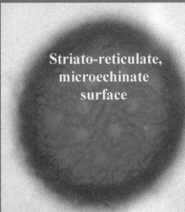

Striato-reticulate, microechinate surface

Polar section view

POLLEN LOAD COLOUR

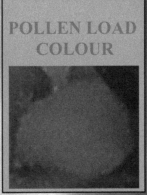

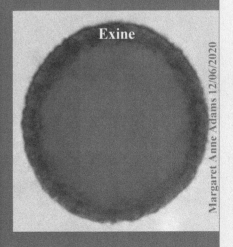

Exine

Geraniaceae,
Geranium maculata,
Wild cranesbill 77 μm

At first glace the plant looks to be monoecious, as there seems to be male and female flowers on the same plant, but when the two flowers are dissected they turn out to be hermaphrodite. The reason for the misconception is that the male reproductive parts develop first, and it is not till they have finished producing pollen that the female parts fully develop. This phenomenon is called 'protandry', and it is to prevent the flower from self fertilising.

The name 'cranesbill' comes from the beak-shaped seed capsule, that forms in the flower, after fertilization.

The photos show that the fresh anthers are purple, but when they dehisce the pale, yellow pollen is visible. The large grains are spheroidal and they have three sunken brevicolpi, as explained on the middle pollen photo.

Geraniaceae
Geranium maculata
Wild cranesbill 77 μm

POLAR VIEW
The pale dots, in the centre of the image are the tops of 'clavae', club shaped elements on the surface of the grains

POLAR VIEW at a slightly lower focus, highlighting the reticulate surface or net. the clavae are projections on the net. A short sunken aperture is visible right of centre; it is a short furrow with a pore called a 'brevicolpus'. There are three brevicolpi on the grain.

OPTICAL SECTION.
The the outer rings are the intine and the exine

Margaret Anne Adams 15/06/2020

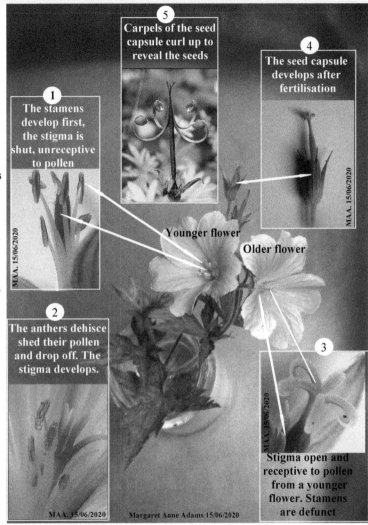

5 Carpels of the seed capsule curl up to reveal the seeds

1 The stamens develop first, the stigma is shut, unreceptive to pollen

4 The seed capsule develops after fertilisation

M.A.A. 15/06/2020

M.A.A. 15/06/2020

Younger flower

Older flower

2 The anthers dehisce shed their pollen and drop off. The stigma develops.

3

M.A.A. 15/06/2020

M.A.A. 15/06/2020

Stigma open and receptive to pollen from a younger flower. Stamens are defunct

Margaret Anne Adams 15/06/2020

Escalloniaceae,
Escallonia rubra marcantha,
Red escalonia 20 μm

Escallonia rubra marcantha is an ideal bee plant for the Western side of Scotland as it tolerates salty winds and frosts down to -5°C. And makes a good hedge.

Madroño or Corontillo honey is from *Escallonia pulverulenta*, an endemic plant species and correspondingly unique honey that is only found in central Chile. There are 23 honeys from around the world currently included in the Ark of Taste, and Chile hopes this will soon be on the catalogue. Corontillo honey tastes of caramel and vanilla.

The small, pale yellow pollen grains of *Escallonia rubra marcantha* are spheroid with three furrows each with a pore. The pore openings are ornamented with 'beading'

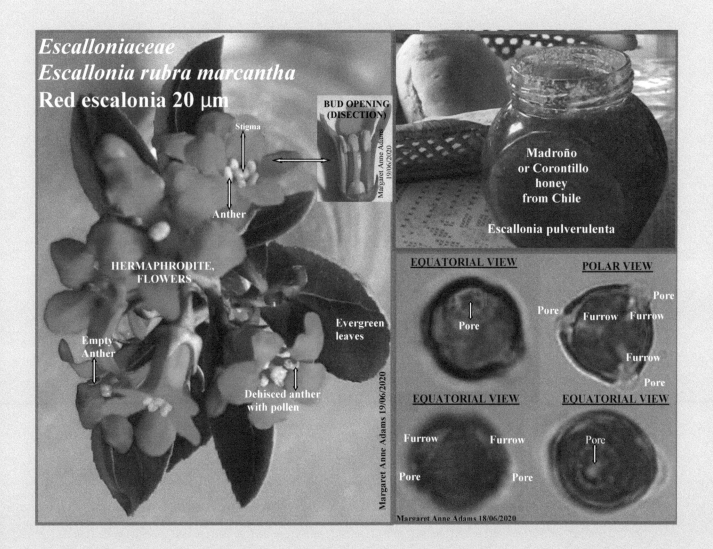

Escalloniaceae
Escallonia rubra marcantha
Red escalonia 20 μm

BUD OPENING
(DISECTION)

Margaret Anne Adams
19/06/2020

Stigma

Anther

Madroño
or Corontillo
honey
from Chile

Escallonia pulverulenta

HERMAPHRODITE,
FLOWERS

Evergreen
leaves

Empty
Anther

Dehisced anther
with pollen

Margaret Anne Adams 19/06/2020

EQUATORIAL VIEW

POLAR VIEW

Pore

Pore

Pore

Furrow

Furrow

Furrow

Pore

EQUATORIAL VIEW

EQUATORIAL VIEW

Furrow

Furrow

Pore

Pore

Pore

Margaret Anne Adams 18/06/2020

Asteraceae, Leucanthemum vulgare, Oxeye daisy 23 μm

The Oxeye daisy has high yields of pollen and nectar so it should be valued by beekeepers as a garden, hedgerow and roadside verge plant. It is invasive, and as cows and pigs don't eat it, it can reduce the amount of pasture available to these farm animals. However, a local Scottish farmer says it is an antidote to mastitis in cows

The stigma does not open till it has pushed through the ring of stamens, avoiding self pollination.

The small, spikey, yellow, spheroidal pollen grains have three sunken furrows with pores

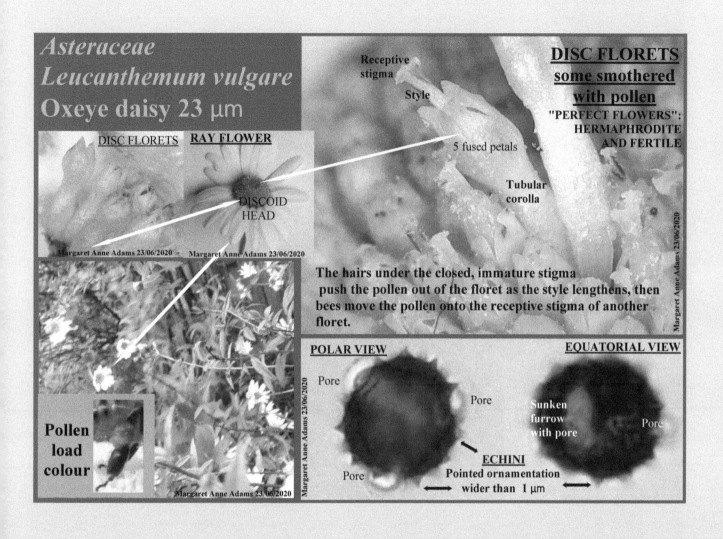

Asteraceae
Leucanthemum vulgare
Oxeye daisy 23 μm

DISC FLORETS

RAY FLOWER

DISCOID HEAD

Margaret Anne Adams 23/06/2020

Margaret Anne Adams 23/06/2020

Pollen load colour

Margaret Anne Adams 23/06/2020

Receptive stigma

Style

5 fused petals

Tubular corolla

DISC FLORETS
some smothered
with pollen
"PERFECT FLOWERS":
HERMAPHRODITE
AND FERTILE

Margaret Anne Adams 23/06/2020

The hairs under the closed, immature stigma push the pollen out of the floret as the style lengthens, then bees move the pollen onto the receptive stigma of another floret.

POLAR VIEW

EQUATORIAL VIEW

Pore

Pore

Pore

Sunken furrow with pore

Pore

ECHINI
Pointed ornamentation wider than 1 μm

Margaret Anne Adams 23/06/2020

Onagraceae,
Epilobium angustifolium,
Rosebay willowherb 102 μm

Rosebay willowherb honey is 'first-prize winning', pale and very clear. The clarity is due to the scarcity of pollen caused by the filtering action of the proventricular valve, between the bee's crop and ventriculus; this action removes the very large pollen grains from the nectar as the forager returns to the hive. The honey's Pollen coefficient is only 0.3 compared with 5000 for Forget-me-not.

Rosebay willowherb often takes over areas charred by forest fires or devastated by war.

The very large, pale green, pollen grains have three pores, viscin threads and a perforated, beaded surface –the beads or gemmae, are over 1μm in diameter. The grains are triangular when dry and spheroidal when hydrated.

As with Fuchsia pollen grains, the viscin threads fasten the grains together like ropes, and the grains become entangled with the bee's plumose hairs and scopae. This feature of the exine assists insect pollination in the absence of pollenkitt.

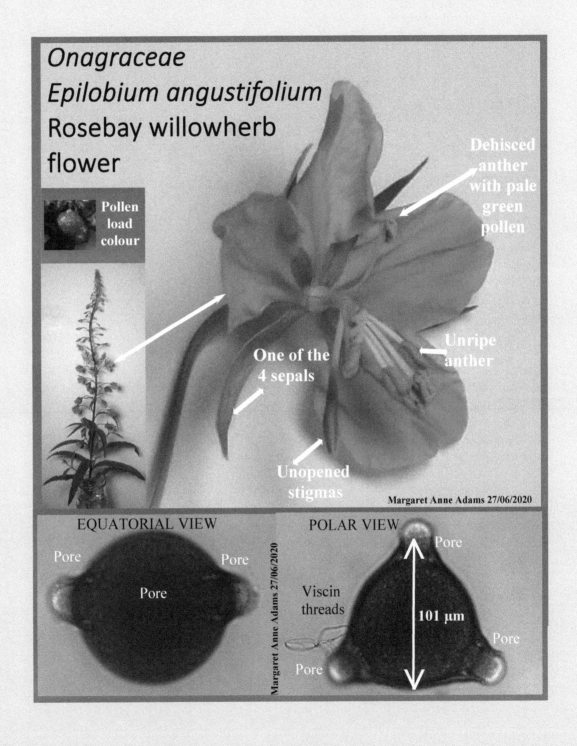

Onagraceae
Epilobium angustifolium
Rosebay willowherb
flower

Pollen load colour

Dehisced anther with pale green pollen

Unripe anther

One of the 4 sepals

Unopened stigmas

Margaret Anne Adams 27/06/2020

EQUATORIAL VIEW

Pore
Pore
Pore

Margaret Anne Adams 27/06/2020

POLAR VIEW

Pore

Viscin threads

101 μm

Pore

Pore

Malvaceae,
Tilia,
Lime or Linden 28 – 33 μm

Two mature lime trees, each about 20 metres high and 12 metres wide, can yield as much nectar as an acre of nectar yielding clover, to produce about 200 pounds of honey.

Lime trees are also host to aphids, so the honey can contain sticky honeydew and adhering unappetising airborne particles and insect parts. Early on warm, summer mornings, honey bees collect the moist honeydew and work the lime flowers later, when the sun has dried the honeydew. Having made a microscope slide, of a sample of the pollen and honeydew particles from a jar of Lime honey, from a big city, it will be the subject of the next page.

The small, yellow oblate pollen grains have a regular netted surface. The germination apertures are three short furrows or colpi.

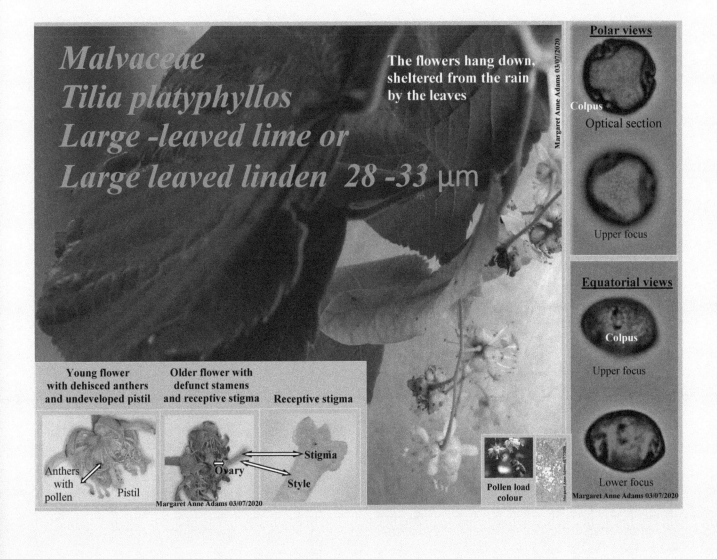

Malvaceae
Tilia platyphyllos
Large -leaved lime or
Large leaved linden 28 -33 μm

The flowers hang down, sheltered from the rain by the leaves

Polar views

Colpus

Optical section

Upper focus

Equatorial views

Colpus

Upper focus

Lower focus

Young flower with dehisced anthers and undeveloped pistil

Older flower with defunct stamens and receptive stigma

Receptive stigma

Anthers with pollen

Pistil

Ovary

Stigma

Style

Pollen load colour

Margaret Anne Adams 03/07/2020

Honeydew and Lime Honey

The picture shows some of the solids spun from a sample of honey from a very big UK city. Besides flower pollens the sample includes pollen from wind pollenated plants, fungal spores, algae, soot and crystals of the trisaccharide melezitose. It does not spoil the taste or appearance of the honey as these particles are microscopic.

Aphids suck the phloem sap from plants, but to gain sufficient nutrients, they imbibe vast quantities and excrete the surplus as honeydew which bees and ants collect. They also suck xylem sap when they need more minerals and moisture.

However, it is important to remove and extract honeys containing honeydew honey, at the latest, in the autumn. Melezitose is indigestible to bees and accumulates in the gut and rectum. If this happens during the winter, and the weather prevents the bees from taking cleansing flights, they will have to defecate in the hive and this will cause problems. The Swiss and the Germans prize honeydew honey from forests, and beekeepers have learnt manage these difficulties.

Balsaminaceae,
Impatiens glandulifera,
Himalayan Balsam 28μm

Himalayan Balsam is nutritious for cattle and provides pollen and nectar from July until the first frosts. The light amber coloured honey has a fairly thick consistency and is very slow to granulate.

It is interesting to watch honey bees in the flowers; they go in, turn round at the bottom and come out head first, covered in white pollen. Chubby bumble bees cannot turn round at the bottom of the flowers, so they back out instead.

After the pollen is mixed with saliva and nectar the pollen loads are no longer white. At the hive entrance, it is easy to tell which of the Himalayan foragers are specialist pollen gatherers and which are the nectar gatherers, The pollen gatherers have white backs and loaded corbiculae; The nectar gatherers are dusted with white pollen.

The small white, oblate pollen grains look like plump oblong cushions. There are germination apertures at the corners; these four short colpi have ornamented edges. The surface of the grains is covered with a regular net with beading in the polygonal spaces.

202

Balsaminaceae
Impatiens glandulifera
Himalayan balsam 28 μm

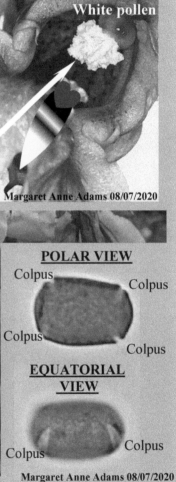

As the forager enters and exits the flower, the anther deposits white pollen on her thorax. A flower that does this is nototribic

White pollen

Margaret Anne Adams 08/07/2020

Before returning to the hive, the forager brushes the pollen from her body, mixes it with saliva and nectar to fix it in the corbiculae, but she cannot reach her own back, so the house bees clean her before she sets out again.

Pollen load colour

Margaret Anne Adams 29.9.2017

Margaret Anne Adams 29.9.2017

POLAR VIEW

Colpus

Colpus

Colpus

Colpus

EQUATORIAL VIEW

Colpus

Colpus

Margaret Anne Adams 08/07/2020

Asteraceae,
Centaurea nigra,
Black knapweed 38 μm

Centaura nigra is one of the best flowers for producing nectar and pollen rewards. This was discovered in research done to produce the best seed mixes, for planting wildflower meadows in the UK. It flowers from June till September

The knapweed flowerhead is composed of tiny florets. Each floret functions as an hermaphrodite flower. Together the florets are capable of attracting pollinators over a long period, as the outer florets develop first and those at the centre last.

The white, medium size, spheroidal pollen grains have three germination apertures in the form of furrows, each with a pore. The surface is covered in wart-like granules.

Asteraceae
Centaurea nigra
Black knapweed
38 μm

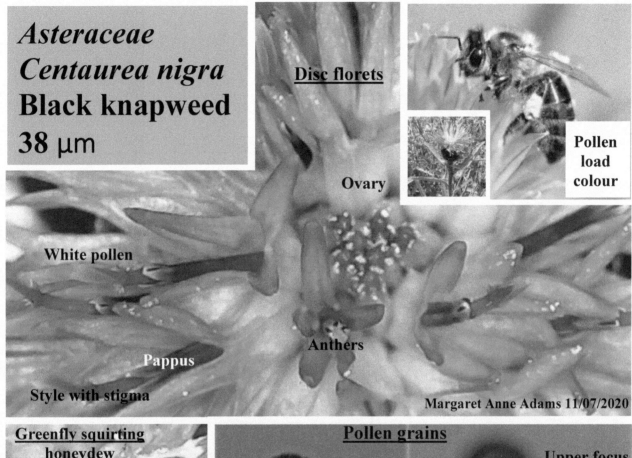

Disc florets

Ovary

White pollen

Pappus

Anthers

Style with stigma

Pollen load colour

Margaret Anne Adams 11/07/2020

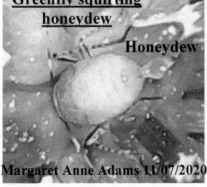

Greenfly squirting honeydew

Honeydew

Margaret Anne Adams 11/07/2020

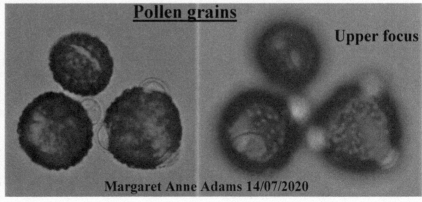

Pollen grains

Upper focus

Margaret Anne Adams 14/07/2020

Asteraceae, Jacobaea vulgaris, Ragwort 28 µm

"Ragwort honey" is very rare, which is fortunate as it is "dark, waxy, unpalatable and unsuitable for retailing or blending with other honeys". However, if a few bees forage on ragwort, and there is a little ragwort nectar and pollen in a batch of honey, it will be safe to eat and after keeping it for a few months, it will not taste unpleasant.

Due to concern about the safety of eating Ragwort Honey, here is the 2016 statement, from the Food Standards Agency following Research Project code FS102056, conducted by Fera:

"Concern over Pyrrolizidine alkaloids (PAs) form a large group of natural toxicants. PA consumption from locally produced honeys is not a cause for concern, even when hives are situated near to ragwort plants."

Asteraceae
Jacobaea vulgaris
Common ragwort 28 μm

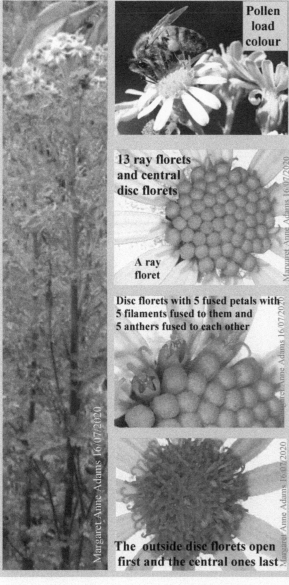

Pollen load colour

13 ray florets and central disc florets

A ray floret

Disc florets with 5 fused petals with 5 filaments fused to them and 5 anthers fused to each other

The outside disc florets open first and the central ones last

Margaret Anne Adams 16/07/2020

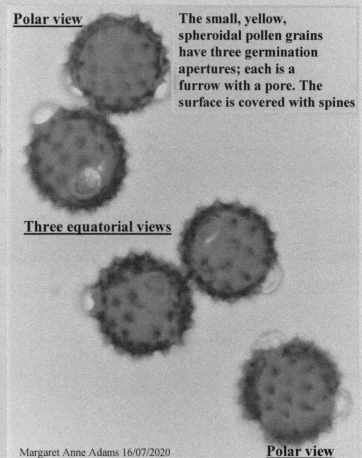

Polar view

The small, yellow, spheroidal pollen grains have three germination apertures; each is a furrow with a pore. The surface is covered with spines

Three equatorial views

Margaret Anne Adams 16/07/2020

Polar view

Hypericaceae,
Hypericum perforatum,
St John's wort, 18 μm

These plants self seeds easily, but sowing seeds or potting up cuttings, then planted on in April, will produce a fast-growing hedge covered in beautiful yellow flowers and fruits that change from green to yellow to red then to black. Once the plant is established, Bees will collect loads of pollen from May till August. But the plant is poisonous to sheep, cows and horses, and it is not advisable to use it as a medication for depression or for healing wounds these days!

The stamens fall off each flower, in three tufts.

The very small, yellow, spheroidal pollen grains have three germination apertures, in the form of long, sunken furrows, each with a pore. The surface of the grain is finely netted, with perforations in the hollows.

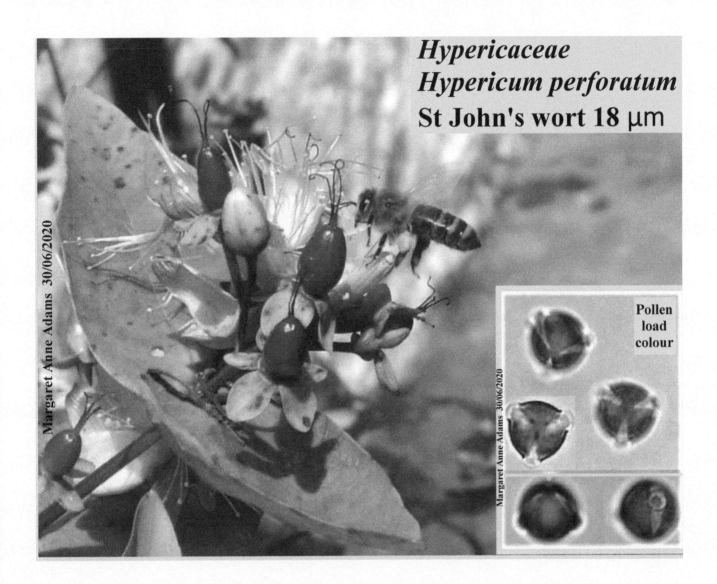

Hypericaceae
Hypericum perforatum
St John's wort 18 μm

Margaret Anne Adams 30/06/2020

Margaret Anne Adams 30/06/2020

Pollen load colour

Asteraceae,
Achillea millefolium,
Common Yarrow 26 μm

In perennial meadows, Yarrow is a drought resistant plant, and a rich source of pollen and nectar for bees at the end of July and during August It has deep roots that bring up minerals; especially potassium, phosphorus and copper which accumulate in the leaves, enriching poor soil and the compost heap.

The small, spheroidal, orangy-yellow pollen grains have three germination apertures in the form of furrows, each with a pore. The surface of the grain is covered with thorn like projections.

Asteraceae
Achillea millefolium
Common Yarrow 26 μm

Pollen load colour

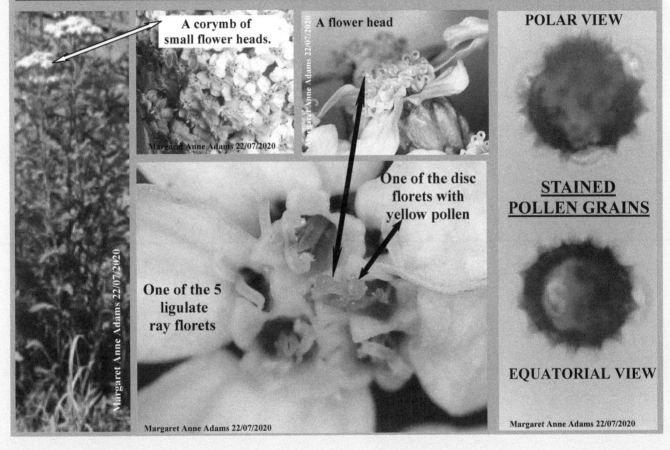

A corymb of small flower heads.

A flower head

One of the disc florets with yellow pollen

One of the 5 ligulate ray florets

POLAR VIEW

STAINED POLLEN GRAINS

EQUATORIAL VIEW

Margaret Anne Adams 22/07/2020

Lamiaceae,
Lamium purpureum,
Red dead-nettle 31 μm

Bees benefit, between February and November, from Red dead-nettle pollen. They can only get at the nectar from a hole on the outside, if a short-tongued bumblebee has already bitten through the base of the long flower tube.

The foragers return to the hive with their wings and the top of the thorax still covered with brick red pollen as they are unable to reach those parts, to groom the grains into their pollen baskets.

The brick red, medium size, spheroidal pollen grains have three germination apertures, in the form of furrows. The grains are covered in a very fine net.

Lamiaceae, Lamium purpureum, Red dead-nettle 31 µm

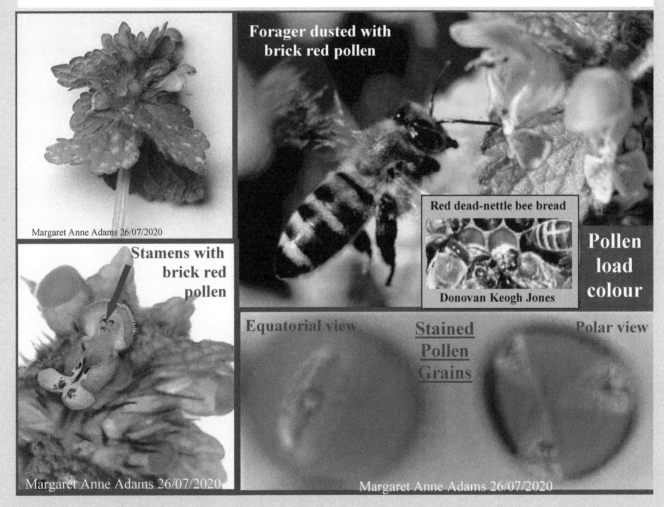

Margaret Anne Adams 26/07/2020

Forager dusted with brick red pollen

Stamens with brick red pollen

Margaret Anne Adams 26/07/2020

Red dead-nettle bee bread

Donovan Keogh Jones

Pollen load colour

Equatorial view **Stained Pollen Grains** Polar view

Margaret Anne Adams 26/07/2020

Asteraceae,
Onopordum Acanthium,
Scottish thistle 51 μm

"Thistle"- O Flower of Scotland

O flower of Scotland
When will we see your like again
That fought and died for
Your wee bit hill and glen
And stood against him
Proud Edward's army
And sent him homeward
Tae think again

The hills are bare now
And autumn leaves lie thick and still
O'er land that is lost now
Which those so dearly held
And stood against him
Proud Edward's army
And sent him homeward
Tae think again

Those days are passed now
And in the past, they must remain
But we can still rise now
And be the nation again
That stood against him
Proud Edward's army
And sent him homeward
Tae think again

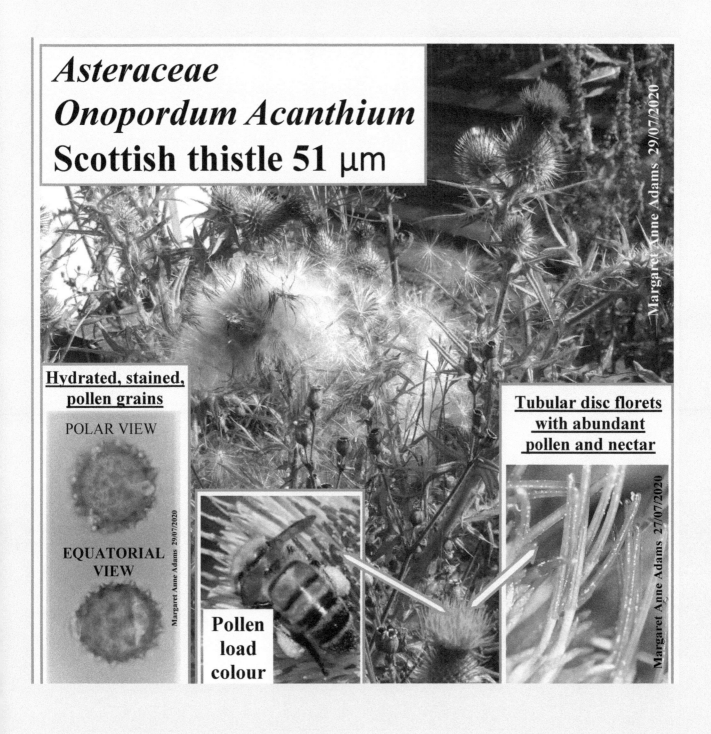

Asteraceae Onopordum Acanthium Scottish thistle 51 μm

Margaret Anne Adams 29/07/2020

Hydrated, stained, pollen grains

POLAR VIEW

EQUATORIAL VIEW

Margaret Anne Adams 29/07/2020

Pollen load colour

Tubular disc florets with abundant pollen and nectar

Margaret Anne Adams 27/07/2020

Oleaceae,
Ligustrum vulgare,
Common privet 31 μm

If Privet is allowed to grow into a tree, it gives the bees a very rich source of nectar and pollen, at the end of July for over a month – which can be period of scarcity. The bees will be found foraging on it, late into the evening and again first thing in the morning, even in wind and drizzle. The scent of the flowers is strong but pleasant and the taste of the honey being stored is not tainted by it.

The medium size, spheroidal, yellow pollen grains have three germination apertures in the form of furrows with pores, and the grain's surface is covered with a coarse net.

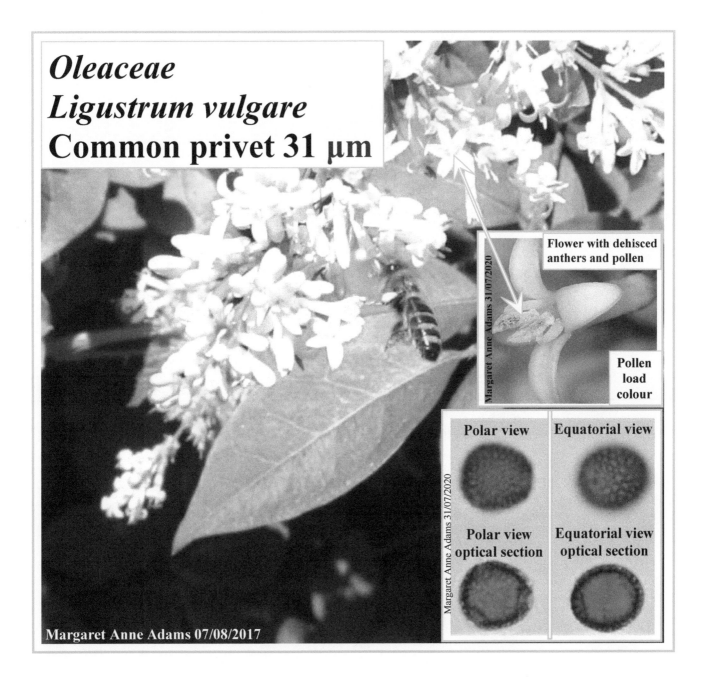

Oleaceae
Ligustrum vulgare
Common privet 31 µm

Margaret Anne Adams 31/07/2020

Flower with dehisced anthers and pollen

Pollen load colour

Margaret Anne Adams 31/07/2020

Polar view

Equatorial view

Polar view optical section

Equatorial view optical section

Margaret Anne Adams 07/08/2017

Papaveraceae,
Papaver somnifera
Bread seed poppy 28 µm

All the poppies in the picture originated from the same seed head, given to me by John's father, in the 1980s. Fritti Moore's and Nick Adams's photos complete the story of the short life of the pollen. Whenever the soil is disturbed, the seeds germinate and when the tiny, pastel green leaves appear we are reminded of Pop or Granddad Adams.

The seeds of these poppies are edible and contain oil. The green pods contain insufficient latex to be called 'Opium poppies'. Is illegal to grow them in the UAE but not in the UK despite 'somnifera' meaning 'sleep-giving'.

The small, off-white, spheroidal pollen grains have three germination furrows. The surface is covered with minute spines and a fine net.

Papaveraceae
Papaver somniferum
Bread seed poppy 28 μm

Margaret Anne Adams 30/07/2011

Nicholas Guy Adams 25/07/2020

No pollen by mid morning

Fritti Moore 03/08/2017

A group of hydrated, stained, poppy pollen grains

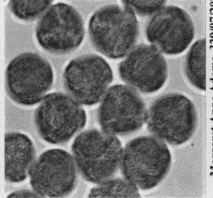

Margaret Anne Adams 329/07/2020

Early in the morning there is plenty of pollen, by mid morning the bees will have removed it all

Pollen load colour

Rosaceae, Filipendula ulmaria, Meadowsweet 15 µm

The meadowsweet flowers, growing wild on the verges of the C12, in the Rhins of Galloway, have green pollen.

Filipendula ulmaria flowers have always been known for their fragrance. When archaeologists opened a bronze age cist, at Ashgrove Farm, Methil, Fife, they found an abundance of immature meadowsweet pollen, suggesting that a bunch of these flowers was buried with the dead person.

The very small, green, spheroidal pollen grains have three germination furrows, each consisting of a furrow with a pore. The surface is covered with minute spikes. However numerous, meadowsweet pollen grains should be left out of a pollen count, as the flowers produce hardly any nectar.

Rosaceae, Filipendula ulmaria
Meadowsweet 15 μm

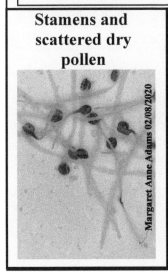

Margaret Anne Adams 02 08 2020

Meadowsweet bee bread

Donovan Keogh Jones 04/08/2020

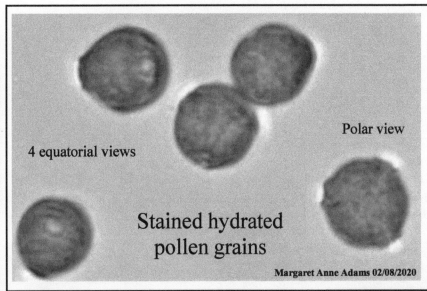

4 equatorial views

Polar view

Stained hydrated
pollen grains

Margaret Anne Adams 02/08/2020

**Stamens and
scattered dry
pollen**

Margaret Anne Adams 02/08/2020

**Pollen soaking in
isopropanol**

Margaret Anne Adams 02/08/2020

**Grains re-dried
x 400**

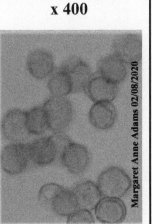

Margaret Anne Adams 02/08/2020

**Pollen load
colour**

Margaret Anne Adams 06/08/2020

Scrophulariaceae,
Buddleja 'Lochinch' 15 µm

"Buddleja 'Lochinch' is an old hybrid cultivar, raised from a chance seedling found in the garden of the Earl of Stair at Lochinch Castle, Wigtownshire, Scotland, circa 1940; the shrub's parents believed to be Buddleja davidii and Buddleja fallowiana. B. 'Lochinch' was accorded the Royal Horticultural Society Award of Garden Merit in 1993, this was reaffirmed in 2010"

(2016, The Buddleja National Collection).

Buddleja pollen grains have a variety of forms. In my 'Lochinch' slide there were 3 and 4 germination aperture grains; in my 'self set' slide and my Davidii slide there were 3, 4 and 5 aperture grains. In all three slides 4 aperture grains were the most frequent. These all took the form of furrows with a pore. The Pollen grains are white, spheroidal, very small and perforated.

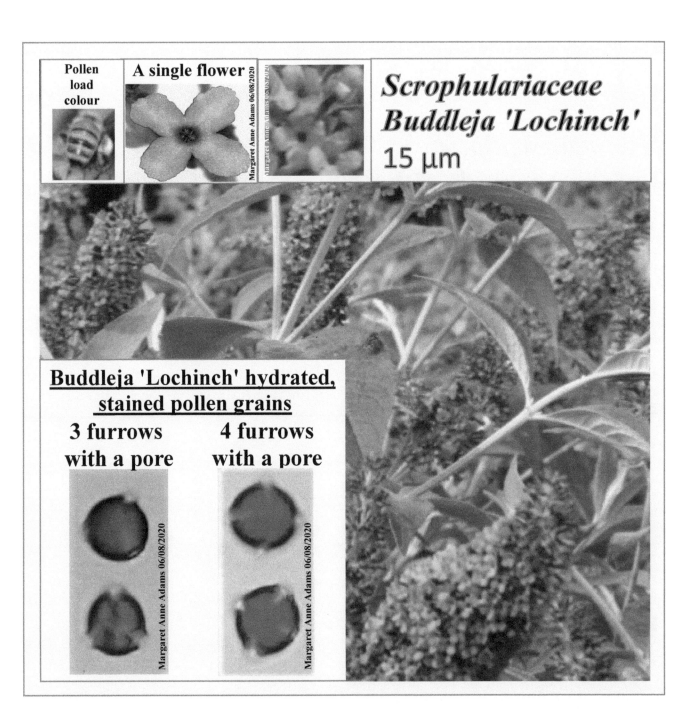

Pollen load colour

A single flower

Margaret Anne Adams 06/08/2020

Margaret Anne Adams 06/08/2020

Scrophulariaceae
Buddleja 'Lochinch'
15 μm

Buddleja 'Lochinch' hydrated, stained pollen grains

3 furrows with a pore

4 furrows with a pore

Margaret Anne Adams 06/08/2020

Margaret Anne Adams 06/08/2020

Fabaceae,
Lotus corniculatis,
Birdsfoot trefoil, 13 by 19 μm

Birdsfoot trefoil is ideal for bees between early and late summer, as the flowers are rich in accessible nectar and pollen. It needs to be re-sown every two or three years.

As pollen is dusted to the underside of the forager these flowers are said to be 'sternotribic' whereas Himalaya balsam flowers are 'nototribic' as the back of the bee is dusted with pollen.

The very small pollen grains are round in polar view but oval in equatorial view. The three germination apertures are long, sunken furrows with ornamented edges and a central pore. The surface is smooth and finely perforated.

Fabaceae
Lotus corniculatus
Birdsfoot trefoil 13 μm

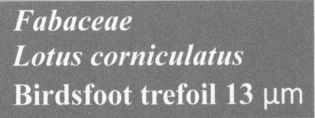

Pollen load colour

Birds foot shaped seed pods

Weight of a bee landing on the keel exposes the style, anthers and nectaries

Keel

Pollen adheres to the underside of the bee and can pollinate another flower. The flowers are sternotribic

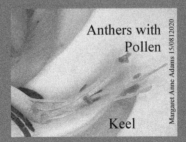

Anthers with Pollen

Keel

Margaret Anne Adams 15/08/2020

Stained pollen grains

Polar views

Equatorial views

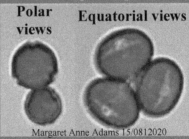

Margaret Anne Adams 15/0812020

Ranunculaceae,
Anemone hupehensis,
Japanese anemone 20 μm

The Japanese Anemone is an excellent bee plant, as it produces abundant pollen from August till October. It produces no nectar, which is good as the sap is slightly toxic, but there is usually a drop of dew or water in the flower, which the foragers can use, if needed, to help with the packing of their pollen loads.

This autumn Anemone is an easy plant to propagate. It produces new plants from underground, horizontal rhizomes. The plants can be split in the spring, and replanted in places that don't dry out and have shade during the hottest time of the day.

The Japanese Anemone was brought to the UK by the Scottish botanist Robert Fortune in 1844, from Southern China, where it originated.

The small, pale green, spheroidal pollen grains have germination apertures composed of three furrows, each with a pore. The grain surface is perforated and has tiny spines.

Ranunculaceae
Anemone hupehensis
Japanese Anemone
20 μm

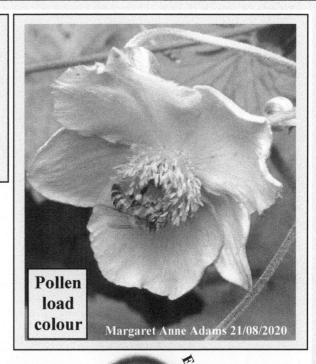

Margaret Anne Adams 21/08/2020

STAINED, HYDRATED POLLEN GRAINS

On a microscope slide of Japanese Anemone pollen grains, the polar view is the dominant orientation. Four out of these five grains are in polar view.

Pollen load colour

Margaret Anne Adams 21/08/2020

Equatorial view

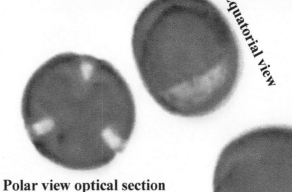

Polar view optical section

Oblique polar view

Margaret Anne Adams 21/08/2020

Lamiaceae,
Stachys palustris,
Marsh woundwort 31 μm

When a compatible pollen grain lands on the stigma there is an interaction between the two that stimulates a pollen tube to appear from one of the germination apertures and this tube elongates by tip growth. The tip moves down the style, to the ovary to deliver sperm cells. In the case of Marsh woundwort, the diameter of a pollen grain is only 31 μm or 0.031 mm and the style is 10mm long, which means the pollen grain will have to produce a tube 322 times its own diameter, in length. All this growth requires energy, guidance and nourishment.

Energy is minimized as tip growth causes little friction.

Growth and guidance towards the ovary is by chemotropic proteins.

Nourishment of the growth tip, along the route, for extending the cell wall and the plasma membrane of the pollen tube is obtained by enzyme action on the cells of the style.

The medium sized, white, spheroidal pollen grains have 3 germination apertures in the form of sunken furrows, the surface is covered with a fine net.

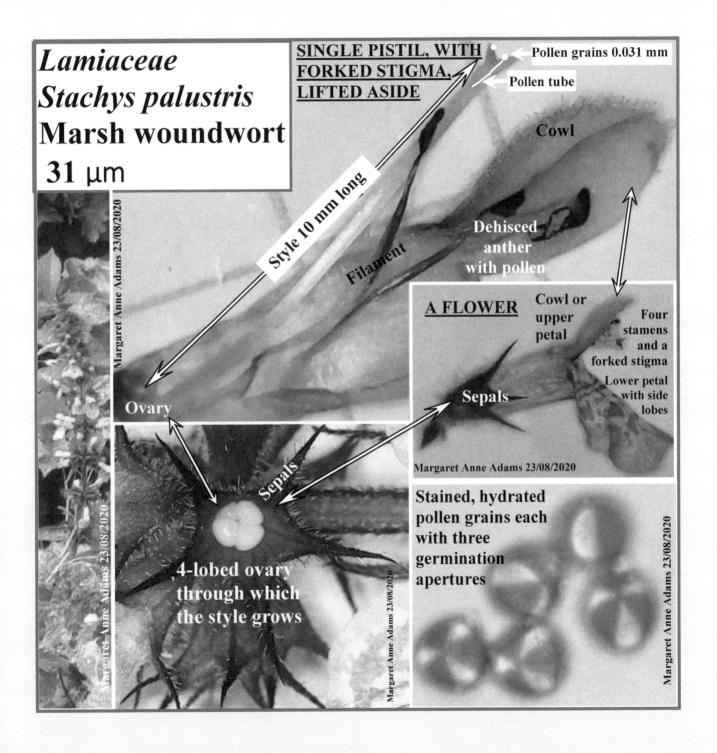

Lamiaceae
Stachys palustris
Marsh woundwort
31 μm

SINGLE PISTIL, WITH FORKED STIGMA, LIFTED ASIDE

Pollen grains 0.031 mm

Pollen tube

Cowl

Style 10 mm long

Filament

Dehisced anther with pollen

Ovary

Sepals

4-lobed ovary through which the style grows

A FLOWER

Cowl or upper petal

Four stamens and a forked stigma

Lower petal with side lobes

Sepals

Stained, hydrated pollen grains each with three germination apertures

Margaret Anne Adams 23/08/2020

David Adamson's Raspberry and white clover honey pollens

Rosaceae, Rubus adaeus, raspberry 26 μm
Fabaceae, Trifolium repens, white clover 23 μm

Here is a glimpse of a few of the thousands of pollen grains in a 10 gram sample of honey.

The vast majority of grains were from raspberry and white clover. Raspberry and White Clover both have a pollen coefficient of 50 in 1000 grains (10 grams of honey).

David Adamson's Honey sample A

Microscope slide
Grid ref 2736, 1221

White clover

White clover

Hawthorn

Raspberry

Raspberry

Hawthorn

Raspberry

White clover

White clover

White clover

100 μm

Broom

Margaret Anne Adams 29/08/2020

David Adamson's Bramble honey
Rosaceae, Rubus fruticosus
Bramble 28 µm

The photo shows a few of the thousands of grains of pollen in a 10 gram sample of honey.

Most of the grains come from blackberry flowers.

David Adamson's Honey Sample B

100 μm

Blackberry
Blackberry
Blackberry
Blackberry
Blackberry
Thistle Carduus Tenuiflorus
Blackberry
Blackberry
Allium

Margaret Anne Adams 01/09/2020

Pollen loads at the hive entrance – 03/09/2020

These pollen loads, taken at the hive entrance, are not ivy as the grains resemble dandelion pollen grains, but dandelions are not in flower. Hawksbit and Catsear are in flower in our garden and surrounding area, at the moment, and I will prepare some slides of these flowers.

Grains from the orange pollen load at the hive entrance 03/09/2020 will be compared with pollen from fresh Catsear and Hawksbit flowers as the pollen load grains are from the Asteraceae family not from Ivy flowers

Pollen load at the hive entrance 03/09/2020

Margaret Anne Adams 03/09/2020

Pollen grains from load at the hive entrance 03/09/2020

Dandelion pollen from a flower 16/03/2020

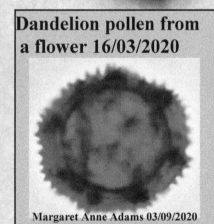

Margaret Anne Adams 03/09/2020

IVY POLLEN

Margaret Anne Adams 03/09/2020

Asteraceae,
Hypochaeris radicata,
Catsear 28 μm

The orange pollen loads, collected at a hive entrance on the 3rdSeptember 2020, were not from Ivy flowers, but instead, the pollen grains resembled those of the dandelion flower, a member of the Asteraceae family.

Catsear pollen was examined from flowers near the apiary, and it was found that the pollen grains were the same as those in the pollen loads.

The orange, medium sized, spheroidal pollen grains have three germination apertures each in the form of a furrow with a pore. The surface is a pattern of ridges surrounding depressions, and decorated with spines.

236

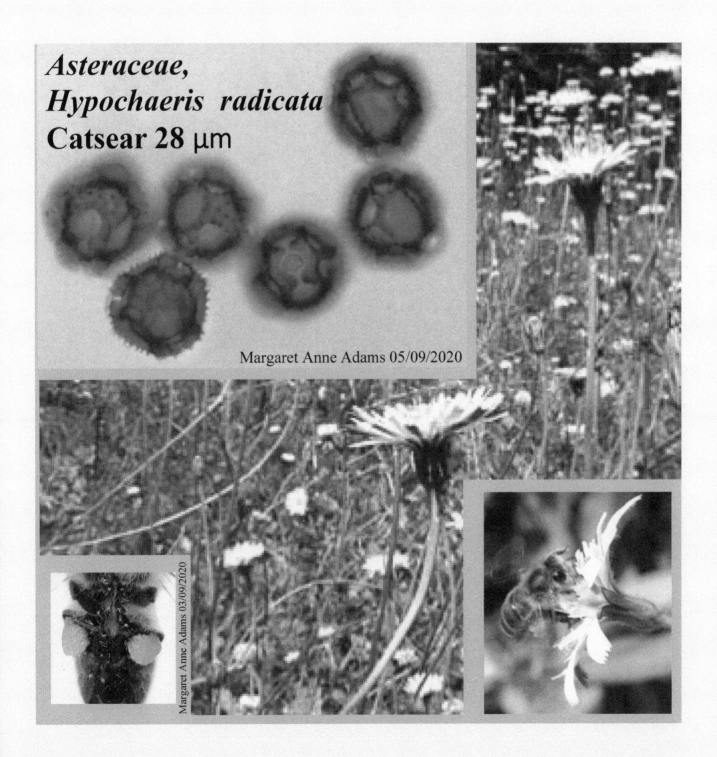

Asteraceae,
Hypochaeris radicata
Catsear 28 μm

Margaret Anne Adams 05/09/2020

Margaret Anne Adams 03/09/2020

Pollen loads at the hive entrance – 03/09/2020

The top photo shows the plumose hairs on the top of the foragers thorax full of Himalayan balsam pollen that she could not reach to pack into her pollen loads. Queens have these plumose hairs too, so it is important to take this into account when marking her. The paint must penetrate through her hairs to her exoskeleton if it is to last her a lifetime.

The pollen grains in the corbiculae are held together with nectar and some of the foragers saliva. To get rid of this 'adhesive' the grains must be washed twice with warm water.

Pollen loads at the hive entrance 03/09/2020

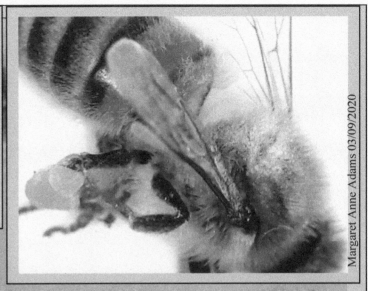

Margaret Anne Adams 03/09/2020

Himalayan Balsam pollen grains with some nectar and saliva

Margaret Anne Adams 07/07/2020

Balsaminaceae
Impatiens glandulifera
Himalayan balsam 28 μm

Margaret Anne Adams 03/09/2020

Blue queen marking ink

Margaret Anne Adams 03/09/2020

Ericaceae,
Calluna vulgaris,
Ling heather 31 to 36 μm (depending on the tetrad)

All pollen grains are in the tetrad stage during development. Usually the grains forming the tetrad, separate at maturity into 4 single pollen grains called monads.

This does not happen with ling; they shed their pollen in permanent tetrads. There are 6 possible spacial arrangements of 4 pollen grains. Ling pollen grains are mostly arranged in a tetrahedral tetrad. However, on my slide there were also decussate tetrads and rhomboidal tetrads and there are examples of all three arrangements among the 8 grains in the photo.

There are three germination apertures in the form of furrows each with a pore as shown in the rhododendron tetrads.

Pollen loads at the hive entrance 06/09/2020

Ericaceae
Calluna vulgaris
Ling heather
31 to 36 μm

A rhomboidal tetrad

Ling honey in the comb

Margaret Anne Adams 14/10 2014

Margaret Anne Adams 06/09/2020

A rhomboidal tetrad

A tetrahedral tetrad polar view

8 ling heather grains from the pollen loads

Margaret Anne Adams 06/09/2020

A tetrahedral tetrad equatorial view

A decussate tetrad

Mica Goldstone's very dark honey

Several suggestions were made about the possible origin of the jar of extremely dark honey in the photo:

- The bees could have been raiding something like treacle tins in the skips of the local biscuit factory.
- A Master Beekeepes said it was cherry honey
- Caroline Mackenzie suggested on Facebook that it was Honeydew honey

The slide of the solids obtained by centrifuging 10 grams of treacle were nothing like honey solids.

Cherry Blossom honey idea was not feasible in the Blackpool area, but the person may have been thinking of boot polish.

The slide of the solids obtained by centrifuging 10 grams of the dark honey, showed Caroline was right: it was honeydew honey.

The huge quantities of black solids were not just the usual fungal spores and algae, nor the usual small specks of soot found in the London sample of Honeydew honey: they were mainly the soot from the Blackpool Pier fire on 17the July 2020, which had blown over the lime trees where Mica's bees were foraging for honeydew. The crystals reflecting green light in the photo are melezitose crystals.

Araliaceae,
Hedera,
Ivy 33 μm

Ivy is the end of season foraging plant for bees, rich in pollen and yielding nectar with a high sugar content.

Like Oilseed rape honey, it sets rapidly in the comb with a fine crystal structure. In most parts of the world beekeepers leave ivy honey in the frames for the bees to feed on in the winter months. Another reasons for this, is the uninteresting flavour with a bitter aftertaste, but this bitterness diminishes if the honey is stored. The flavour has been described as like a smoky rum and the honey has a creamy texture.

The medium sized, yellow pollen grains have 3 germination apertures in the form of furrows each with a pore However, you will notice that one of the grains on my slide has 4 apertures –it was like finding a 4 leaved clover in a field!

Araliaceae
Hedera
Ivy 33 µm

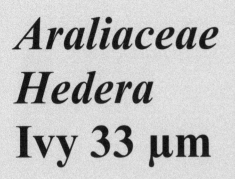

Stained pollen grains direct from the Ivy flowers

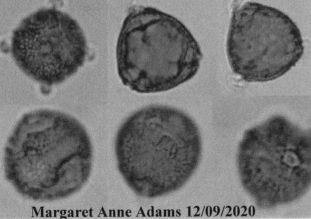

Margaret Anne Adams 12/09/2020

MIEL DE LIERRE

Flower in the male stage

Stamens
with
pollen

Margaret Anne Adams 12/09/2020

Iridaceae,
Crocosmia 'Lucifer',
Montbretia 'Lucifer' 59μm

Crocosmia was introduced to Europe from Africa. There are now hundreds of Crocosmia cultivars, an orange, ornamental, 1880 French cross, called Crocosmia .crocosmiiflora or simply Montbretia has escaped from cultivation to become invasive, and in parts of the British isles it grows thickly, for miles along verges, coastlines and forest edges. In these places, honey will contain its nectar and pollen.

The large, pale yellow pollen grains have only one germination aperture, in the form of a furrow with a pore. The edges of the furrow and pore are ornamented, and the surface is granular.

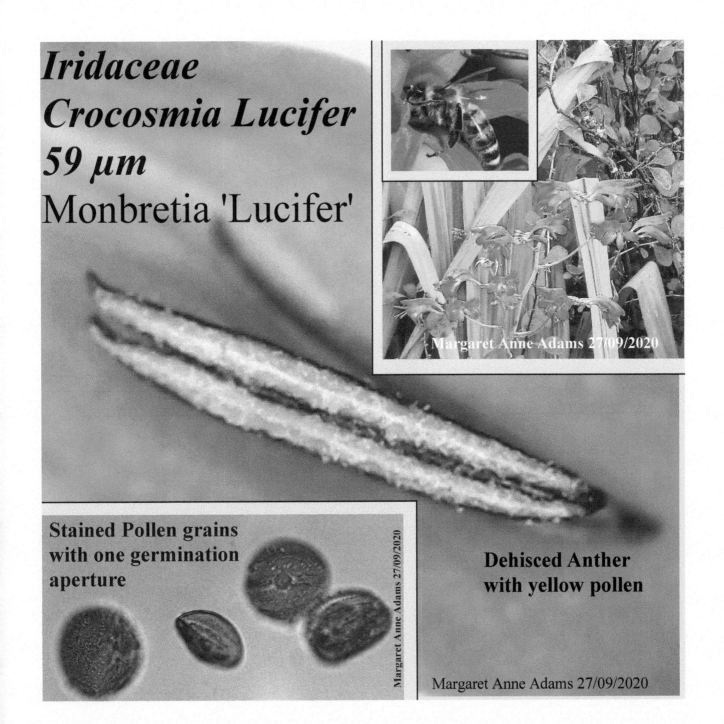

Iridaceae
Crocosmia Lucifer
59 μm
Monbretia 'Lucifer'

Margaret Anne Adams 27/09/2020

Stained Pollen grains
with one germination
aperture

Margaret Anne Adams 27/09/2020

Dehisced Anther
with yellow pollen

Margaret Anne Adams 27/09/2020

Asteraceae,
Guizotia abyssinica,
Niger bird seed flowers 31 μm

Niger seeds often germinate under the bird feeders in the autumn, and when the tall plants flower, bees forage for pollen and nectar. This is another very welcome source of pollen in September, even though the seeds are supposed to be heat treated to prevent Niger becoming an invasive species.

In Ethiopia, pollination by bees increases the seed yield by up to 20%. Like oil seed rape, Niger seeds can be crushed to produce oil and the remains provide a protein-rich feed for livestock.

The small, spheroidal, yellow pollen grains have three germination apertures in the form of furrows, each with a pore. The surface of the grain is covered with thorn like projections.

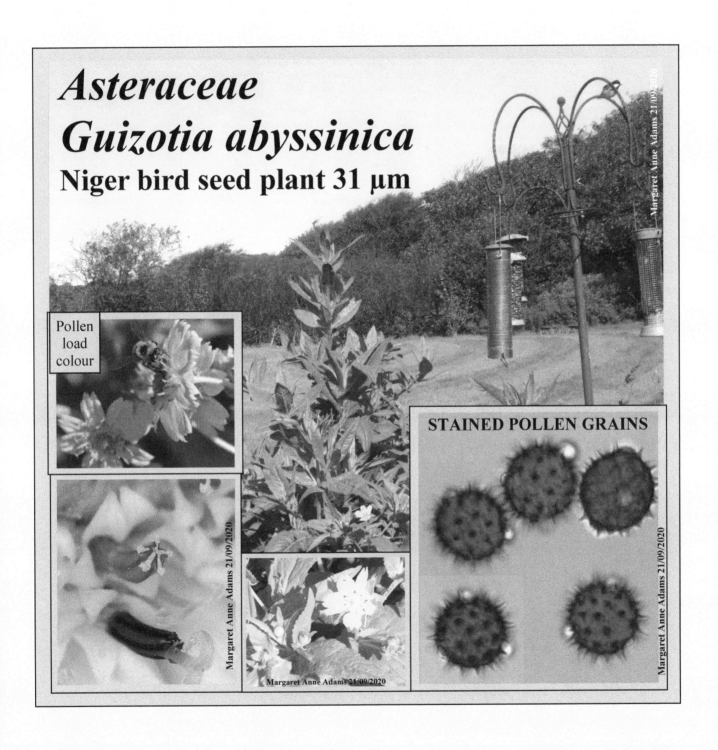

Asteraceae
Guizotia abyssinica
Niger bird seed plant 31 µm

Pollen load colour

STAINED POLLEN GRAINS

Margaret Anne Adams 21/09/2020

Violaceae,
Viola arvensis,
Field pansy 70 μm

There are many flowers in and near apiaries that we rarely or never see a bee on, but when you see the pollen grains in your honey you discover where bees have found some nectar.

When we find these grains of pollen we can try and provide more space and better conditions, for the plants to reproduce. It will then be more profitable for the bees to return to them to forage.

A 10 gram sample, from one of the four lots honey we extracted on 28th September 2020, contained mainly Himalayan balsam and Blackberry pollen. Among the many other, rarer pollen grains were several large ones with five germination apertures. These came from the Field pansy. A very exciting find! These tiny yellow flowers that pop up when the ground is disturbed are exquisite.

Violaceae, Viola arvensis,
Field pansy, 70 µm, in honey
extracted on 28/09/2020

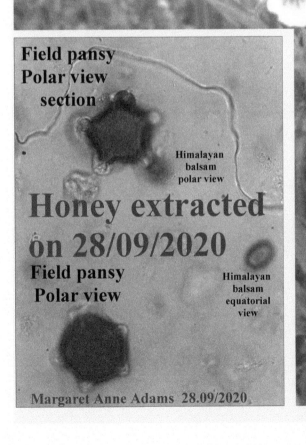

Field pansy
Polar view
section

Himalayan
balsam
polar view

Honey extracted
on 28/09/2020
Field pansy
Polar view

Himalayan
balsam
equatorial
view

Margaret Anne Adams 28.09/2020

Margaret Anne Adams 28.09/2020

Bruce Burns' Birdsfoot Trefoil and Blackberry Honey and other pollens in the sample

This is an analysis of the pollens in the beautiful, tasty, golden honey for which Bruce Burns won a First at the Scottish Beekeepers Association, Scottish National Honey Show, in Dundee, in September 2019. The honey had relatively few grains of pollen, but they ranged in size from 13 μm to 51 μm and there were honeydew particles and Lime pollen grains.

Most of the pollen was from Birdsfoot trefoil and Blackberry, and even though a year had passed the honey had not started to granulate.

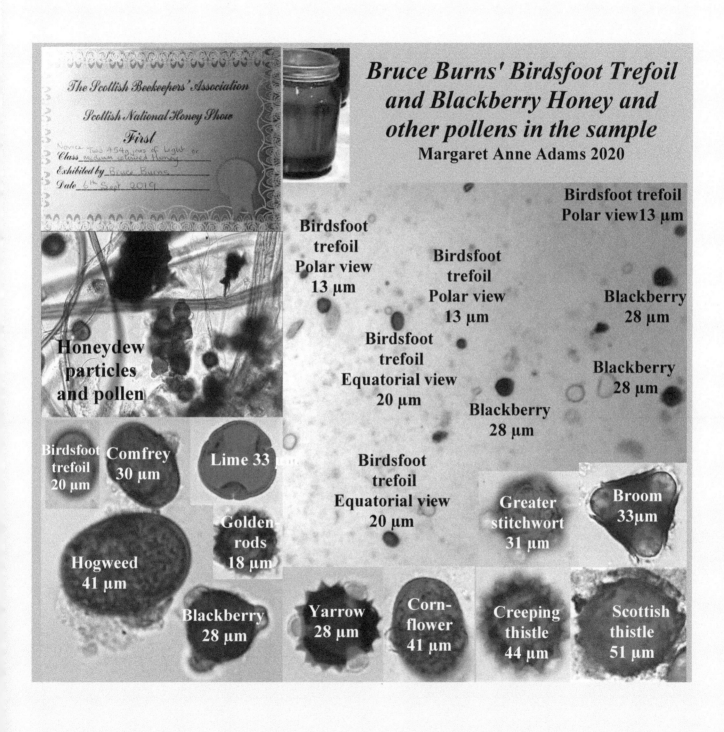

Bruce Burns' Birdsfoot Trefoil and Blackberry Honey and other pollens in the sample
Margaret Anne Adams 2020

The Scottish Beekeepers' Association

Scottish National Honey Show

First

Class _Novice Two 454g jars of Light or medium coloured Honey_

Exhibited by _Bruce Burns_

Date _6th Sept 2019_

Honeydew particles and pollen

Birdsfoot trefoil Polar view 13 μm

Birdsfoot trefoil Polar view 13 μm

Birdsfoot trefoil Polar view 13 μm

Birdsfoot trefoil Equatorial view 20 μm

Blackberry 28 μm

Blackberry 28 μm

Blackberry 28 μm

Birdsfoot trefoil Equatorial view 20 μm

Birdsfoot trefoil 20 μm

Comfrey 30 μm

Lime 33 μm

Golden rods 18 μm

Hogweed 41 μm

Blackberry 28 μm

Yarrow 28 μm

Corn-flower 41 μm

Greater stitchwort 31 μm

Broom 33μm

Creeping thistle 44 μm

Scottish thistle 51 μm

Boraginaceae,
Symphytum officinale,
Common comfrey 26 μm by 28 μm

Not only is Comfrey a good plant for pollinators, being rich in pollen and nectar, but also, if it is planted in an orchard, the trees will thrive and in the spring Honey bees will benefit from the pollen and nectar in the fruit blossom.

The reason for this, is Comfrey's tap root, which can grow down 5 feet and bring up essential minerals for plants. These minerals rise up in to the leaves, which are eventually form a mulch under the trees. The leaves can also be composted or shredded, and made into a liquid plant food.

The deep root also enables the plant to survive droughts and the trees in the orchard also benefit from the moisture and ground cover.

The small, white, elongated pollen grains have 7 to 12 germination apertures in the form of furrows each with a pore. The photos shows a grain with 9 pores.

Boraginaceae
Symphytum officinale
Common Comfrey
28 μm by 26 μm

Short tongued *Bombus pratorum*, make a hole to rob the nectar. Honey bees will then use the hole to rob too.

STAINED POLLEN

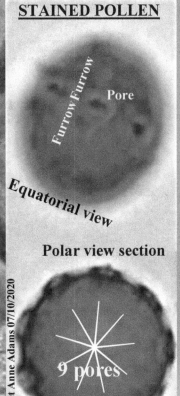

Furrow Furrow

Pore

Equatorial view

Polar view section

9 pores

Margaret Anne Adams 07/10/2020

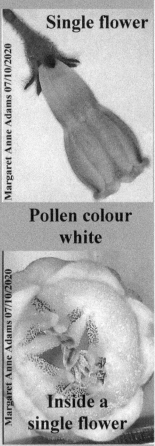

Single flower

Pollen colour white

Inside a single flower

Margaret Anne Adams 07/10/2020

Margaret Anne Adams 07/10/2020

Danny Ralph's Moray, Summer 2020
Rosebay willowherb, White clover and honeydew honey

The solids in Danny's tasty honey, paint a beautiful picture of the wide range of plants round his apiary.

It took an hour rather than the usual twenty minutes to spin off the solids from 10 grams of honey. This is because the Rosebay Willowherb nectar brought to the hive, only has a very small amount of pollen. The foragers proventriculus is able to pass the very large grains from the honey crop to the gut, in transit.

The honey has set because of the abundant small, White clover pollen grains.

As there is no sign of sycamore pollen, the foragers have collected the honeydew before the sun dried it up and then, later in the morning, rather than returning to the tree, they concentrated on nectar from Rosebay willowherb and clover and also some bees returned to the hive with nectar and pollen from the wide range of other wildflowers.

Despite the typical microscopic particles in honeydew, its honey is valued in most European countries. The Scots pine pollen grain got trapped on the sticky honeydew as it floated in the breeze.

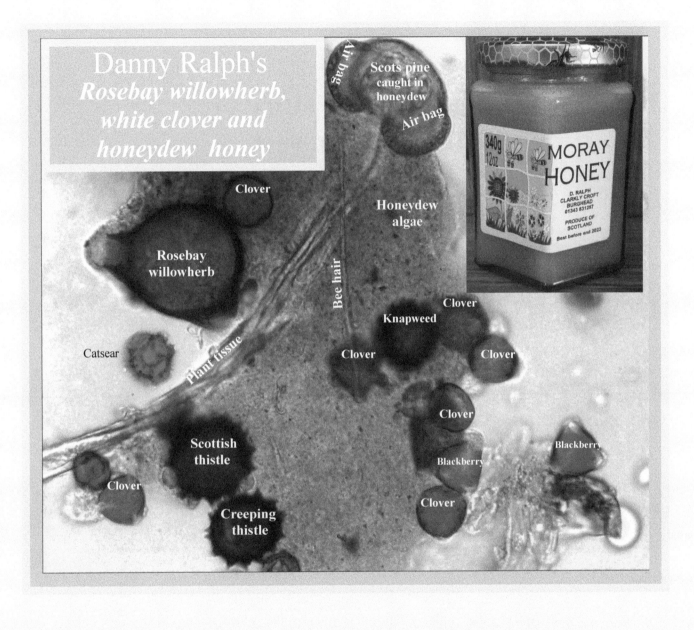

Danny Ralph's
Rosebay willowherb,
white clover and
honeydew honey

Air bag

Scots pine caught in honeydew

Air bag

Honeydew algae

Clover

Rosebay willowherb

Bee hair

Plant tissue

Catsear

Clover

Knapweed

Clover

Clover

Clover

Scottish thistle

Clover

Blackberry

Clover

Blackberry

Clover

Creeping thistle

340g
12oz

MORAY
HONEY

D. RALPH
CLARKLY CROFT
BURGHEAD
01343 831257

PRODUCE OF
SCOTLAND

Best before end 2023

David Charles tells me the story of his surprise 2020 honey harvest

"I don't know if you realise but I gave up beekeeping when I moved last year. I had intended keeping a couple of hives at a site I have, on the fringe of the village, in a neglected orchard. However, when my driving licence was revoked I could no longer drive there.

That was that. I still had a couple of unoccupied hives. Sometime last spring or very early summer a swarm moved into one that had a super on, over the crown board. When someone eventually took me there I came home with 4 or 5 shallow combs, three of which were quite full. I gave the bees away and scraped the honey into the mixing bowl, then strained and bottled it. This is all I have of this year's honey. It is medium coloured and a bit lacking in viscosity. So I cannot be precise about when it was stored by the bees. However, the not very special flavour is one I recognise as being typical of honey from this area. I would expect some apple."

David

David Charles' blossom and and honeydew honey 2020

A glimpse at a few more of the thousands of pollen grains in the 10 g sample

Also showing other pollens found elsewhere on the slide

Honeydew algae

Hogweed

Raspberry

Raspberry

Apple

White clover

White clover

Honeydew algae

Blackberry

Margaret Anne Adams 14/11/2020

White clover

Horse Chestnut

Honeydew algae

Fungal spore, a normal honeydew element

Honeydew algae

Raspberry

Blackberry with 4 pores

Honeydew algae

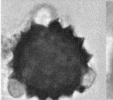

Yarrow
26μm

Astrantia
44 μm

Hogweed
36 μm

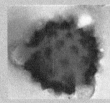

Creeping thistle
46 μm

Catsear
31 μm

Aubretia
26 μm

Ian Hutchinson's dark honey
Himalayan balsam and pine honeydew

Ian extracted this honey on 17th September 2020. Within a three mile radius of his apiary there is a choice of foraging areas, comprising a National Trust garden, farmland that produces grain, a river, huge private houses and an allotment ground.

The solids, spun off a 10 gram sample of Ian's dark honey, consisted of thousand upon thousands of Himalaya balsam pollen grains mixed with Honeydew elements.

Himalaya balsam honey is pale but Ian's honey is a deep reddish colour because his bees have also collected pine honeydew.

There are Pine trees in the National Trust garden. The pine honeydew was produced by the aphid *Cinara pini*. This aphid moves onto the tender, growing parts the pine trees, sucking excessive amounts of phloem sap just to use the protein content, and excreting the rest as droplets of reddish honeydew, which Ian's bees harvested.

Ian Hutchinson's Himalayan balsam and Pine honeydew honey
September 2020

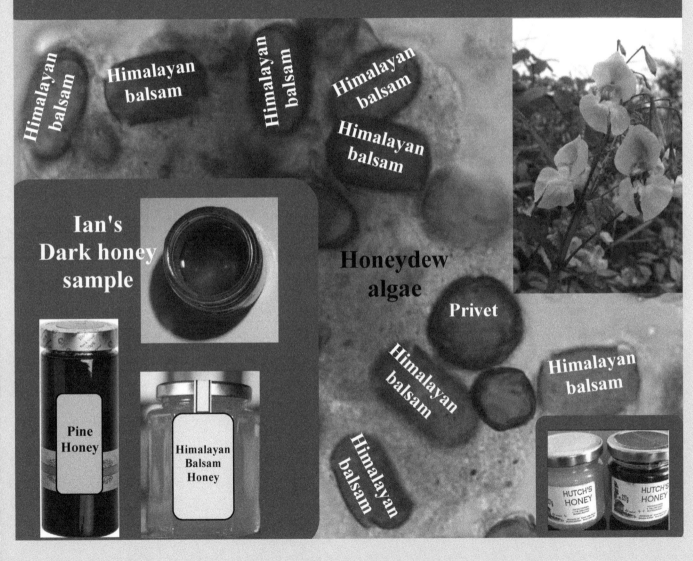

Himalayan balsam

Himalayan balsam

Himalayan balsam

Himalayan balsam

Himalayan balsam

Ian's Dark honey sample

Honeydew algae

Privet

Himalayan balsam

Himalayan balsam

Himalayan balsam

Pine Honey

Himalayan Balsam Honey

HUTCH'S HONEY

HUTCH'S HONEY

Ian Hutchinson's 2020 light honey
Clover, jasmine and top fruit

Ian extracted this honey on 17th September 2020. Within a three mile radius of his apiary there is a choice of foraging areas, comprising a National Trust garden, farmland that produces grain, a river, huge private houses and an allotment ground.

The solids, spun off a 10 gram sample of Ian's dark honey, consisted of thousand upon thousands of Himalaya balsam pollen grains mixed with Honeydew elements.

Himalaya balsam honey is pale but Ian's honey is a deep reddish colour because his bees have also collected pine honeydew.

There are Pine trees in the National Trust garden. The pine honeydew was produced by the aphid *Cinara pini*. This aphid moves onto the tender, growing parts the pine trees, sucking excessive amounts of phloem sap just to use the protein content, and excreting the rest as droplets of reddish honeydew, which Ian's bees harvested.

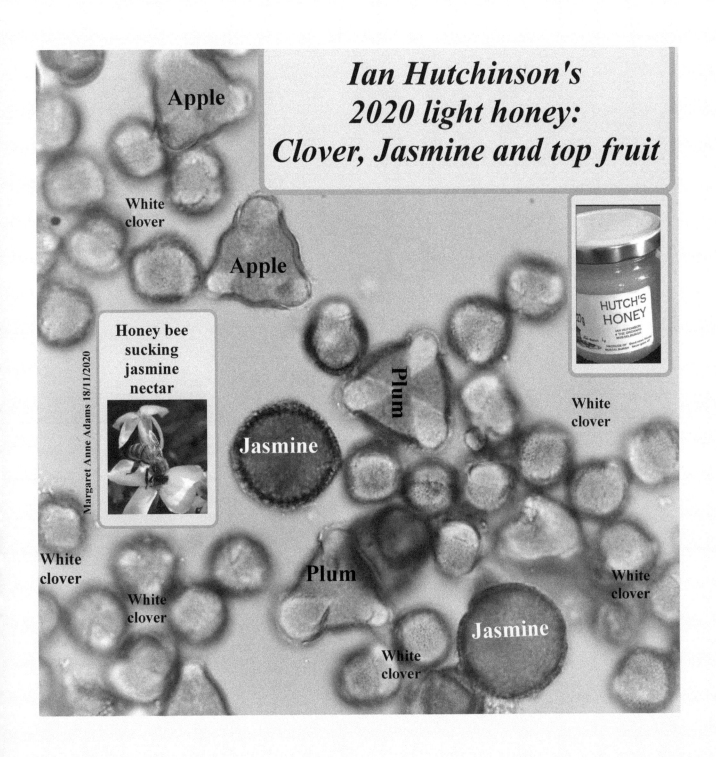

Ian Hutchinson's 2020 light honey: Clover, Jasmine and top fruit

Apple

White clover

Apple

Honey bee sucking jasmine nectar

Margaret Anne Adams 18/11/2020

Plum

White clover

HUTCH'S HONEY

Jasmine

White clover

White clover

White clover

Plum

White clover

White clover

White clover

Jasmine

Berberidaceae, Mahonia x media, 'Charity'

Mahonia is the most difficult pollen to study. After four failures using the usual methods, the fifth slide was rushed from having the cover slip laid down, straight to the microscope and 25 photos were taken in rapid succession as the grains hydrated and took up the stain. Ten minutes later all the grains had burst yet again. The last grain in the picture has burst

The problem arises because the exine of the Mahonia pollen wall is clypeate, that is subdivided into shields. The shields spring apart when the surface area of the swelling cytoplasm exceeds the total of area of the shields.

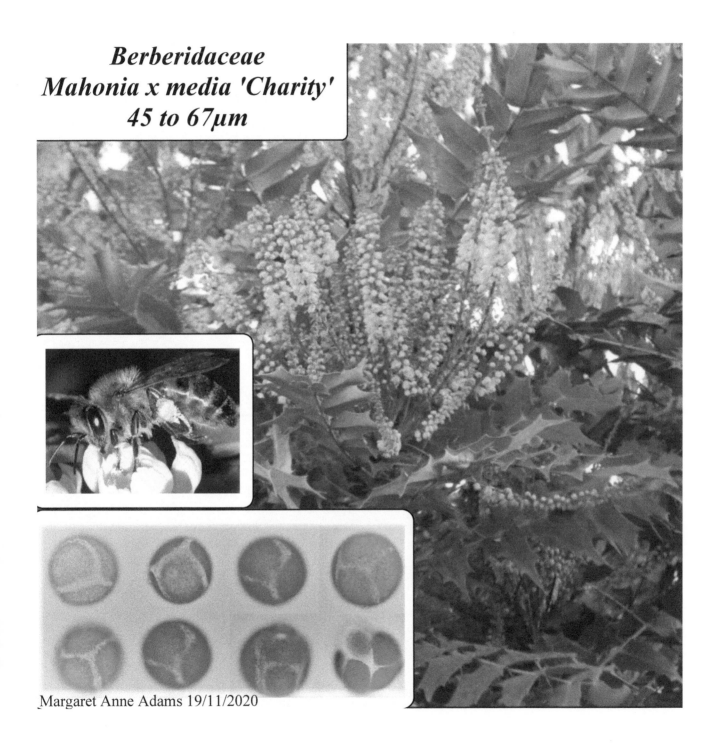

Berberidaceae
Mahonia x media 'Charity'
45 to 67μm

Margaret Anne Adams 19/11/2020

Dani Akrigg's 2020 honey
Rosebay willowherb and Himalayan balsam

Dani's lovely pale gold, unset honey is mainly from Rosebay willowherb and Himalayan balsam, but the variety of other pollen grains in the honey reflect the huge range of flowering plants the scouts were able to sample in the apiary.

Rosebay Willowherb nectar brought to the hive, only has a very small amount of pollen in it because the forager's proventriculus is able to pass the very large grains from the honey crop to the gut, in transit.

Himalayan balsam pollen grains are small and there so are thousands of them in a 10 gram sample of the honey.

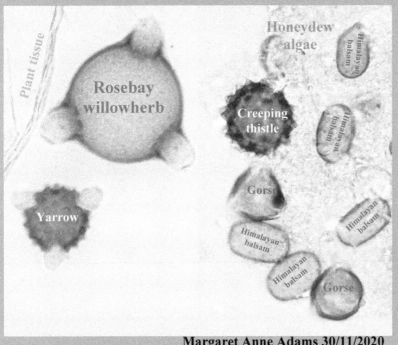

Dani Akrigg's 2020 Rosebay willowherb and Himalayan balsam honey and some of the other pollen grains therein

Plant tissue

Rosebay willowherb

Honeydew algae

Himalayan balsam

Creeping thistle

Himalayan balsam

Himalayan balsam

Yarrow

Gorse

Himalayan balsam

Himalayan balsam

Gorse

Margaret Anne Adams 30/11/2020

Cow parsley

Blackberry

Ragwort

Prickly Sowthistle

Catsear

Privet

Raspberry

Hypericum

Hawthorn

Scottish thistle

Lime

Dani Akrigg's 2020 honey (additional notes)
Rosebay willowherb and Himalayan balsam

In a comment about Dani' Akrigg's honey post, Steven Riley asked, "Is the HB an example of "over representation".

The list of pollen coefficients already determined from monofloral honeys starts with Rosebay willowherb at 0.3 grains in a gram of honey, and ends with that of forget-me-not at 5000 grains in a gram of honey.

The picture below is a x 400 microscope camera capture of a few of the thousands of pollen grains in a 10 gram sample of Dani's honey.

We would be a mistake to say this is Meadowsweet and Himalayan balsam honey, as Meadowsweet produces virtually no nectar, and it just happens that one of the Rosebay willowherb pollen grains is not on this part of the slide. Himalayan balsam does yield copious amounts of nectar as we all know, from seeing the foragers back at the hive entrance dusted with white HB pollen and only rarely with HB pollen loads.

To sum up, Rosebay willowherb is under represented and Meadowsweet is so over represented that, it is always omitted from calculations for a complete analysis of a honey sample. Himalayan Balsam honey is a newly welcome crop in the UK, and its Pollen Coefficient will probably be determined next season from a monofloral sample from a comb.

ADDITIONAL NOTES ON
Dani Akrigg's 2020 Rosebay willowherb and Himalayan balsam honey and some of the other pollen grains therein

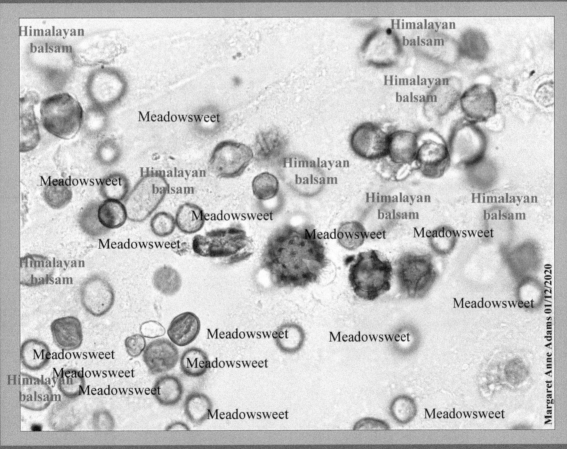

Asteraceae,
Senecio greyi,
Daisy bush 38 µm

Finding a grain of pollen resembling Ragwort, in honey from a colony in our garden, but measuring 38 µm instead of 28 µm was surprising.

Fortunately the Daisy bushes still had a few flowers even though it was 5th December, and there was pollen on the anthers for a microscope slide. Being in the same genus as Ragwort (*Senecio Jacobaea vulgaris*) the pollens were similar and the Daisy bush pollen measured 38 µm like the grain in our honey. This pollen is the 109th collected from flowers, that were available to our bees, between 10th February and 5th December 2020.

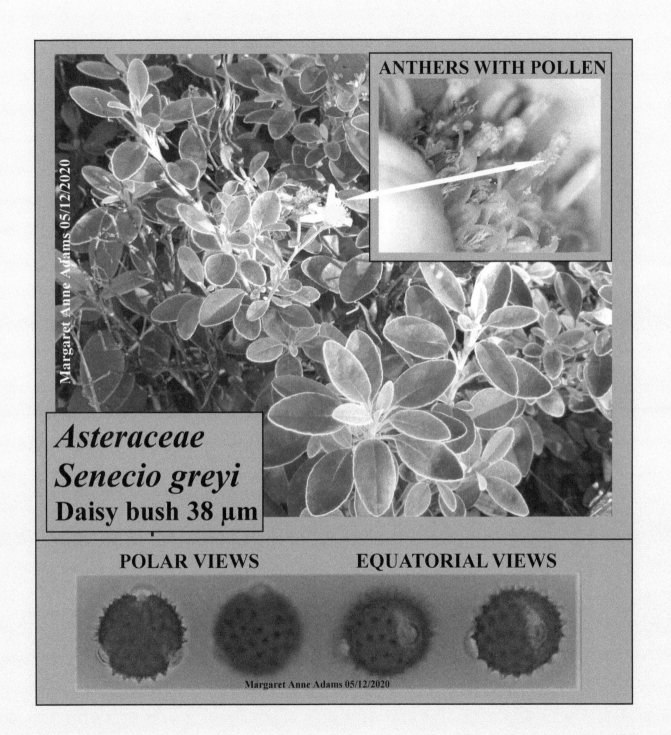

ANTHERS WITH POLLEN

Margaret Anne Adams 05/12/2020

Asteraceae
Senecio greyi
Daisy bush 38 μm

POLAR VIEWS

EQUATORIAL VIEWS

Margaret Anne Adams 05/12/2020

Ian Ventham's family's Dorset honey sample (2019)

Ian's bees have been most resourceful in producing a very tasty honey, in the June/July gap, in Dorset, in 2019. The weather was very hot at times and there was more rain than usual.

In the lime rich soils of the area, the Large leaved Lime, *Tilia platyphyllos*, is a native plant. Not only does it flower earlier in June than other Limes, but also it attracts aphids that produce abundant Honeydew through the leaves. Nectar and honeydew production are both affected by wind, heat and rain, but there is usually one or other for the bees to harvest. However, in this case, there were only a few Large Leaved Lime pollen grains in the honey, which tells us that honeydew was foraged in greater quantity than nectar.

In the damp conditions after rain, high levels of yeast may occur in honeydew honey that come from the environment, rather than from fermentation of the ripened honey. Some yeast cells can be seen in the individual pollen pictures.

Most honeys contain some honeydew and the characteristic elements rarely affect the quality of the honey especially in a rural area.

Many of the bees in the colony were exploring the neighbourhood for other sources of nectar and found a huge variety of cultivars and wild flowers, whose pollen grains ended up in the honey with the nectars. No pollen appeared in large enough quantities to dominate the honey.

Ian Ventham's
June/July 2019
Lime Honeydew
and Flower Honey

Lime honeydew elements

Astrantia major

Large-leaved Lime

Heather

Clustered bellflower

Common Ash

Yeast

White clover

Red dead-nettle

Wild carrot

Sweet Chervil

Escallonia

Blackberry

Knapweed

Cistus heterophyllus
Rock rose

Bryonia cretica
Cretan White bryony

Cistus albidus
White rock rose

Margaret Anne Adams 19/12/2020

Alison George's honey (July/August, 2020)
Ling heather and honeydew, from the New Forest.

Alison learned beekeeping as a small child, from her Grandmother, on the family farm in Fife. Alison continues to use her Grandmother's century old copper smoker for her own beekeeping. Every August her Grandmother took a dozen hives up onto the heather moors in the Highlands of Scotland so it is lovely that Alison's own bees found Ling heather in the New Forest down in Hampshire. The main attraction for the foragers was Ling heather nectar and honeydew but the scout bees found other flowers to sample and these are represented by the other pollens in the honey, ten of which feature in the pictures.

Alison George's 2020 July/August, Ling and Honeydew Honey from the New Forest

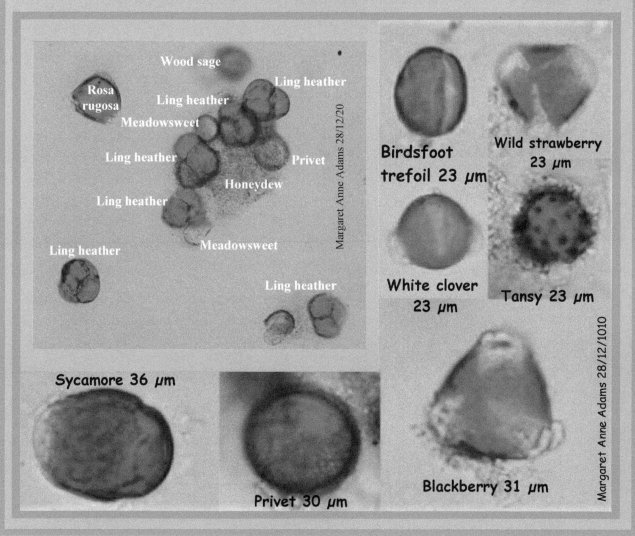

Plantaginaceae,
Hebe,
Hebe 'lilac time' 31 μm

It is January, yet Hebe 'lilac time' is in flower in a sheltered corner of our Rhins of Galloway garden, a mile from the Irish Sea and 400 feet above sea level.

There are nearly 100 native species of Hebe in New Zealand; they are easy to grow in the UK and by choosing a range of species, honey bees can forage Hebe from spring to late autumn for nectar and pollen.

Bryan Mason's beautiful photo, of one of his foragers collecting pollen from Hebe, shows how the colour of the flower's white pollen is altered by the forager adding Hebe nectar and her own saliva, while packing the pollen in her corbiculae, for the journey back to the hive.

Hebe pollen grains are white, medium sized, and spheroidal. The surface is netted. The three germination apertures are ornamented, sunken furrows.

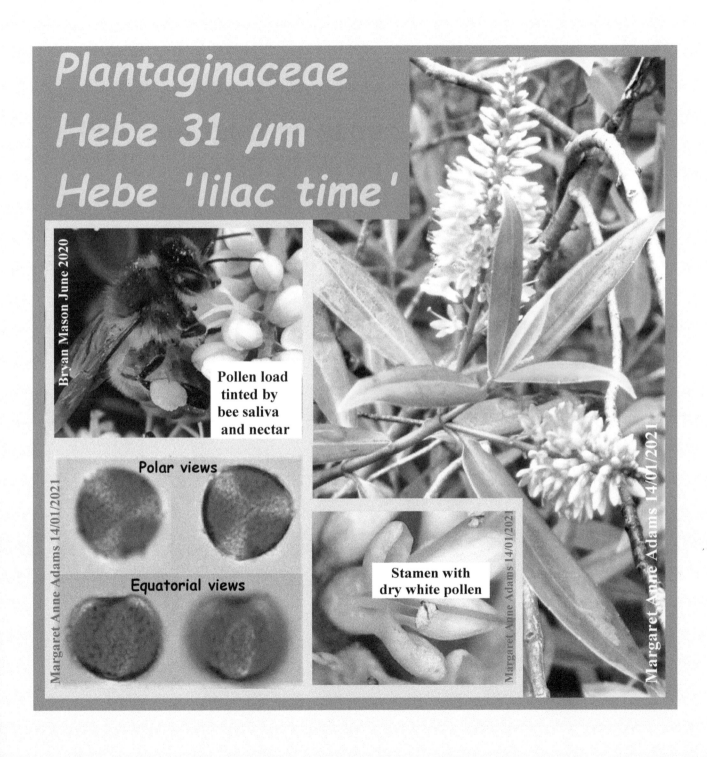

Plantaginaceae
Hebe 31 μm
Hebe 'lilac time'

Bryan Mason June 2020

Pollen load tinted by bee saliva and nectar

Polar views

Equatorial views

Margaret Anne Adams 14/01/2021

Stamen with dry white pollen

Margaret Anne Adams 14/01/2021

Margaret Anne Adams 14/01/2021

Paul Grand's French honey (springtime 2020)
Wild colza, Top fruit and Wild flower

Paul's bees have naturally produced a gourmet, creamed honey that Elton Dyce aspired to make himself.

There were two factors that allowed this to happen.

Firstly Paul's Burgundy garden and fruit orchard which wraps around his ancient farmhouse, are full of flowers for his bees to forage from, all year round.

Secondly, French farmers were forbidden to sow Colza (Oilseed rape) in 2019 and 2020 because of some genetically modified seed that infiltrated the market; Colza oil has been produced in France for lamps and lubrication since the middle ages, so despite the ban there were just sufficient native colza plants, among the wild flowers in the surrounding countryside, to give Paul's honey its fine, smooth texture without making it set hard.

Paul Grand's French, Springtime, Wild colza, Orchard top fruit blossom, garden cultivars, tree flowers and wild flower honey, 2020

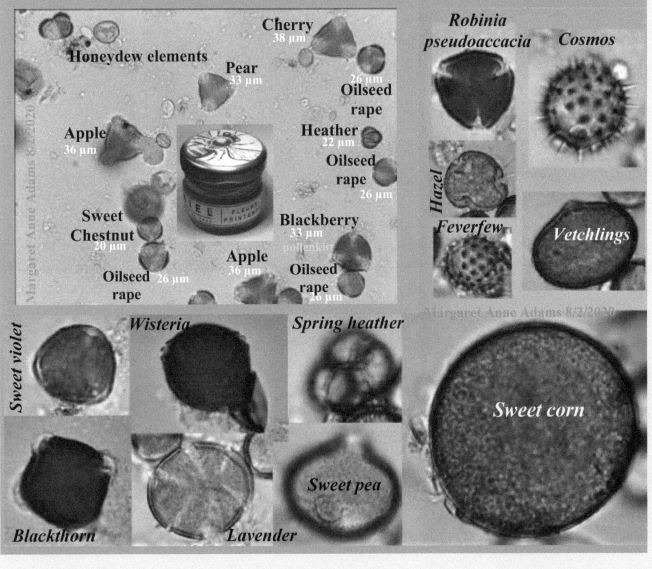

Miel Pont de Vaux printanier 2020

Le miel crémé Pont de Vaux a été produit par les abeilles et pas par la méthode Dyce.

Cela est le résultat de circonstances exceptionnelles. Premièrement, les ruches sont dans un verger qui entoure la ferme et son jardin, tous deux bien fournis de plantes aimées par les abeilles; ensuite en 2019 et 2020, les fermiers n'ont pas semé du Colza, néanmoins il y avait suffisamment de colza indigène, parmi toutes les autres fleurs sauvages, pour rendre le miel printanier crémeux sans le durcir.

Miel Pont de Vaux printanier, provenant de Colza indigène, fleurs d'arbres fruitiers et du jardin plus des fleurs sauvages, en 2020

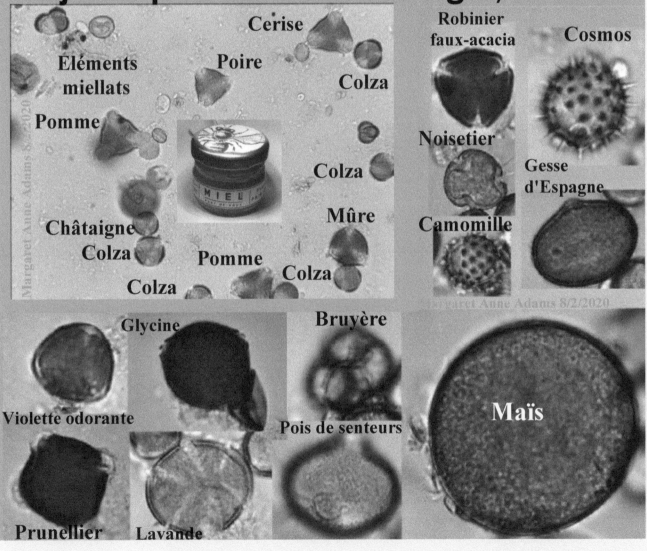

Paul Grand's French honey (summertime 2020)
Wild and garden flower

There were four different Centaurea species in Paul's honey; we call them knapweeds in the UK. The name 'Star Thistle Honey' used in the USA for Centaurea honey is prettier. The four are *Centaurea jacea* (Brown knapweed); *Centaurea simplicicaulis*; *Centaurea montana* (Perennial cornflower); *Centaurea cyanus* (cornflower). The flowers are all beautiful and the plants spread, yielding plenty of pollen and nectar for bees.

Like Paul's springtime honey this summertime honey is derived from nectar from a wide variety of flowers and from lime honeydew.

Paul's bees have made some excellent honey to see them through the winter months.

Paul Grand's French, summertime, wild and garden flower honey 2020

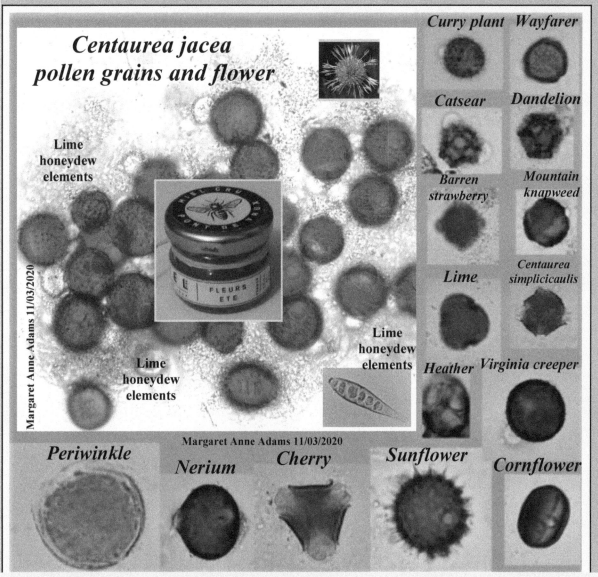

Centaurea jacea pollen grains and flower

Lime honeydew elements

Lime honeydew elements

Lime honeydew elements

Margaret Anne Adams 11/03/2020

FLEURS ETE

Curry plant

Wayfarer

Catsear

Dandelion

Barren strawberry

Mountain knapweed

Lime

Centaurea simplicicaulis

Heather

Virginia creeper

Margaret Anne Adams 11/03/2020

Periwinkle

Nerium

Cherry

Sunflower

Cornflower

Honey bees do collect Daffodil pollen

There are thousands of daffodils in the garden, and this year the Honey bees are harvesting their pollen in daffodils, all through the foraging day, despite Alder, Hazel Wych elm and Willow pollen being available. There is tasty, sweet nectar too, in the bottom of the pollen tube, as a reward, if they manage to reach it.

Bees do collect daffodil pollen

Unusual pollen for March, at a hive entrance

All photos by Margaret Anne Adams March 2021

Returning forager at the hive entrance with pale yellow pollen loads at 1 pm on 29/03/2021

Close up of one of the bee's pollen loads

The pollen loads are daffodil pollen Grains 56 μm

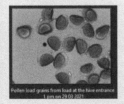

Pollen load grains from load at the hive entrance 1 pm on 29 03 2021

Forager with pollen loads captured by John on a white daffodil at 3 pm on 29/03/2021

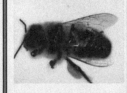

Close up showing pollen loads

The pollen loads are daffodil pollen Grains 56 μm

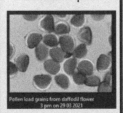

Pollen load grains from daffodil flower 3 pm on 29 03 2021

Returning forager at the hive entrance with pale yellow pale yellow pollen loads at 4 pm on 29/03/2021

Close up of both of the bee's pollen loads

The pollen loads are daffodil pollen Grains 56 μm

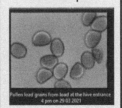

Pollen load grains from load at the hive entrance 4 pm on 29 03 2021

Daffodil Narcissus albus, picked to examine it's pollen on 30/03 2021

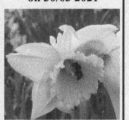

Close up of the pool of sweet nectar at the bottom of the flower tube

Close up of the stigma and style and of the dehisced anthers with pollen

Grains 56 μm

Amaryllidaceae Daffodil pollen 30 03 2021

Gorse pollen loads can be brown or orange

The nutritional value of daffodil pollen does not seem to have been recorded, but today the colonies had organized the foragers to bring in one of the most nutritious pollen available as if they were compensating.

In Scotland, Whin or Gorse pollen is a valuable source of protein for bees; the crude protein is well above the 20% minimum level required. Wherever honeybees have access to quantities of this brown or orange pollen, colonies should expand, and the resulting bees should be long lived.

GORSE POLLEN LOADS CAN BE BROWN OR ORANGE

Pollen load colour partly depends on the saliva, nectar and honey crop contents that the forager mixes with the pollen grains,when she packs the pollen baskets

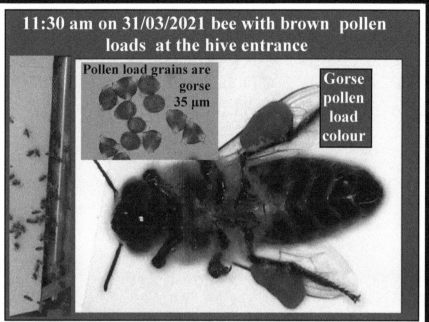

11:30 am on 31/03/2021 bee with brown pollen loads at the hive entrance

Pollen load grains are gorse 35 µm

Gorse pollen load colour

Photos Margaret Anne Adams 31/03/2021

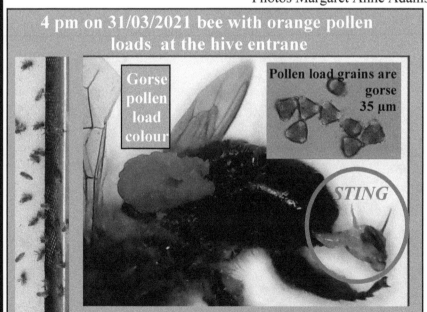

4 pm on 31/03/2021 bee with orange pollen loads at the hive entrane

Gorse pollen load colour

Pollen load grains are gorse 35 µm

STING

Gorse flowers

Honey bees do forage for pollen in the yellow King Alfred daffodils too

It seems that bees will work daffodils that have recently opened and are bathed in sunshine.

One of the foragers in the King Alfred daffodils was photographed while she was in the flower, foraging for pollen; she was then trapped, for examination of her pollen loads, by folding the top of the trumpet and cutting the flower stem. The pollen loads were washed in water, to remove most of the saliva, nectar and crop contents that she had used, to stick the grains securely together, into the pollen baskets, on her hind legs; the grains were then stained and examined on a slide, under the microscope. They were large grains, measuring 64 μm.

There was a second surprise, as a rare Heath bumblebee, Bombus jonellus was going from daffodil to daffodil, foraging for nectar in the bottom of the trumpets. It would be amazing to see her young in the garden, if she raises brood successfully this year.

Even BETTER news

Honey bees forage for pollen in the yellow King Alfred daffodils

King Alfred daffodils in the morning sun 02/04/2021

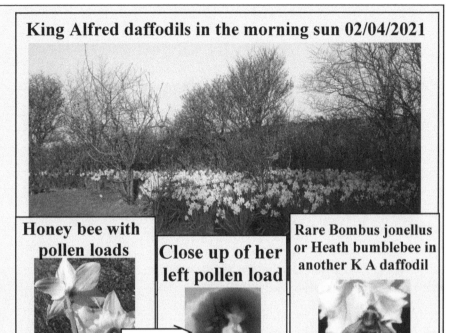

Honey bee with pollen loads

Close up of her left pollen load

Rare Bombus jonellus or Heath bumblebee in another K A daffodil

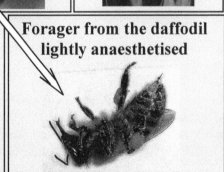

Forager from the daffodil lightly anaesthetised

Pollen load grains washed in water, and stained 64 μm

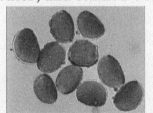

Detail of pollen load

Photos: Margaret Anne Adams 02/04/2021

Pollen loads at the hive entrance – 03/04/2021
Salicaceae, *Salix caprea*, Goat willow 18 μm

The pollen loads on the bee in the photo are beautifully made. As she gathered the pollen to pack it into the pollen baskets, she had moistened the pollen grains to the extent that the separate batches, extruded from the pollen press, are clearly visible on the outside of the load. There were a few tiny patches of brown gorse pollen in the pollen load too.

The moisture applied by the forager has washed some colour from the exine and made the green cytoplasm, inside the transparent grains, more visible. This is seen even more clearly after washing the pollen load in warm water, to get rid of the nectar, honey and saliva; all the yellow surface colour of the exine disappeared and all the grains were green because the cytoplasm inside was visible. After being dried, the grains were stained with glycerine jelly for the microscopic examination.

Wind pollinated plants like goat willow, produce clouds of pollen when touched. When the forager returns to the hive dusted with so much pollen, many grains fall off in the hive and drop onto the frames and the floor.

Pollen loads 03/04/2021, from the hive entrance. Salicaceae, Salic caprea, Goat willow, 18 μm

Detail of a beautifully formed load, made from pollen thoroughly moistened by the forager into a paste, squeezed out a bit at a time, from the pollen press onto the corbicula, and pushed in place by the middle leg tarsus.

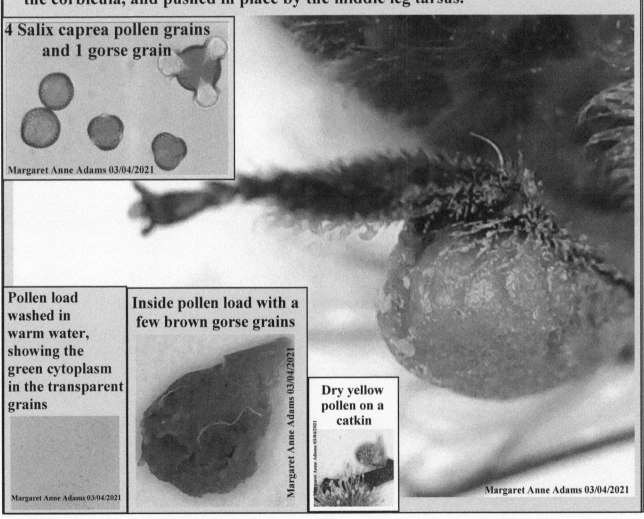

4 Salix caprea pollen grains and 1 gorse grain

Margaret Anne Adams 03/04/2021

Pollen load washed in warm water, showing the green cytoplasm in the transparent grains

Margaret Anne Adams 03/04/2021

Inside pollen load with a few brown gorse grains

Margaret Anne Adams 03/04/2021

Dry yellow pollen on a catkin

Margaret Anne Adams 03/04/2021

Margaret Anne Adams 03/04/2021

Section 6

Identifying pollens in honey, that are not in our own collection of microscope slides from flowers

by Christine Coulsting

The architecture of a pollen grain
Reproductive mechanism

Pollination is the transfer of pollen grains from an anther to the stigma of a different flower of the same species of plant which results in fertilisation and the production of seeds. This transfer from plant to plant is cross-pollination, although a few plants can self-pollinate.

For the majority of plants this transfer of pollen is aided by insects, who travel from plant to plant transporting the pollen grains as they move around. Other plants are wind pollinated, these plants produce a lot of pollen as transfer by wind is less efficient.

In plants, the male gamete is protected for transport within a protective capsule - the pollen grain. In the interior of the grain, the sperm cells are surrounded by cytoplasm, and this is covered by a thin layer called the intine.

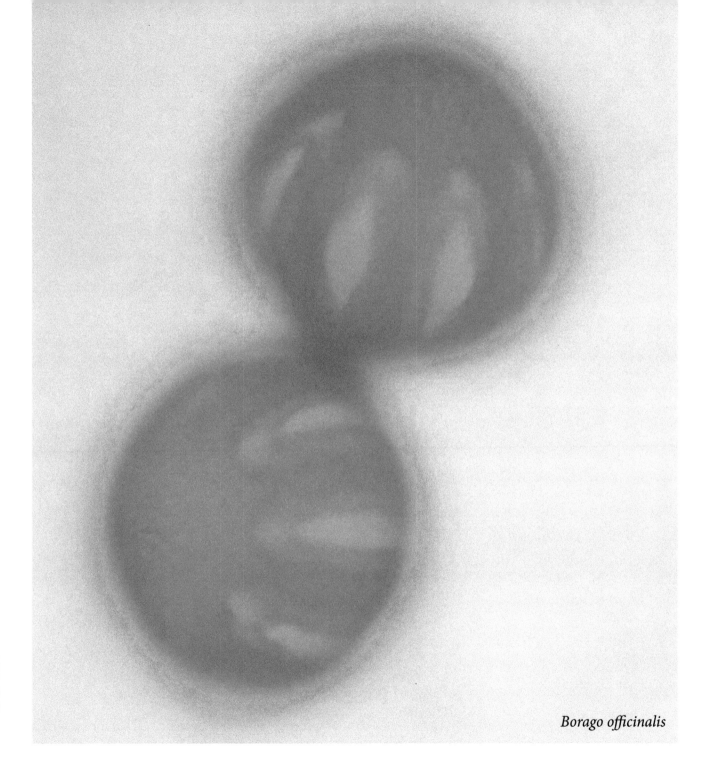

Borago officinalis

The architecture of a pollen grain
Surface and exine

The outer protective layer is the exine is made of a very hard, durable material - sporopollenin.

The exine itself can be made up of several layers: A base layer covers the intine and then there is often a columellar layer, before the outer surface called the tectum. Some of these layers may be absent.

The base layer usually stains well, and can be seen under the microscope.

The surface pattern, any ornamentation such as spikes or striation that we see under the microscope are all either modifications of the tectum or of the exposed columellae.

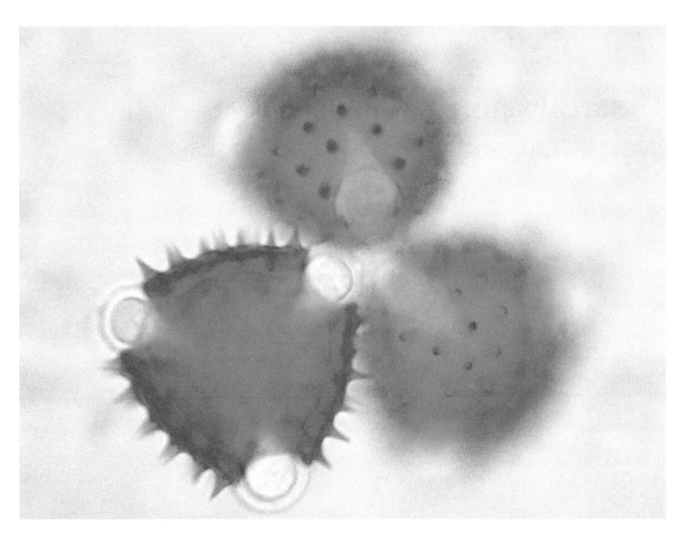

Calendula

The architecture of a pollen grain
Escape hatches – Furrows and pores

Whether the pollen grains are transferred by wind or insect transportation to the stigma, the sperm cells then have to escape from the protective casing of the exine and travel down the style to reach the ovary so that fertilisation can take place.

All pollen grains have one or more areas on the grain where the exine is absent. These are the furrows and pores, each of these areas is covered by an aperture membrane over the intine layer and the membrane is designed to burst under pressure.

In its natural state, pollen grains are shrivelled up and they expand when hydrated. The furrows and pores not only allow the pollen tube to exit from the grain but also allow the grain to hydrate and expand.

Moisture on the surface of the stigma expands the pollen grain and the intine bursts through an aperture membrane forming a pollen tube.

The sperm cells are carried in the tip of the pollen tube which grows down the style to the ovary where fertilisation takes place.

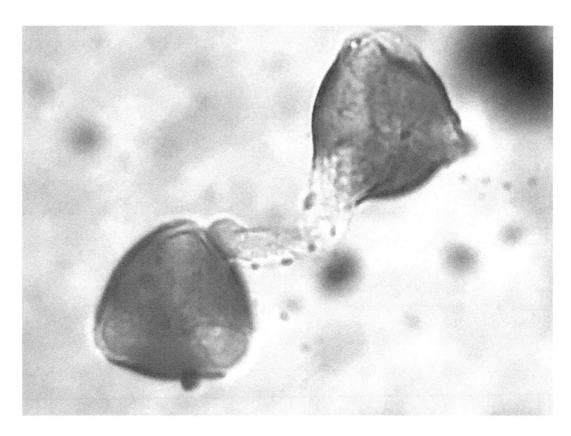

Malus domestica
Pollen tube

The architecture of a pollen grain
Shape

Pollen grains vary in shape, although photos of pollen grains very often show the polar view, don't forget that the grains are 3-dimensional. A typical polar view may present a round or round-triangular grain, but looking at the equatorial view will reveal that the grain may actually be a sphere, cylinder, football, rugby ball, or smartie shape in 3d.

To describe the orientation of pollen grains, we use the same terminology as that used for a planet. Many pollen grains have furrows which run longitudinally from pole to pole, although they vary in length. Pores are usually located on the equator. These factors can help determine the orientation of a pollen grain.

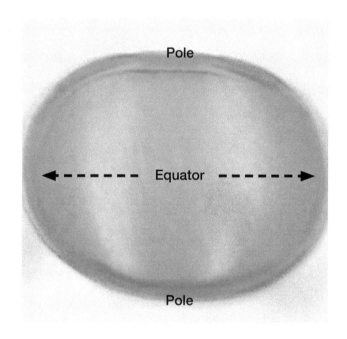

Rosmarinus officinalis (equatorial view)

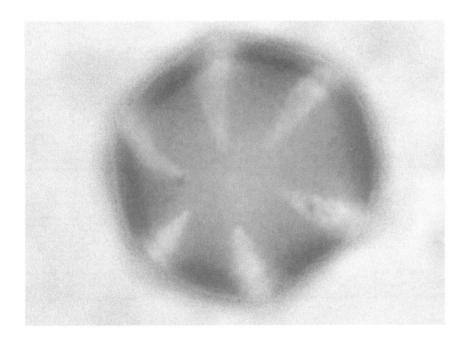

Rosmarinus officinalis (polar view)

The architecture of a pollen grain
Variations

The shape of the pollen grains of a particular species can also vary depending on how well the grain has hydrated. e.g. *Brassica napus* – depending on hydration can be seen as a rugby ball shape, or football.

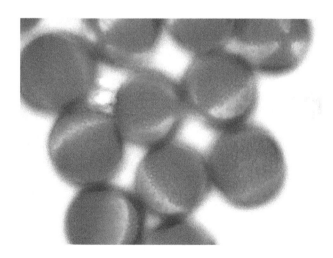

Brassica napus

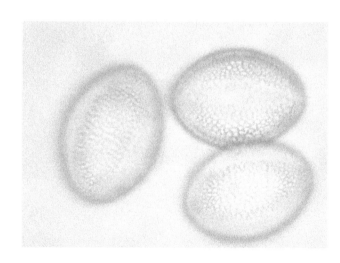

Brassica napus

Shrivelled grains

Some of these grains of *Erysimum cheiranthus* have not expanded and look shrivelled.

Rubus, *Trifolium repens* and *Clematis vitalbaoften* show this.

I have also heard of *Crocus* presenting as a giant grain.

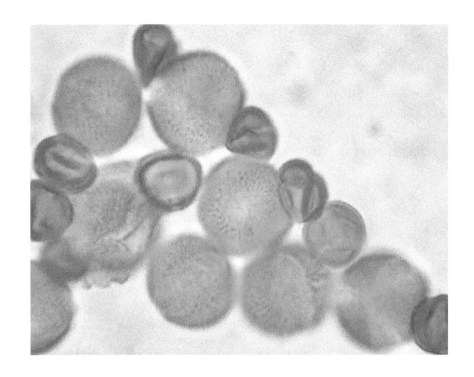

The architecture of a pollen grain
Pollenkit

Pollenkittis an oily substance which is produced by the inner layer of the anther wall. Once the pollen grain matures it is covered in pollenkitt.

In addition to protecting the cytoplasm from solar radiation (sunscreen for pollen grains), the pollenkitt attracts insects, helps the grain to stick to visiting insects and maintains the pollen protein inside the exine cavities.

Some plant families tend to have more pollenkittthan others – Asteraceae species in particular. Anemophilous (wind blown) pollens have less pollenkittas the insect functions are not required.

When preparing your reference slides, wash the grains with IPA to remove the pollenkitt. Some grains may need more cleaning than others.

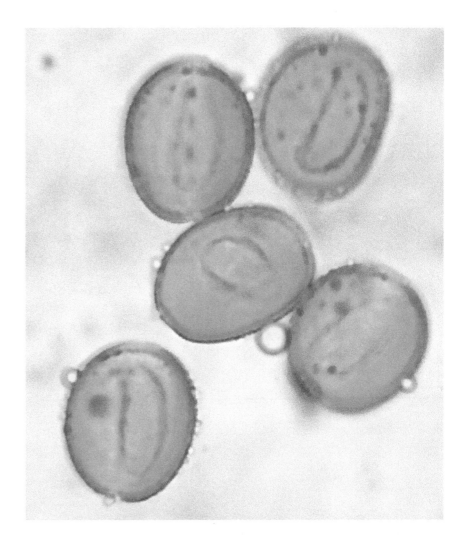

Pollenkitton *Galanthus nivalis* pollen

Recognising and recording the characteristics of pollen grains

Web resources

- Wikipollen
- Paldat
- Global Pollen Project

⊘ Alliaceae Hyacinthoides non-scripta

⊘ Amaryllidacea e Galanthus nivalis pollen 33 um

⊘ Amaryllidacea e Galanthus nivalis

⊘ Amaryllidacea e Leucojum pollen 30 um

⊘ Amaryllidacea e Leucojum

⊘ Apiaceae Heracleum Sphondylium

⊘ Apocynaceae Vinca major pollen 94 - 101 um

⊘ Apocynaceae Vinca major

⊘ Aquifoliaceae Ilex aquifolium pollen 33 um

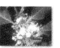
⊘ Aquifoliaceae Ilex aquifolium

⊘ Asteraceae 1 Bellis perennis

⊘ Asteraceae 1 Senecio jacobaea pollen 32 u...

⊘ Asteraceae 1 Senecio jacobaea pollen 32 um

⊘ Asteraceae 1 Senecio jacobaea

⊘ Asteraceae 2 Helianthus annus

306

Plant name	Common name	Flowering time	ID Notes	Plant family		Slide numbers	Size µm as per Wiki	My measuremnt Size µm	Sawyers sizing	2. Sawyers Shape	Shape PV	Shape Eq View	3. Aperture number	4 Aperture type	5. Surface	6. Exine Section	7. Other structural feature	8 Pollen colour
Acer campestre	Common maple			Aceraceae			34		3	2 5	5	2	3	2	3	2 3		1 5
Acer pseudoplatanus	Sycamore			Sapindaceae		167,168,169	38	40	3	2 5	5	2	3	2	3	2 3		2
Achillea millefolium	Yarrow			Asteraceae 3		297,298,299	32	29	2	1 5	5	1	3	3	2 5	5 7		5
Aegopodium podagraria	Ground elder			Apiaceae			33	33	3	4	1	4	3	3				
Aesculus hippocastrum	Horse Chestnut	May>	Brick red pollen	Sapindaceae		164,165,166 oval round	24	21	1	3	1	3	3	3	1 3	1	4	3
Alnus glutinosa	Alder		CC	Betulaceae		42,43,44,	26	21 - 24	2	2 7	7	2	4	1	1	2	2 5	5
Alopecurus pratensis	Foxtail grass			Gramineae			29		3	1 1	1	1	2 2	1	1	1	2 3	1
Amelanchier lamarkii				Rosaceae		386,387		27 - 32	2		5	2	3 4	3				
Anenome nemorosa	Wood anemone			Ranunculaceae			27		2	2 5	5	2	3	2	2	2 3	4	1
Anthriscus sylvestris	Cow Parsley			Apiaceae		388,389	26	27	2	4	1	4	3	3	1 4	2 3		5
Arctium	Burdock		CC	Asteraceae		2	44	44	3									
Asparagus officinale	Asparagus		CC	Asparagaceae		220,221,222	22	24	2	6			6	2	1 4	2 3	6	4
Aster amellus (novi-belge)	Michaelmas daisy		CC Med ex plus broad spines	Asteraceae 1		3,5	29	27 - 32	2	1 5	5	1	3	3	5	2 7		5
Bellis perennis	Daisy		CC	Asteraceae 2		123,124,125	18	21	2			1	3	3	5	7		
Borago officinalis	Borage		Surface net/granular	Boraginaceae		304,305,306	36	36	2 3	1 2	1	2	5	2 3	2 4	2 -3		1

Pollen Identification for Beekeepers
Rex Sawyer

HONEY IDENTIFICATION
Rex Sawyer
Cardiff Academic Press

THE POLLEN LOADS OF THE HONEY BEE
DOROTHY HODGES

Building a reference collection of pollen slides

There are thousands of pollen producing plants, so where to start?

Use a list of local plants in your area that you think your honey bees forage on as a starter, otherwise find a list such as theone given for the BBKA Microscopy Certificate. The plants the bees forage on will vary considerably from apiary to apiary, as you will have seen from the profiles of the honey samples that Margaret has analysed. Even two hives side by side may be quite different.

A longer list of plants is available from the NDB website if you would like to expand your collection.

Add to this basic list, plants that flower around your apiaries perhaps plants such as *Tilia*, *Castanea sativa*, *Chamerion angustifolia*, *Impatiens glandulifera*.

Do be careful to identify the plants accurately. There are many plants which are very similar.

Once you start analysing your honey samples, other pollen grains may be found and there may be particular plants you can then locate and add to your collection, even grass pollen.

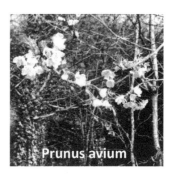
Prunus avium

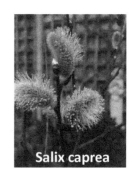
Salix caprea

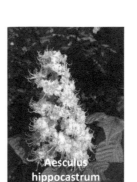
Aesculus hippocastrum

Vicia faba

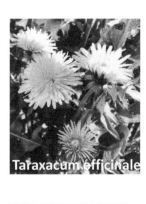

Taraxacum officinale

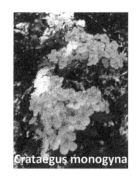

Crataegus monogyna

Brassica napus

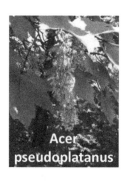

Acer pseudoplatanus

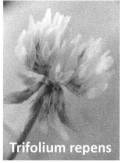

Trifolium repens

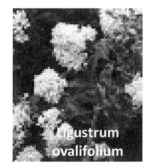

Ligustrum ovalifolium

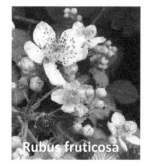

Rubus fruticosa

Hedera helix

Practice identifying the characteristics of pollen

As you make your reference slides – practice identifying the characteristics of the pollen, and then compare your findings against Sawyers spreadsheet of characteristics and start building a spreadsheet of your own.

This will help to clarify how to interpret the features you will be seeing down the microscope.

Building a crib sheet of features may be helpful using your own photographs of pollen, or even drawing the detail you can see.

The level of detail that is visible will vary according to your microscope and the magnification you are using.

Taking your time to ensure that your microscope is set up correctly will pay dividends in producing a clearer view of the detail of the characteristics used to distinguish pollen grains.

Name	Time of year	Features							
		1. Size	2. Shape	3. Aperture numbers	4. Aperture type	5. Surface	6. Exine, Section	7. Other structural features	8 Pollen colour
Forget me not Myosotis		1	4/7	4/5	(3)	1	1	.	5 Boraginacae
Dandelion Taraxacum		2/3	1/7	3	1	4/5	8/9	.	4 Asteracae
Achillea millefolium Sawyer	July.	29µm. 2 ✓	1/5.	3	FWP 3	2 4/5 ✓	5+7 ✓	—	5. ✓
Verbena.		29-32 2/3.	4/5	3.	1 Pores baly ✓short F.	1 indet.	2 med no rods	—	white.
30/ Borage Sawyer	July.	29-30 2 3	1/2 Round oval	(7-12) 5 ✓	Furrows. 2+ Pores 2/3 ?Somewll Pores?	(4) Net. 1/2?? carlook granulas or Netted.	2 med (3)	?Granules or pattern on F. —	White to Grey. 1 ✓
31/7 Knautia arvensis Scabious July.		114µm. 5	1-5.	3/4 4-6	① ✓	9. 5 2+5	5.8. 5+8	4.6 4+7	yellow orange. 4.5 pink/Red 3.
7/8 Linum Bienne Aug	Sawyer 113	4-5 61µm 4	2-5. 4/5	✓ 3	Furrows 5.2	2 ?	2	4+7	1 Flax
8/8 Polemonium caeruleum Sawyer Polemoniaceae.	*photos 30x transfixed	43µm. 3 ✓	1 Round	6 -✓ (12+)	Pores 1 ✓	3-Small 3/4 ✓	Bead or coarse rods	spaced = coarse rods intire thick white/grey. 6/7	white/yellow? 4/5 orange
9/ cominops		~60µm	6 semic Bluesh					6/7	1

Practice identifying the characteristics of pollen
Measuring

Use an eyepiece graticule which has been pre-calibrated using a stage micrometerto guagethe size of the grain.

The measurement is usually taken across the equatorial section at the widest point. Any ornamentation should not be included (ref paldat) or excess bulging of pores.

Long, or long oval grains are measured lengthwise from pole to pole as this tends to be how they sit on a reference slide. I like to take and record measurements for both polar and equatorial view as this can help identification.

Do be very aware that pollen grains vary in size, even grains from the same species. Applying hydration and warmth will influence this. Dry pollen will be smaller, and in a dehydrated, shrivelled form.

Materials used to prepare the slide iegel, water and IPA will all hydrate the pollen grain and the size will also tend to increase over a period of time from when a reference slide has been prepared.

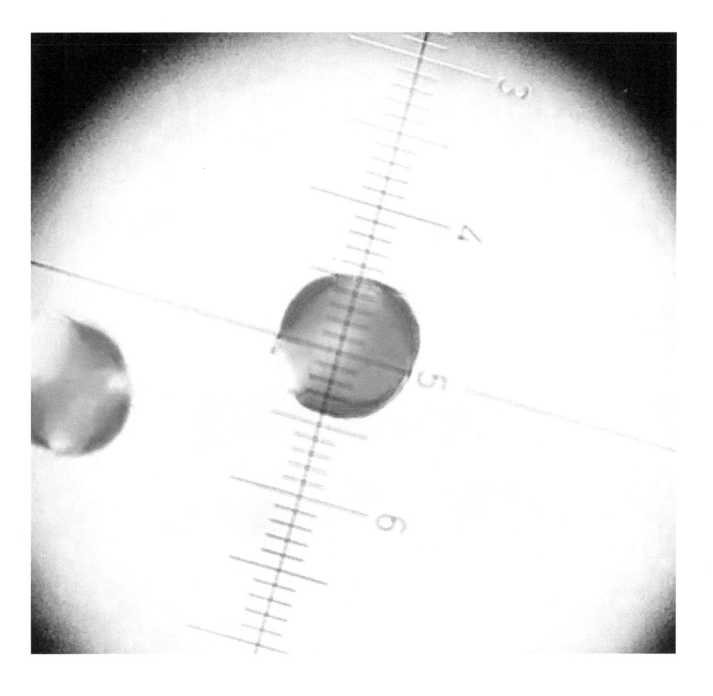

Practice identifying the characteristics of pollen
Shape

Record the shape of the grain from both the polar view and also the equatorial view.

When working on a honey sample, due to the extra depth which results from the residue of the honey, the pollen grains may present differently to those usually seen on a reference slide and be viewed from a different aspect to normal.

Having separate columns on your record system for polar and equatorial view helps to determine the shape more accurately.

Reference slide – equatorial views

This pollen grain was found in a sample of honey. I puzzled over it for a long time. Other round pollens that I had found with this granular surface were Gramineae species, but they only have one pore, whereas this specimen had three.

I eventually realised that this is in fact the polar view of *Vicia faba*.

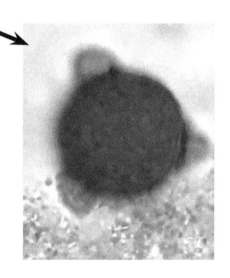

Vicia faba
Polar view (samples in honey)

Oblique polar and
equatorial views

Apertures
Types

Furrows range in width and length and run longitudinally from pole to pole.

Pores tend to be circular in shape and are usually situated on the equator of the grain.

Some apertures consist of furrows with pores.

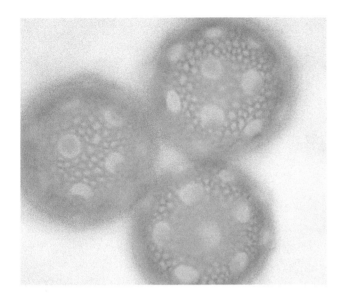

Silene latifolia
Pores

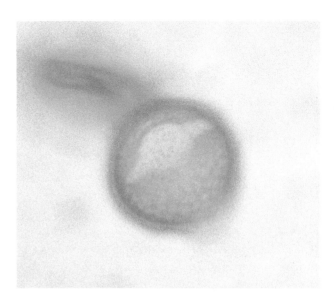

Trifolium pratense
Furrow with pore

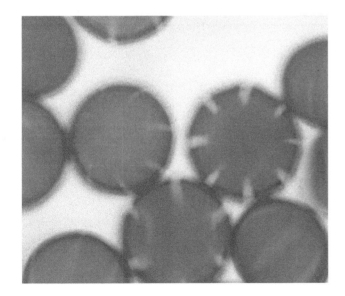

Primula vulgaris
Furrows

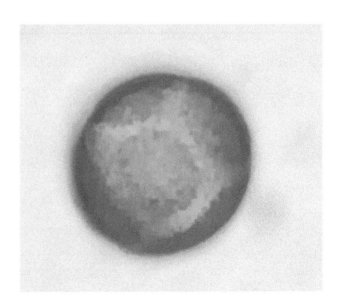

Mahonia x media
Irregular furrows

Apertures
Number

Whilst many pollen grains will have three apertures, the number of apertures can vary from one to many.

Sawyer uses two columns, to record the number of apertures and type separately.

Another method is to use the latin terms – Wikipollen and Paldat categorise pollen using this method.

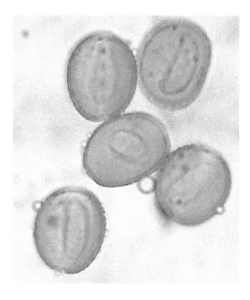

Galanthus nivalis
Single furrow (monocolpate)

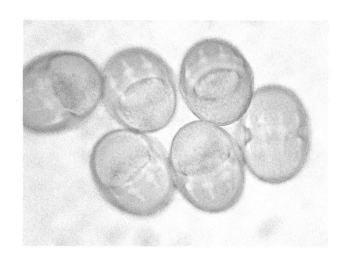

Symphytum glandiflorum
6+ furrows with pores (stephanocolporate)

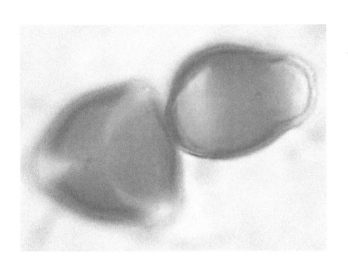

Prunus lauroserasus
3 furrows with pores (tricolporate)

Onobrychis viciifolia
3 furrows (tricolpate)

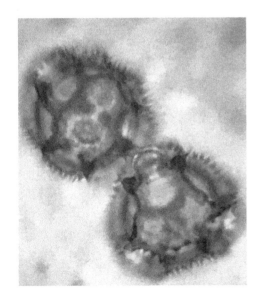

Sonchus olerasus
3 pores (triporate)

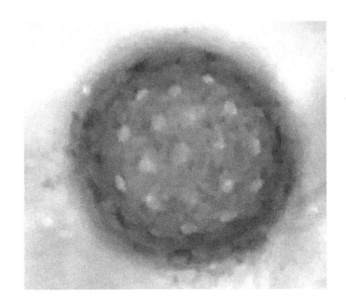

Chenopodium
Multiple pores (periporate)

Apertures
Variations of number

Just to confuse matters slightly, some species are more likely to have a varying number of pores.

Whilst Rosaceae species usually have 3 apertures, some individual specimens may have 4, as shown in these photos of Amelanchier.

 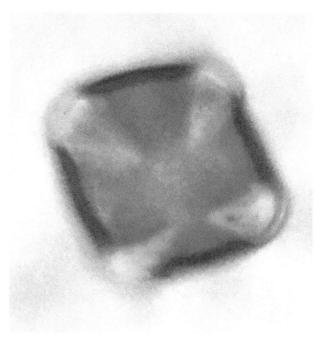

Amelanchier – 3 and 4 apertures

Surface

If we were all lucky enough to be able to view the grains using SEM we would see the surface clearly and be able to differentiate a granular surface from a striate one. However, using light microscopy we are more limited in the detail we can distinguish.

What may in reality be a striate surface, will be observed as granular or indefinite at a lower magnification. Sawyers spreadsheet sometimes lists the more detailed view which may be visible in brackets.

Paldat is a useful reference site as SEM photos are available of many specimens and these can help interpret what you are observing.

Beware of recording more detail in your record system than you can see using your own microscope.

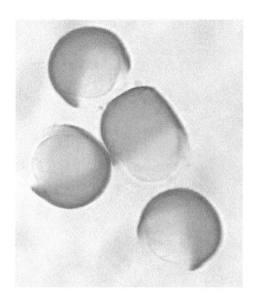

Asparagus officinale
Smooth surface

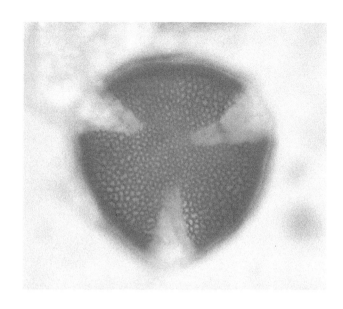

Jasminum nudiflorum
Netted surface

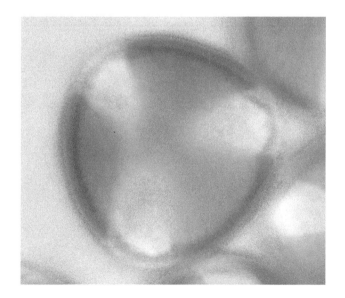

Acer pseudoplatanus
Striate surface

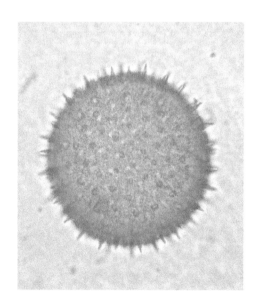

Malva sylvestris
Isolated dots

Exine

To see the exine clearly adjust the focus down through the centre of the grain to see the optical section.

These are some examples of the varying characteristics of the exine to look out for.

Salix caprea
Medium spaced rods

Coryllus avellana
Medium, no rods

Ligustrum ovalis
Coarse rods

Crocus chrysanthis
Thin exine

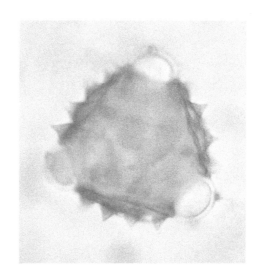

Carduus crispa
Large, broad based spines

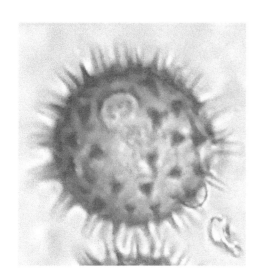

Helianthus annus
Long, thin spines

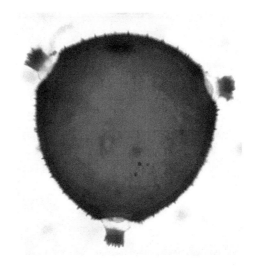

Knautia arvensis
Close thin rods and small surface projections

Other features

Onobrychis viciifolia
Ornamented furrow

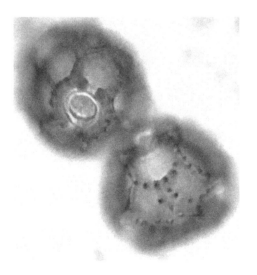

Sonchus oleraceus
Fenestrate

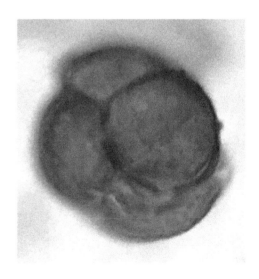

Calluna vulgaris
Compound grains

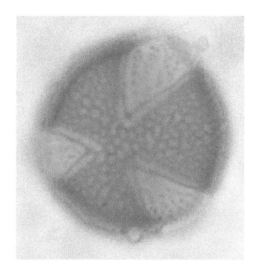

Helleborus
Ornamented edge to furrow

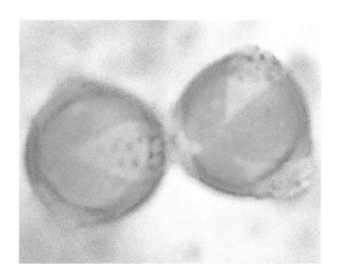

Aesculus hippocastrum
Granules on apertures

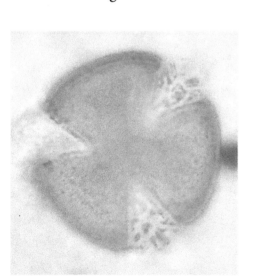

Centranthus ruber
Ornamented furrow

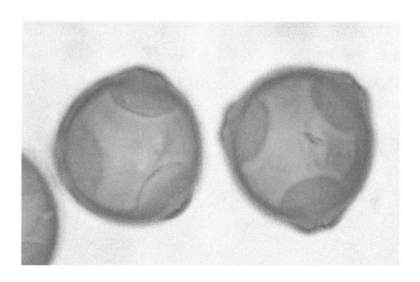

Coryllus avellana
Projecting edges and swollen intine to apertures

Colour

If we were all lucky enough to be able to view the grains using SEM we would see the surface clearly and be able to differentiate a granular surface from a striate one. However, using light microscopy we are more limited in the detail we can distinguish.

What may in reality be a striate surface, will be observed as granular or indefinite at a lower magnification. Sawyers spreadsheet sometimes lists the more detailed view which may be visible in brackets.

Paldat is a useful reference site as SEM photos are available of many specimens and these can help interpret what you are observing.

Beware of recording more detail in your record system than you can see using your own microscope.

Gather a few more clues to help you

A little knowledge goes a long way

There are 1000s of flowering plants available for the bees to forage on and many grains have very similar characteristics.

- What time of year was the honey extracted?
- Situation: Rural? Urban? Orchard? Heather stand?
- What is growing in the vicinity of the apiary?

If the time period of the sample is known, the number of potential nectar producing plants can be reduced.

Sometimes other grains in the sample will give you a clue as to when the honey was collected.

Recording the pollen reference slides to form a spreadsheet or database

If you have good technical skills you may be able to set up a database to record the features of the pollen. A database would be capable of including photos, and would enable you to filter out a range or ranges of characteristics which will help with identifying a pollen grain from an unknown source.

For those us with less technical knowhow, a spreadsheet is an alternative tool but perhaps not quite as versatile.

Plant name	Common name	Flowering time	ID Notes	Plant family
Acer campestre	Common maple			Aceraceae
Acer pseu-doplatanus	Sycamore			Sapindaceae
Achillea millefolium	Yarrow			Asteraceae 3
Aegopodium podagraria	Ground elder			Apiaceae
Aesculus hippocastrum	Horse Chestnut	May>	Brick red pollen	Sapindaceae
Alnus glutinosa	Alder		CC	Betulaceae
Alopecurus pratensis	Foxtail grass			Gramineae
Amelanchier lamarkii				Rosaceae
Anenome nemorosa	Wood anenome			Ranunculacea
Anthriscus sylvestris	Cow Parsley			Apiaceae
Arctium	Burdock		CC	Asteraceae
Asparagus officinale	Asparagus		CC	Asparagaceae
Aster amellus (novi-belge)	Michael-mas daisy		CC Med ex plus broad spines	Asteraceae 1
Bellis perennis	Daisy		CC	Asteraceae 2
Borago officinalis	Borage		Surface net/ granular	Boraginaceae

My spreadsheet of pollen characteristics – adapted from Sawyers chart

Slide numbers	Size μm as per Wiki	My measuremnt Size μm	Sawyers sizing	2. Sawyers Shape	Shape PV	Shape Eq View	3. Aperture number	4 Aperture type	5. Surface	6. Exine Section	7. Other structural feature	8. Pollen colour
	34		3	2 5	5	2	3	2	3	2 3		1 5
7,168, 9	38	40	3	2 5	5	2	3	2	3	2 3		2
7,298, 9	32	29	2	1 5	5	1	3	3	2 5	5 7		5
	33	33	3	4	1	4	3	3				
4,165, 5 oval nd	24	21	1	3	1	3	3	3	1 3	1	4	3
43,44,	26	21 - 24	2	2 7	7	2	4	1	1	2	2 5	5
	29		3	1 1	1	1	2 2	1	1	1	2 3	1
5,387		27 - 32	2		5	2	3 4	3				
	27		2	2 5	5	2	3	2	2	2 3	4	1
3,389	26	27	2	4	1	4	3	3	1 4	2 3		5
	44	44	3									
9,221,	22	24	2	6		6	2	2	1 4	2 3	6	4
	29	27 - 32	2	1 5	5	1	3	3	5	2 7		5
5,124,	18	21	2		1		3	3	5	7		
,305,	36	36	2 3	1 2	1	2	5	2 3	2 4	2 -3		1

Building up a bank of pollen photos

Another useful tool is to build up a bank of photos of your pollen samples.

A helpful tip I picked up from Margaret is to file them in a separate folder and prefix the name of each pollen sample with the flower family and this will group many of the similar specimens together.

Adding the measurement may also help distinguish look alikes.

 Aceraceae - Acer pseudoplatanus 34 um

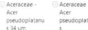 Aceraceae - Acer pseudoplatanus

 Alliaceae Hyacinthoides non-scripta pollen 48 um

 Alliaceae Hyacinthoides non-scripta

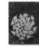 Apiaceae Daucus carota pollen 28 um

 Apiaceae Daucus carota

 Apiaceae Heracleum sphondylium pollen 38 um

 Apiaceae Heracleum Sphondylium

 Asparagaceae Scilla mischt.. pollen

 Asparagaceae Scilla mischtschenkoana

 Asteraceae 1 - Bellis perennis 21 um

 Asteraceae 1 Bellis perennis

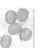 Amaryllidaceae Galanthus nivalis pollen 33 um

 Amaryllidaceae Galanthus nivalis

 Amaryllidaceae Leucojum pollen 30 um

 Amaryllidaceae Leucojum

 Apocynaceae Vinca major pollen 94 - 101 um

 Apocynaceae Vinca major

 Aquifoliaceae Ilex aquifolium pollen 33 um

 Aquifoliaceae Ilex aquifolium

 Asteraceae 1 Senecio jacobaea pollen 32 u..

 Asteraceae 1 Senecio jacobaea pollen 32 um

 Asteraceae 1 Senecio jacobaea

 Asteraceae 2 Helianthus annus

Identifying pollen loads

Identifying pollen loads has some advantages – the pollen colour is easily distinguished, and also the timing and location within the foraging area of an apiary.

Pollen loads can be retrieved off the corbiculae of a returning forager.

I have often found pollen on varroa monitoring boards, or taken samples from cells around the brood nest.

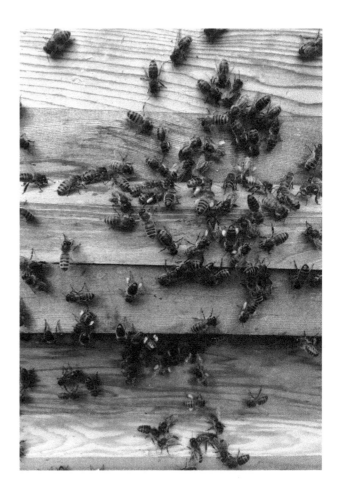

Pollen loads - the bright orange pollen mystery

Our association apiary is nestled in a bluebell wood, sited way out of town in woodland.

Every year, late summer I noticed distinctive bright orange pollen loading the pollen sacs of returning foragers.

Looking up various pollen charts, the colour seemed to indicate that perhaps a keen gardener not too far off was filling up their borders with Dahlias. Last year, when the bright orange pollen started filling up the pollen arc, I took the opportunity of taking a few loads home to make up a slide to assuage my curiosity.

To my surprise, the pollen sample was neither Dahlia or *Gazania* as the charts had hinted.

The grain was a boat shape, size 24 μm.

Boat shape pollen is not common, on referring to my spreadsheet I found just four specimens with this shape: *Echinops*, *Galanthus*, Asparagus and *Hyacinthoides*. *Galanthus* and *Hyacinthoides* were the wrong time of year, and *Echinops*, being a member of the *Asteraceae* family is spikey so these could be eliminated, leaving Asparagus.

In building my reference collection I had made up slides from a list of plants taken from the NDB plant list. One of the specimens matched the orange pollen – Asparagus!

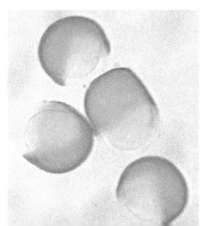

334

Whilst I was confident in my analysis, it seemed unlikely that even a keen gardeners vegetable patch would yield sufficient pollen as indicated by the rate of collection by the bees.

Early autumn, I was driving in the vicinity of the apiary, and noticed a field of butter yellow foliage. Being curious, I stopped and took a look.

Mystery solved – there were acres and acres of Asparagus over several fields and only a mile from the apiary!

A process of elimination – a few examples

Once the honey sample has been centrifuged to separate out the pollen, use the pollen obtained to make a working slide using your preferred method.

Give each honey slide a reference number, and then scan the slide using x100. This will give you an overview of what is on the slide.

Start by picking out a grain with distinctive characteristics, let's say for this example, a grain which is spikey (echinate). Centre the grain and view at x400 – take a few photos to show views of the surface, and also include a section to show the exine detail.

Save the photos and name each one using the slide number, include a slide location reference read from

the vernier scale on the microscope stage and add the measurement. Eg 363 113.2–32 36 µm.

This reference will allow you to return to that particular pollen grain when you need to view more details. If there are a lot of pollen grains in your sample, the photo will confirm which specimen you are working on. Take care to set up the photograph to show the same orientation as you see down the microscope.

Start by noting the characteristics of the pollen grain. Then, choose a distinctive characteristic, something more unusual if possible to reduce the amount of possible grains and select all matching samples in your records. Size is not usually much of a help at this stage, unless the specimen is particularly small or large.

Sample Location	Slide no/Ref	Family/ comparison notes	Size	Shape PV	Shape EV	Ap no	Ap type	Surface	Exine	Other structural feature	Colour	Timing	In vicinity of apiary?	Other notes
Sample A 105.5 - 26	363		46 x 30	nk	Long upright	3	FWP	Net	Thin to med				NK	

In this instance, the long, upright equatorial view was used, long, oval shaped specimens were also included as they are similar.

Work through the specimens and eliminate those which don't match. This is where your reference slides are of value and you can compare the details. If you don't have slides of some of the possible specimens, refer to Paldat or Wikipollen to see further detail.

I find it helpful to note why I have eliminated them.

Don't forget that the size of pollen grains can vary from grain to grain of the same species, so allow some leeway and eliminate on other features if possible.

I change the font of those I have eliminated into red and note the reason for rejection.

There were quite a few specimens like this one in the sample, the sizes varied as did the surface detail which in some specimens appeared to be mottled rather than a clear net.

Sample A

Location	Slide no/Ref	Family/comparison notes	Size	Shape PV	Shape EV	Ap no	Ap type	Surface	Exine	Other structural feature	Colour	Timing	In vicinity of apiary?	Other notes
Sample A 105.5 - 26	363		46 x 30	nk	Long upright		3FWP	Net	Thin to med		NK			
Possibles (inc slide nos) long & oval upright		**Spreadsheet analysis**												
Heracleum spondylium	334-6	Wrong shape, waisted	38		✓								✓	
Daucus carota	331-3	Too small, waisted	32 x 19		✓	✓	✓							
Vicia faba	202-4		48 x 37		✓	✓	✓	✓	✓				✓	
Onobrychis vicifolia	187-9	Too small, no pore	36 x 21		✓		X							
Melilotus officinalis	193-5	Surface granular, not netted	29/30		✓			X						
Centaurea cyanus	346-8	Wrong shape			X								✓	
Centaurea nigra	233-5	Wrong shape			X								✓	
Lotus corniculatus	239-241	Too small	24 x 19					X						

A process of elimination – a few examples

Sample D Location	Slide no Ref	Family/comparison notes	Size	Shape PV	Shape EV	Ap no	Ap type	Surface	Exine	Other structural feature	Colour	Timing	In vicinity of apiary ?	Other notes	
Sample D 109 - 24	363		25.5 um	Round	Round		Pores only 9	Granula r	Medium	Granule on apertures ?	NK			No furrows apparent,	
Possibles (inc slide nos)						2		5	12		2	NK			Spreadsheet analysis Selected AP type 1, no 5 (sawyers)
Plantago media	Wiki	Too granular	28	✓	✓	✓		X							
Plantago sempervirens	Wiki	Don't recognise plant	28	✓	✓	✓							No		
Plantago major	Wiki	Too granular	21	✓	✓	✓		X							
Plantago lanceolate	Wiki		28	✓	✓	✓							Yes		
Juglans regia	Sawyer	Too big	40	✓	✓	✓									
Ribes sanguineum	Wiki	Pores extend too far	32	✓	✓	✓									
Ribes uva-crispa	Wiki	Wrong timing,	24	✓	✓	✓						Too early			
Calystegia sepium	Wiki	Far too big	80	✓	✓	✓									

This was an unusual specimen – a spherical grain measured at 25.5 μm with a granular surface and multiple pores.

None of my reference slides were of help in this case.

According to Sawyer, the only possible candidates were *Plantago* or Juglans species.

I also searched on Wikipollen for periporate (multiple pore) specimens. These pollen class results are listed in size ranges. There was only one small specimen, but that had a netted surface – so was eliminated. In the medium size range (over 25 μm) possible candidates included: *Plantago*, *Ribes*, *Calystegia*.

Ribes – *R. sanguinium* - pores extend further and generally larger, *Uva-crispa* – possible, a better size but the wrong time of year.

Calystegia – Close, thin rods to exine and far too big – hence not picked up previously from my spreadsheet.

Of the Plantago specimens, all but one was eliminated as these were too big, too granular and *Plantago sempervirens* didn't look a familiar plant that I have seen locally. *Plantago lanceolate*, Ribwort plantain is growing close by to the apiary.

Sample H	Slide no Ref	Family/comparison notes	Size	Shape PV	Shape EV	Ap no	Ap type	Surface	Exine	Other structural feature	Colour	Timing	In vicinity of apiary ?	Other notes
Location 117.36.5	363		48 um	1		1	1 ?	Striate? 1Mottled	3					
Possibles (inc slide nos)		Spreadsheet analysis												
Hordeum murinum (Barley)		Gramineae	43											
Avena Sativa (Oats)		Gramineae	45											Shape not so good
Triticum sativum (Wheat)		Gramineae	52					.					No	
Oats and Barley grown 2020 (Matt)														

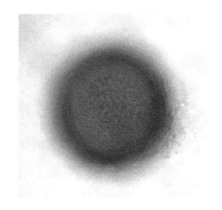

Another spherical grain, this one appears to only have one pore and an unusual pattern on the surface.

Most monoporate pollens are Gramineae (Grass family), and specimens in a similar size range included Barley, Oats and Wheat.

The manager of this Farm apiary site confirmed that in 2020, Barley and Oats were grown in adjacent fields to this hive.

The two grains are very similar, Barley is closer in shape and surface pattern and was also grown the other side of the hedge to the apiary – I have kept options open for now until I can take a sample of my own for direct comparison.

Using online resources

Your own reference slides will always provide the best detail for direct comparison of specimens.

As there are many 1000s of different pollen producing plants, no resource has a complete record of every plant.

However, the following online resources are particularly useful to help identify or eliminate potential pollen grains.

The main sites I find most useful are:

- Pollen wiki
- Paldat

Do be aware that these resources include plants from other parts of the world.

Each has their benefits and limitations.

Pollen Wiki

https://pollen.tstebler.ch/MediaWiki/index

There are various ways to search Pollen Wiki – take your time to explore the site.

'Species' – lists all plants to species level as a chart that can be further sorted into family, pollen class and size.

Each of the categories eg periporate – lists the specimens in size groupings.

'Left' option gives links to further information on pollen structure and further Palynology resources including other pollen databases.

Paldat

www.paldat.org

I find Paldat useful as it provides a search by Genus once you have identified a specimen to this level.

This provides a list that can be helpful to distinguish between the available species.

A combined search facility is also available, although more complicated to use.

There are also links to other databases, and a pdf on Illustrated Pollen terms is available as a download.

Section 7
Determining the composition of honey by measuring the proportions of the different pollens that it contains

by Alan Riach, August 2021

Determining the composition of honey by measuring the proportions of the different pollens that it contains

The number of pollen grains ending up in a given quantity of honey is always the same for a given plant. However, the number of grains varies widely for different plants. To determine on which plants the bees have been foraging, thus requires a proportioning measure. This involves using a Pollen Coefficient which is the number of pollen grains in a given quantity of honey. The standard used is the number of thousands of pollen grains in 10g of honey.

Pollen Coefficients have been established for various plants.

As an example, for bees foraging on Ling Heather, they will always end up leaving 12000 grains of heather pollen in a 10g sample of honey – the coefficient is therefore 12.

The following table [A] (from Rex Sawyer's Honey Identification), gives the coefficients in 1,000's of grains per 10g of honey for various plants.

[A]

Coefficient	Plant	Pollen grain size (micron)
0.3 (300 grains/10g of honey)	Willowherb	70 x 100
10 (10,000 grains/10g of honey)	Erica Lime	25 x 40 32
12	Ling heather	35
25	Fruit Blossom	30 to 45
50	Holly Bramble/Raspberry White clover	30 23 to 29 25 to 27
150	Canola (OSR)	25
5,000	Forget-me-not	6 x 3

It is of course possible to determine coefficients by yourself from honey that you are sure is from one plant. Often a patch of single source honey can be found on a frame, and this can be extracted by only uncapping and extracting that patch to obtain the pure honey. Extract the pollen from 10g of the honey, make up a slide(s) and count the grains of pollen. If the total count is 500 for example, the coefficient will be 0.5

To determine the relative quantities of honey from a given source in a sample divide the percentage of pollen grains measured from that source by the pollen coefficient.

All of the centrifuged or gravity-settled, sediment (pollen grains) from a 10g sample of honey is spread onto a slide to cover less than the cover slip area, dry & add a small amount of lightly stained jelly, apply cover slip and heat gently for 10mins).

Examine the slide under a microscope at x400 and determine the area of the field of view (using the mechanical stage, eye graticule & stage micrometer) and calculate that area as a percentage of the total area under the cover slip (correct for areas not filling the cover slip). Count the numbers of all of the different types of grains seen in 10 randomly selected fields of view and take the averages.

The relevant quantities can then be expressed as a percentage (Column 2 in example table [B] on page 328). For example, Rubus grains comprised 36% of the total number of pollen grains in the field of view.

Column 4 - Divide the percentages by the relevant pollen coefficient to find the relevant percentages of the different plant nectars collected by the bees. Total the different quantities in Col 4 (3.246 in example}

Column 5 Divide the individual quantities in Column 4 by the Totals for Column 4 to find the proportions of honey deriving from the various plants (multiply by 100 to express as a percentage).

Usually there will be one predominant plant source identified for any honey sample. This is Lime for the example given.

The table on page 328 [B] (Ref Rex Sawyer Honey Identification) gives an example.

Determining the composition of honey by measuring the proportions of the different pollens that it contains

[B]

1	2	3	4	5
Plant Source	Pollen % (Obtained from Slide count)	Published Pollen Coeffs. (1000's of grains Per 10g honey	Relative Quantities Of Honey (Pollen%/Pollen Coeff.(Col 2/Col3)	Percentage Composition Of Honey (Col 4/ QtyTotals for Col 4) x 100
Rubus (Bramble/ Raspberry)	36	50	0.72	22.2
Castanea (Sweet Chestnut)	26	1000	0.026	0.8
Tilia (Lime)	21	10	2.1	64.7
Trifoleum Repens (White Clover)	9	50	0.18	5.5
Ligustrum (Privet)	3	25	0.12	3.7
Others	5	50	0.1	3.1
TOTALS	100		3.246	100

Column 5 - % Composition of honey = Column 4 Value x 100/ Col 4 TOTAL e.g. 0.72 x 100/3.246 = 22.2%

Preparing a pollen slide from a honey sample

The following are the steps needed to prepare an analysis slide for checking from which flowers the honey (nectar) has been gathered.

Two methods are described, firstly using a centrifuge and secondly if access to a centrifuge is not available, using a sedimentation method.

Centrifuge method

1 Stir the honey sample (warm if necessary)

2 Weigh out 10g into a 50ml beaker,

3 Add warm water to make 25 to 30 ml of fluid. Warm and stir (ensure the honey is completely dissolved).

4 Pour into two 15ml centrifuge tubes – balancing the amount in each tube.

5 Centrifuge for 5-10 minutes.

6 Decant the water from both tubes.

7 Transfer all the sediment to one of the tubes (use a plastic pipette).

8 Add 10ml of water to both tubes and balance.

9 Centrifuge for 5 minutes.

10 Decant the water from the sediment tube.

11 Using a pipette to ensure all the sediment (pollen) is collected, transfer the sediment to a clean slide and spread it to about 1 cm2

12 Dry on the warming plate

13 Add a drop of warm stained glycerine jelly.

14 Carefully lower a clean coverslip onto the jelly.

15 Leave on the warming plate for about 10 to 15 minutes, during which time the pollen grains will take up the stain.

16 Examine under the microscope.

17 A few hrs later, when cold and set, excess jelly may be cut away and the edge of the coverslip sealed with nail varnish.

Sedimentation method

1 Dissolve 10g of honey in a honey jar or beaker with a capacity of at least 250 ml.

2 Cover and .leave for at least 20 hrs in a draught free place.

3 After 20hrs, decant all but 10ml of the liquid.

4 Swirl around the 10ml to disturb the sediment and pour into a short test tube. Leave for 20hrs.

5 After 20 hrs decant the liquid from the test tube and continue as from 11 above.

Limitations of the Method

Whilst the above methods work reasonably well for determining the type of honey by measuring the pollen contained therein, it is only suitable for extracted honey. It cannot really be used for pressed honey (such as pressed heather honey) as the pressed combs may contain a few cells of pure pollen which would of course add substantially to the number of pollen grains in the sample.

References

Honey Identification by Rex Sawyer – Cardiff Academic Press

Measured Coefficients - Todd & Vansell 1942, Berner 1952, Pritsch 1956, Maurizio 1958, Demianowicz 1961, Moar 1985

Lightning Source UK Ltd.
Milton Keynes UK
UKHW021548171221
395752UK00005B/65